Visual Studies

Visual Studies

A Skeptical Introduction

James Elkins

ROUTLEDGE
NEW YORK AND LONDON

Published in 2003 by
Routledge
29 West 35th Street
New York, NY 10001
www.routledge-ny.com

Published in Great Britain by
Routledge
11 New Fetter Lane
London EC4P 4EE
www.routledge.co.uk

Routledge is an imprint of the Taylor & Francis Group.

Library of Congress Cataloging-in-Publication Data

Elkins, James, 1955-
Visual studies : a skeptical introduction / James Elkins.
 p. cm.
Includes index.
 ISBN 0-415-96680-9 (HB : alk. paper) — ISBN 0-415-96681-7 (PB : alk. paper)
 1. Art and society. 2. Culture. 3. Visual communication. 4. Visual perception. 5.
Visual literacy. 6. Communication and culture. I. Title.
N72.S6E45 2003
700'.1—dc21 2003013585

The text of this book was composed in Scala, with Veljovic and Scala Sans as display
faces. Book design by Dutton & Sherman Design. Printed and bound in the United
States of American by Edwards Brothers, Inc.

Contents

Preface

VISUAL STUDIES IS POISED to become one of the most interesting and conceptually challenging subjects that has emerged in academic life in the last several decades. It can be the place where questions of visuality are discussed—where people from different disciplines come to discover new ways of understanding images. Visual studies has the potential to contribute a voice significantly different from the text-based practices that are preeminent in the humanities and it has the capacity to uncover connections between parts of the university that are now largely disjointed.

Yet in order for visual studies to become the field that I think it can be—the field toward which it is tending—it has to become more ambitious about its purview, more demanding in its analyses, and above all more difficult. The field, which is barely a decade old, has already produced a number of excellent texts written at a very high level of scholarship: I think, for example, of essays by Douglas Crimp, Fredric Jameson, Irit Rogoff, and Jay Bernstein, among many others. At the same time it has generated anthologies and books that are more celebratory than reflective and it has given rise to a grow-

ing literature of undistinguished cultural criticism. It is relatively easy to write an acceptable visual-culture essay on any number of subjects, from *The Sixth Sense* to Six Flags Great America. As the field grows, it needs to take that ease seriously.

This book can be used as an introduction to visual studies, provided it's understood that a field so recently named and so scattered in its purposes cannot really be introduced. Readers new to the subject will be able to find their way into the literature and make up their own minds on the contested issues. In that sense this is an ordinary introduction. It is a "skeptical introduction" because my main purpose is not to survey the field but to raise the ante. I want to make life harder—and therefore more interesting—for people who love the visual world as much as I do.

This book starts slowly, surveying existing programs, perusing the bibliography, looking at leading concepts such as interdisciplinarity. After that the argument gathers speed and becomes more critical. I thought it would be best to begin with a sober assessment because there is still no book that considers the field as a whole. If you're more interested in polemics than protocol, you may want to begin with chapter 3.

I owe thanks to my colleagues, especially George Roeder, Maud Lavin, and Joe Grigely, for giving me so many ideas over the last few years as we at the School of the Art Institute of Chicago have developed our own visual studies program. Thanks also to Laurie Palmer, Gregg Bordowitz, Margaret Olin, and Roderick Coover for their work in a faculty seminar that led to the creation of the program; and to Tom Mitchell for sharing his unpublished lectures. Michael Ann Holly read a proposal for this book and offered useful comments. Hans Dam Christiansen of the University of Copenhagen, Jill Casid, Melinda Szaloky, and Edward Branigan, Peter Blank, Michael

Newman, Mikkel Bolt Rasmussen, David Bordwell, Sunil Manghani, Jeff Skoller, and Tom Gunning gave me helpful advice. Ziauddin Sardar, Ashis Nandy, and Ravi Vasudevan helped me find Indian and Southeast Asian universities interested in visual culture. Hannah Bennett of the Ryerson and Burnham Libraries provided a useful list of European periodicals. I found Margarita Dikovitskaya's dissertation on the rise of visual studies to be an excellent resource. And finally, special thanks to the Chicago Theory Group: *omni re scibili et quibusdam aliis.*

Paris, Dublin, Chicago 2002

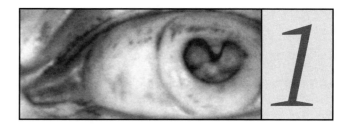

What Is Visual Studies?

A GOOD PLACE TO START in considering a new field is with some basic questions of the kind administrators or librarians might ask: Where did it get its name? What are its journals and its principal books? Where is it taught, and what texts are required? How is it different from its nearest neighbors? And finally—most sensitively—is the field a new discipline or an initiative that exists between disciplines?

CULTURAL STUDIES, VISUAL CULTURE, VISUAL STUDIES

Visual studies is actually one of several expressions that are sometimes distinguished and other times indifferently mixed. In particular, there are vague but significant differences between three of the choices: cultural studies, visual culture, and visual studies.

1. *Cultural studies* started in England in the late 1950s; it is still often associated with a small number of texts by Richard Hoggart (*The Uses of Literacy*, 1957), Raymond Williams (*Culture and Society*, 1958), and Stuart Hall ("Cultural Studies: Two Paradigms," 1980).[1]

That first wave of texts inaugurated a combination of historical writing and social concern that has continued—though often in an attenuated and politically inactive form—to the present. In the 1970s, cultural studies spread through the "red-brick universities" in England (the polytechnics, reimagined by Margaret Thatcher's government as liberal arts universities), gathering and borrowing from a number of neighboring disciplines, including art history, anthropology, sociology, art criticism, film studies, gender and women's studies, and general cultural criticism, including journalism.[2] In the 1980s, British cultural studies spread to America, Australia, Canada, and India, and there are now cultural studies departments and initiatives in a number of countries.

2. *Visual culture* is slightly but measurably different, even aside from its emphasis on the visual. It is preeminently an American movement and it is younger than cultural studies by several decades. The term was used—perhaps for the first time in an art-historical text—in 1972 in Michael Baxandall's *Painting and Experience in Fifteenth-Century Italy,* but visual culture did not appear as a discipline until the 1990s.[3] As the field spreads through the Western university system, there are increasing numbers of ephemeral and local debates about the putative discipline's coherence and definition. In general terms, it would be fair to say that visual culture is less Marxist, further from the kind of analysis that might be aimed at social action, more haunted by art history, and more in debt to Roland Barthes and Walter Benjamin than the original English cultural studies. It is also, as in the work of Janet Wolff, closer to sociology in the European sense—that is, unquanti-

Plate 1, opposite: Windowsill with stork made of straw, c. 1998. All photos are by the author unless otherwise credited.

I love the idea of a visual studies that can concentrate on the technical details of some scientific image, and then relax into the capacious and unfocused frame of mind that is right for a photograph like this one. It is one thing to be interdisciplinary, in any of the meanings of that word, and another to relinquish disciplines long enough to let the image find the right mixture of approaches. Image-making practices that involve extremes of violence can be just as hard for discipline-bound interpretation as those that seem too gentle or soft. Here a straw stork presides over a collection of stones on a windowsill. The light comes down past grape leaves and filters through an old-fashioned metal screen.

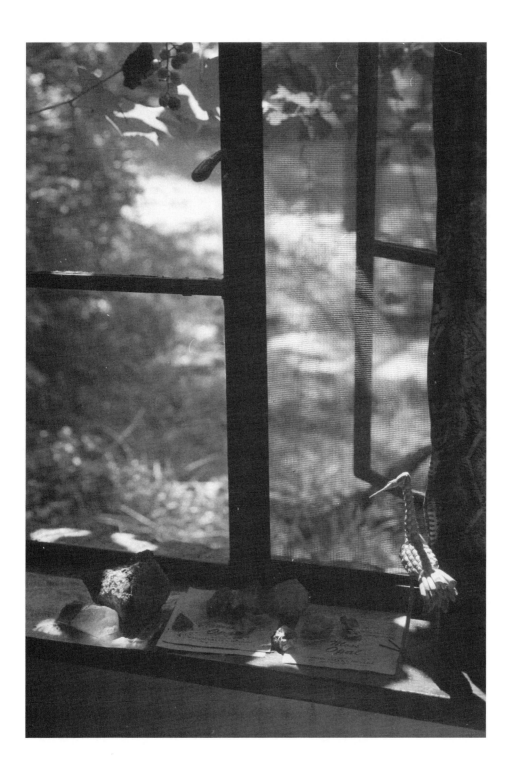

fied and culturally oriented sociology.[4] In those and other respects, visual culture is "a narrower area of cultural studies," as Douglas Crimp puts it.[5] Visual culture is oriented toward the visual, although the extent of that interest is an ongoing subject of debate. The best brief definition I know is George Roeder's, which he borrows from Gertrude Stein. "Visual culture is what is seen," Roeder says, and continues: "Gertrude Stein observes that what changes over time is what is seen and what is seen results from how everybody's doing everything. What is seen depends on what there is to see and how we look at it."[6] Given that a definition of visual culture would go against the grain of visual culture's ambition to remain fluid, Roeder's paraphrase of Stein does a good job: it is no more rigid than Stein's abstract grammar permits, and it hints at the viewer's share and the work that images do in culture.

In the mid-1990s a spate of books on visual culture appeared, proposing a variety of definitions of visual culture: *Visual Culture,* edited by Michael Ann Holly, Keith Moxey, and Norman Bryson (1994), Victor Burgin's *In/Different Spaces: Place and Memory in Visual Culture* (1996), and Malcolm Barnard's *Art, Design, and Visual Culture* (1998).[7] From a publisher's point of view, it began to seem appropriate to issue textbooks and readers, such as Chris Jenks's edited volume *Visual Culture* (1995), Nicholas Mirzoeff's *Visual Culture Reader* (1999), and Marita Sturken and Lisa Cartwright's *Practices of Looking: An Introduction to Visual Culture* (2001).[8] The first dissertation on the rise of visual culture, by Margarita Dikovitskaya, also appeared in 2001, a sure sign of the academic acceptance of the new field.[9]

3. *Visual studies* is the youngest of the three. The phrase appears to date from the early 1990s, perhaps inspired by the University of Rochester's program in Visual and Cultural Studies. In 1995 W. J. T. Mitchell used *visual studies* as a name for the confluence of art his-

tory, cultural studies, and literary theory, each of them in the sway of what Mitchell calls the "pictorial turn" (sequel to the "cultural turn" that had produced cultural studies thirty-five years earlier).[10] When the University of California at Irvine inaugurated its program in Visual Studies in 1998, its committe members decided that the phrase *visual culture* had been tarnished by a public forum in the journal *October* in 1996. (More on that below.) Anne Friedberg says that the committee felt that the field of interest had been "tarred" by association with visual culture, as if it were "no longer . . . about form itself, so much as social meaning."[11] To avoid that association, they chose *visual studies*.

The term *visual studies* has considerable—perhaps unhelpful—latitude. Some of the principal concerns have been nicely summed up by Dikovitskaya:

> some researchers use the term *visual studies* to denote new theoretical approaches in art history (Michael Ann Holly, Paul Duro); some want to expand the professional territory of art studies to include artifacts from all historic periods and cultures (James Herbert); others emphasize the process of seeing (W. J. T. Mitchell) across epochs (David Rodowick); while still others think of the category of the visual as encompassing non-traditional media—the visual cultures of not only television and digital media (Nicholas Mirzoeff), but also of the institutional discourses of science, medicine, and law (Lisa Cartwright).[12]

In the last three years of the 1990s, visual culture was adopted as a recognized field. Authors such as Mirzoeff, who may be identified with the phrase *visual studies* as much as with *visual culture,* tend to insist on the preeminence of the visual and on the kind of institutional or disciplinary stability that would warrant the production of textbooks and anthologies.

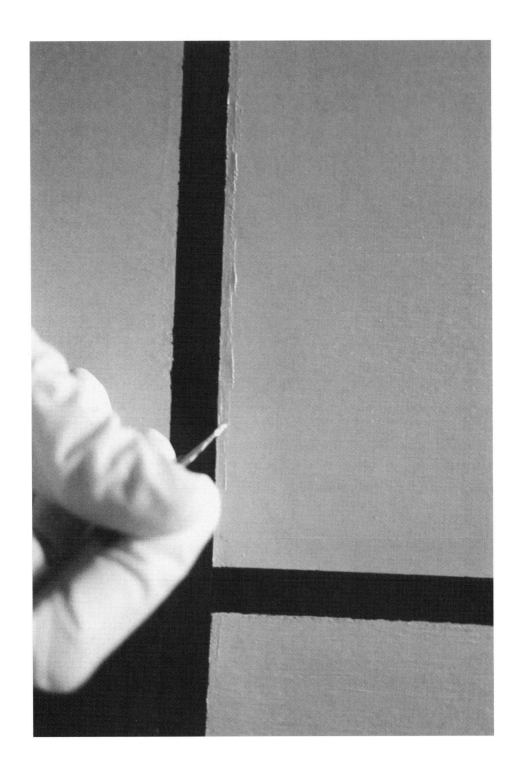

In this book I generally use the expression *visual studies* to denote the field I think that visual culture might grow to be: the study of visual practices across all boundaries. That was my project in the book *Domain of Images,* and it is an interest shared in different ways by Mitchell, Herbert, and others.[13] For consistency's sake I will usually use *visual culture* to refer to the current state of the field, which is appropriate because *visual culture* is still much more common an expression than *visual studies.* I also use *visual culture* to denote the field of study, just as *visual studies* does. That is to avoid the locution *visual culture studies,* in the same way that "English" avoids "English literature studies." (Another synonym for *visual studies* in the sense I am using it here is *image studies,* an expression that is not yet widely used.)[14]

Plate 2, opposite: A student, wearing a yellow dishwashing glove, copies a Mondrian painting in the Art Institute of Chicago. He is trying to mimic the little ridges of paint that can be found on either side of some of Mondrian's stripes. Sometimes the stripes look like stepped embankments, creating a strong sense of three-dimensional relief when they're seen from a normal viewing distance. Even after a close study over the course of two years, I am still unsure how Mondrian ended up creating those effects. There is a kind of visual intelligence, a kind of knowledge, that can come only from making.

In 1995, when Mitchell set up a course on visual culture at the University of Chicago, he called it "visual culture" rather than "visual studies" because the latter seemed "too vague." "It could mean anything at all to do with vision," he told Dikovitskaya in an interview, "while 'visual culture' suggests something more like an anthropological notion of vision . . . as culturally constructed."[15] It is exactly that apparently unconstricted, unanthropological interest in vision that I think needs to be risked if the field is to move beyond its niche in the humanities: but more on that in Chapter 3.

THE SPREAD OF VISUAL CULTURE PROGRAMS

It is said that new programs in visual studies and visual culture are starting every year, but the claim is hard to assess. The major international indices of universities are not organized by subject, making it

difficult to discover how many universities have departments, fields, concentrations, seminars, committees, or emphases in visual culture.

Peterson's Graduate Programs in the Humanities lists American and Canadian universities by subject; it divides visual culture programs between two officially recognized headings: "Theory and Criticism of Film, Television, and Video" (twenty-one universities) and "Cultural Studies" (twelve more). The lists include some universities with well-developed programs, such as Columbia University, Cornell University, and the University of Chicago, and also some smaller institutions not generally known for their work in this field, such as Chapman University in Orange, California, and Hollins University in Roanoke, Virginia.[16] At the same time, *Peterson's* omits some of the principal players in visual culture: the Graduate Visual and Cultural Studies Program in Rochester (the first graduate program, founded in 1989) and the Graduate Program in Visual Studies at the University of California at Irvine (the second).[17] The scattered listings are due to the fact that there is no agreed-upon name for the field and that individual courses in visual studies can be offered in a wide range of existing departments. In practice, a bewildering number of departments offer visual studies courses, among them Art History, English, Women's Studies, Comparative Literature, Art Education, Sociology, Philosophy, Visual Communication, and Television, Film, and Media Studies. As universities expand and new courses are introduced, the normal pattern is that Film Studies is the first to host courses on visual culture. The new field can also find a home in the departments of Art History, Literature, or Philosophy.

In larger American universities, the typical configuration is that visual studies is taught in the Film Studies Department, the Women's Study Department, or the Media Studies Department—leaving art history with older painting, sculpture, and architecture.[18]

The same division can be seen in many universities in Europe and Latin America. At University College Dublin, for example, the Art History department offers courses in modern Irish art but focuses on the main sequence of painting and architecture from Greece and Rome to the late nineteenth century. Women's Studies, Media Studies, and Film Studies are taught in a separate building. The division between older art (assigned, by default and preference, to Art History) and new images and media (appropriated by Film Studies and other new departments) is one of the principal political reasons why there is ongoing friction between art history and visual studies. (There are also philosophic reasons, which I will consider later.)

Visual studies varies from place to place: it is significantly different in Irvine, Rochester, the City University of New York, the State University of New York at Stony Brook, Berkeley, Monash University in Victoria, the School of the Art Institute of Chicago, Sussex, Essex, Nottingham, Manchester, Birmingham, the University College London, Lund, Copenhagen, Tokyo, and Delhi. In addition, programs in different universities can be largely independent of one another, so that their methods and results vary widely.

The center of confusion, because it is also the center of cultural studies, is England. It seems that visual culture is taught at nearly every university and polytechnic. Some names are more promising than others: Middlesex University's School of Arts offers research in the History and Theory of Visual Culture; its program is based in Film and Media Studies.[19] The University of Cambridge, on the other hand, puts its visual culture interests in the Department of Architecture and Art History. In Canada, too, initiatives have confusingly similar names. There is a chair in the History of Visual Culture at the University of New Brunswick, as well as an undergraduate degree with an emphasis in Multimedia Studies. (The latter is mainly electronic arts.)

9

The interest in visual culture has spread beyond England, Canada, and the United States. In India there is a visual studies center in Delhi (the Sarai Program), and an archive of visual materials in Calcutta (Centre for the Study of Social Sciences), but other than that visual studies is carried on within Film Studies or Cultural Studies.[20]

On the Continent and in Latin America, visual culture courses are more likely to be found in departments of new media, semiotics, philosophy, visual communication, and anthropology. In my experience, North American and English scholars tend to assume that visual culture is expanding along lines familiar to them—that is, springing from art history, literature, and film studies—but it remains possible that the European or Latin American flavor of visual culture—springing from semiotics, visual communication, and philosophy—may become the predominant model. (Visual studies growing from mathematized theories of communication is very different from visual studies in North America, where visual communications tends to be a more varied and less semiotically informed practice that includes design studies and graphic design.)[21] I imagine that this book, for example, will not find many readers in parts of Europe and Latin America, because visual culture is configured very differently there. It is possible there are three genealogies: in the United States, visual studies departments have grown out of art history departments; in England and southeast Asia, visual studies is more closely allied to cultural studies; and on the Continent, visual studies is allied to semiotics and communication theory.

A sampling shows the current conceptual disarray of the field.

The Center for Art and Media Technology (ZKM) in Karlsruhe, Germany, specializes in new media, including video, digital imaging, and the Internet. The adjoining Hochschule für Gestaltung has some faculty in painting and architecture, but it also concentrates on

new media. The more traditional study of painting, sculpture, and architecture is relegated to the local art academy, the Staatliche Akademie der bildenden Künste. In the Hochschule für Gestaltung, the concerns I am identifying with visual studies are at once compressed in the direction of digital media and isolated from traditional art practices.

In Mexico, the Universidad Nacional Autónoma de México (UNAM) is the principal source of theoretical activity in cultural studies, but the "Tec" de Monterrey, a technical university with a large humanities program, offers courses in visual studies, divided between the Humanities Department and the Department of Communication and Technologies of the Image. A third university, the Universidad Iberoamericana, offers visual studies courses in its Art Department.

In the fall of 2002, the University of Copenhagen began offering an MA in Visual Culture. Niels Marup Jensen's "Billedernes Tid: Teorier og Billeder I den Visuelle Kultur" ("The Time of Images: Theories and Pictures in Visual Culture"), an unpublished manuscript (c. 2000) stresses semiotics, theories of time, and Derridean meditations on context and framing. Jensen's course on "Visuel Kultur" includes readings by Raymond Williams, Martin Jay, Régis Debray ("Three Ages of Looking"), W. J. T. Mitchell, William J. Mitchell, Svetlana Alpers, Jonathan Crary, Susan Sontag ("In Plato's Cave"), John Taylor (from *Body Horror*), Roland Barthes, David Freedberg, Robert Nelson ("Appropriation," from *Critical Terms for Art History*), Hal Foster, Claudine Isé ("To Be Primitive without Culture"), three essays from the *Routledge Visual Culture Reader,* Paul Virilio, and Lev Manovich ("The Automation of Sight").[22] The course is oriented toward American scholarship more than British work and it nearly excludes French writing altogether. The Department of Culture Studies and Art History at the University of Bergen, Norway,

has a similar configuration, with readings including Barthes, Geoffrey Batchen, Victor Burgin, Mitchell, Margaret Olin, Abigail Solomon-Godeau, and Allan Sekula.[23]

One effect of developing visual culture out of visual communications is an emphasis on non-art images, including scientific and technological practices. At the University of Bologna, the Dipartimento delle Arti Visivi has art historians and also semioticians, phenomenologists, and psychoanalytic critics; the courses closest to visual culture are offered in the Dipartimento di Discipline della Comunicazione. The Department of Art History and Visual Studies (Konst- och Bildvetenskap) at the University of Göteborg, Sweden, stresses informational and non-art images, as does the Department of Art and Media Studies (Institutt for Kunst- og Medievitenskap) in the Norwegian University of Science and Technology (Norges Teknisk-Naturvidenskabelige Universitet) in Trondheim, Norway.[24]

Plate 3, opposite: A frog skin, mounted on a piece of paper, part of a display of the frogs native to Ithaca, New York. This is *Rana clamitans,* the Green frog, skinnier cousin of the bullfrog. The circles that look like eyes are tympani (eardrums); they are larger than the holes just above them where the eyes were, and that means this is a male. When I was young I tried catching frogs, and in high school I dissected one. This display belongs with those activities in the sum total of twentieth-century representations of frogs: yet another overlooked subject for a future essay in visual studies.

At Aarhus University, Denmark, visual studies is dispersed among the combined Center for European Culture Studies and Department of Gender Research, the Center for Interdisciplinary Aesthetic Studies ("Center for Tvaeraestetiske Studier," which does not include the philosophic study of aesthetics), and the Center for Semiotics—all of them "centers" and not Departments. There the curricula are similar to those at the University of Copenhagen, but in 2001, when I visited, there was somewhat more attention to French scholarship.

Several studio art departments, art schools, and art academies have also instituted visual studies *de facto* or under various names. In my experience, visual studies grows wild in studio art depart-

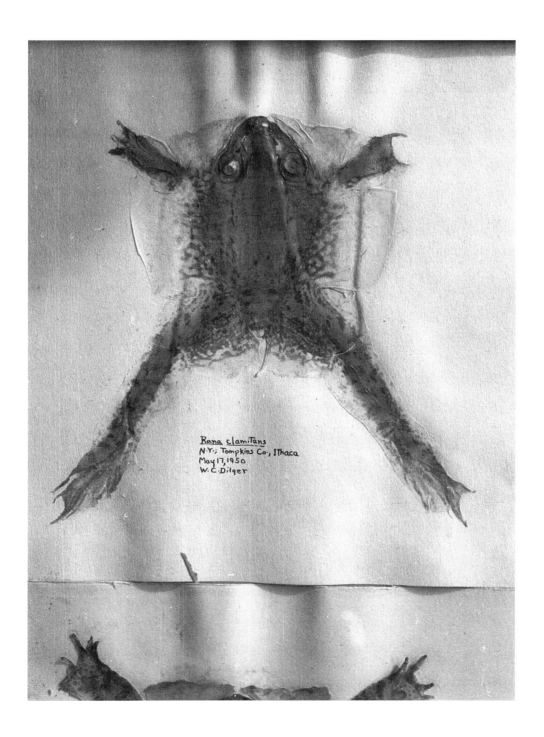

Rana clamitans
N.Y.; Tompkins Co., Ithaca
May 17, 1950
W. C. Dilger

ments and art schools, where it is a standard accompaniment of studies in postmodernism. I teach at the School of the Art Institute in Chicago, which is a large art school; one of the departments I teach in is called Visual and Critical Studies, but visual culture–style courses are also offered in several other departments, including Film, Video and New Media; Department of Art History, Theory, and Criticism; and Visual Communication. (Ours is the first undergraduate department in visual studies, which has so far been aimed at graduate students.)[25] Art academies and art schools tend to disperse visual culture more widely than universities, perhaps because of visual culture's natural affinity to art criticism, which is practiced in regard to all media.

Detail 4, opposite: The contemporary world is full of impromptu pictures that are "subdisciplinary," just beneath the notice of art history. They aren't art or science, and they seem too self-evident for classroom study. This is part of a cave map: the fat man can't squeeze by the narrow passage, but if he could, he'd get a nice view down the cave. (The view is indicated by a camera on a tripod.) Is there a kind of visuality too simple, too informal, to be studied?

The model I will be concentrating on in this book is found mainly in Canada, the United States, Scandinavia, and the United Kingdom; there is no intrinsic reason it should become the model for all visual culture.

PUBLICATIONS IN VISUAL CULTURE

There is a labyrinth of journals that publish texts on visual culture. Two of the most recent, and therefore most sensitive to the emerging status of visual culture as a discipline, are the *Journal of Visual Culture* (2002–) and *Culture, Theory, and Critique,* which has been revived in Nottingham (2002–). The journal *Visual Studies* (2002–) is a continuation of *Visual Sociology Review* (1986–2001), making its new name somewhat misleading.

Among electronic journals, *Invisible Culture* (1998–) is published by a group at the University of Rochester; *M/C* (1998–) is put out by the Media and Culture Studies Centre at the University of

Queensland; *Transcript: A Journal of Visual Culture* (1996–) is the work of a group at the University of Dundee, Scotland; *Modernity: Critiques of Visual Culture* (1999–) edited by Stephen Eskilson at Eastern Illinois University; and *Glossen* (1997–) is a peer-reviewed bilingual journal of German art since World War II.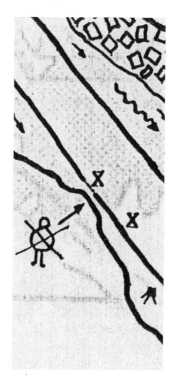

Other journals of interest to visual culture include *Word and Image* (1985–), *Visual Culture in Britain* (2000– , published by the University of Northumbria and tending toward a specialization in Victorian studies), *Parallax: A Journal of Metadiscursive Theory and Cultural Practices* (1995–); *Transcript: A Journal of Visual Culture* (Dundee, Scotland, School of Fine Art, 1994–); *Cultural Studies* (1987–), *Discourse: Berkeley Journal for Theoretical Studies in Media and Culture* (1979–), *Representations* (also edited in Berkeley, 1983–), *Visual Arts and Culture* (1998–), *Visual Anthropology* (1991–), and the *Visual Anthropology Newsletter,* later called *Visual Anthropology Review* (published by the University of California at Los Angeles's Center for Visual Anthropology, 1991–). There are also occasional articles of relevance to visual culture in older literary-critical and cultural studies journals such as *Social Text* (1979–), *Third Text* (1987–), *substance* (1971–) and *diacritics* (1971–).

This listing includes only English-language journals, because the field of visual culture is not often described as such in non-English publications. Much of the same material, however, is covered in journals such as *Kritische Berichte* (1973–). In Scandinavia there are several journals on visual culture: *Øjeblikket: Tidsskrift for Visuelle Kulturer* (*The Moment: Journal for Visual Cultures*), *Periskop: Forum for kunsthistorisk debat*, and *Passepartout: Skrifter for kunsthis-*

torie (University of Århus); in addition there have been several special issues of other journals dedicated to visual culture, such as *Agora* (Norway) no. 2–3 (2001), and *Konsthistorisk Tidskrift* (1932–). In Germany there is also *Texte zur Kunst* (1990–), *Erste Hilfe, Anyp,* and *Argument* (1959–). In Italy a relevant journal is *Agalma;* others are *Area* (1990–) and *Cross: arti visive e cultura contemporanea (visual arts and contemporary culture.)*[26] Others, which I have not been able to see, are *Kunst.ee: Eesti visuaalkultuuri ajakiri (Estonian magazine of visual culture); Laus ADGFAD: disseny gràfie i comunicació visual (disenõ gráfico y comunicació visual; graphic design and visual communication)* (1982–); *Rakurs: zhurnal sovremennoi vizual'noi kul'tury* (2000–); *Umelec* (Prague, 1997–); and *Visual: die Zeitschrift für das Sehen und das Sichtbarmachen* (1994–).[27] These journals are at the edge of a much larger ocean of perhaps three hundred ephemeral culture, fashion, design, and communication journals.[28]

One of my themes in this book is the importance of the sciences; I am going to urge that opportunities to cross the border from the humanities to the sciences be taken whenever possible. There are several dozen scientific journals that are mainly or exclusively occupied with vision and visuality. These aren't journals that report on the social or hermeneutic problems raised by their specialized practices: they are science, purely and not so simply. Among them, my own favorites are *NeuroImage* (1992–), *Ultramicroscopy* (1975–), *Journal of the Optical Society of America, A: Optics, Image, Science, and Vision* (1984–), the *Journal of Imaging Systems and Technology* (1997–), *Journal of Mathematical Imaging and Vision* (1997–), the *British Journal of Ophthalmology* (1917–), *Visual Cognition* (1994–), and the *Journal of Magnetic Resonance Imaging* (1999–). There are many others in cognitive psychology, physiological optics, and neurology, as well as technological journals of digital image processing and

machine vision. The scientific journals have the advantages of being well funded and therefore well produced; in addition they are largely online (with access through major libraries) and in English regardless of their country of origin.

ATTEMPTS TO DEFINE VISUAL CULTURE

So far I have been behaving as a librarian or an administrator, trying to get a preliminary sense of the field by surveying the history of its name, the places it is taught, and its main publications. A first step into deeper water is to consider how writers in the field itself have tried to define what their work is about.

As of 2002, there had been three major attempts to see what visual culture or visual studies might be or might mean.

1. *Anthologies and monographs.* Several texts published in the 1990s purport to describe the new discipline, or imply a definition through their choices of methods and objects. Prominent examples are Nicholas Mirzoeff's books, such as the *Introduction to Visual Culture* (1999); *Interpreting Visual Culture,* edited by Ian Heywood and Barry Sandywell (1999); and *Practices of Looking,* by Marita Sturken and Lisa Cartwright (2001).[29] Taken together, those books imply three distinct directions of visual culture: toward contemporary transnational mass media (Mirzoeff), toward the philosophic interrogation of vision and visuality (Heywood and Sandywell), and toward a social critique of current image-making practices (Sturken and Cartwright). Visual studies emerges from these books as a set of overlapping concerns united by a *lack* of interest in several subjects—older cultures, formalism, and canonical works of art. These books and others like them that are currently being used as textbooks do not so much define a new field as they define their differences from existing fields, especially art history.

There are also books such as the anthology *Bild-Bildwahrnehmung-Bildverarbeitung* (1998) and Hans Belting's *Bild-Anthropologie* (2001) that follow the European interest in sociology, semiotics, visual communication, and anthropology.[30] Belting's book, for example, proposes new, non-art-historical terms such as *Ort* to describe the historical and cultural place of works.[31] It will be interesting to see how Belting's book is received when it is translated into English, given the different valence of anthropology in America and England, where anthropology is conceived as a site of theorizing about the difficulty of objectivity, and as a progenitor of postcolonial studies.

Plate 5, opposite: This lovely photograph conforms to many of the unwritten rules of spontaneous photography from Cartier-Bresson onward: it is a decisive moment, unplanned, caught with a mix of sharpness and motion blur. At the same time it comforms to the unwritten rules of current narrative photography as in Jeff Wall: it looks elaborately posed, and it seems to mock naturalness with its improbable balance. (The boy in the background bends under the slide as if he is mimicking the arc of water form the hose.) But this is really just a family snapshot. Visual studies has to learn to look beyond fine-art expectations.

In different ways the books I have named also hint at the possibility of a new discipline that would be outside existing disciplines. If one were to judge visual culture by its textbooks and anthologies, it would appear as a healthy new discipline with little agreement about its nature. The other two attempts to describe the nature of visual culture were much more tightly constrained in time and space.

2. *The* October *questionnaire.* In 1996 the journal *October* ran the responses to a questionnaire in which a number of scholars in art history, political science, and film studies answered a page of questions about visual culture. The general tenor of that forum—and here I am forced to simplify what is really a wide spectrum of detailed responses—was that visual culture is a disorganized, possibly ineffectual, illegitimate, and even misguided extension of art history and other disciplines. The art historian Rosalind Krauss summed up the reactions best when she proposed that visual studies is really only training students to become better consumers.[32] The *October* survey is particularly interesting because the people who

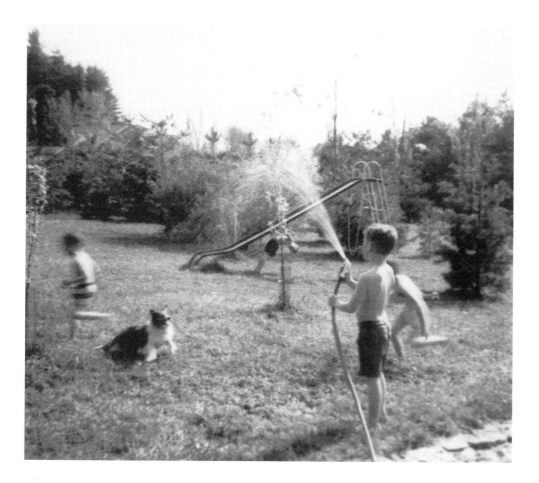

responded would generally be identified with the more experimental sides of art history and literary criticism, and yet a number of the letters are openly or covertly skeptical. (Thomas Crow's response is interesting in that regard, because it could be read as an endorsement of the new field.)[33] The *October* survey gives a sense of the resistance the new visual culture initiatives provoked and the more strident answers that might have resulted from a wider pool of correspondents.

3. *The second Clark conference.* This was held at the Clark Art Institute in the spring of 2001. I can't speak with authority about this conference because I did not attend, but I have read several of the papers and spoken to several people who participated. Again there seems to have been a very wide range of approaches, and again they seemed fairly coherent. This time the overall response to the question of visual studies was that it does not exist as it has been posited. Several people gave papers on the prehistory of the discipline and how it has assembled its agenda from earlier practices. Other speakers outlined their own work instead of attempting to define or critique visual studies as such. The tenor of that conference seems to have been set, for many speakers, by Mitchell, whose paper gave ten reasons not to be skeptical of visual studies.[34] (The paper consists of ten quotations from unnamed writers, together with Mitchell's responses. The writers are wary of the idea that visual culture will study only disembodied images, undermining media specificity and unduly privileging visuality. Their positions reflect the conservative reactions that can also be found in some of the *October* responses.)

So in the shortest possible compass, the history of visual culture to date might be put this way: first there seemed to be a new discipline called visual studies or visual culture, and it grew to the point of threatening some existing disciplines, as the *October* survey demonstrates. By the time of the second Clark conference, in 2001, visual culture seemed to have partly collapsed and been reabsorbed into the various disciplines and individual practices from which it came. As Hegel pointed out, movements that have run their course continue in many forms. As I write this, in the fall of 2002, visual culture is thriving and at the same time provoking resistance and also eliciting sighs of boredom from people who think it is an evanescent collage of existing practices. Thus all three moments in the short history of visual culture's self-definitions are still in force.

VISUAL CULTURE AND ART HISTORY

A common thread of the three moments of self-definition is a newly formed relation to art history. Both conservative scholars and those who associate themselves with visual studies tend to emphasize the distance between the two fields.

Of all the disciplines of use to visual studies—either as a productive contrast or as a potential resource—art history is methodologically and genealogically the most important. I mentioned the tendency of visual culture to trump art history departments, leaving them stranded teaching an apparently old-fashioned, essentially European canon of artists, inculcating what appears to be a traditional aesthetic education centered on painting, sculpture, and architecture. That captures something of the day-to-day friction between the established practice of art history and the mixed interests of visual culture.

Here is a typical scenario. In a university I won't name, the Art History Department has watched passively while film, video, and television have been taught by faculty in the English Department, the Communications Department, and the Department of Modern Languages. In the mid-1980s the university approved a Film Studies Department. That was a typical development: even though art historians have studied film since the 1930s (it was given institutional prominence in 1929 when Alfred Barr included film and photography in the original exhibitions of the Museum of Modern Art), the literature of film studies is still not widely known in art history, and vice versa.[35]

The Art History Department in this university has a full-time faculty member who works on modern and postmodern art, but his classes attract only a fraction of the students who flock to the other departments to study the history of film and television. The univer-

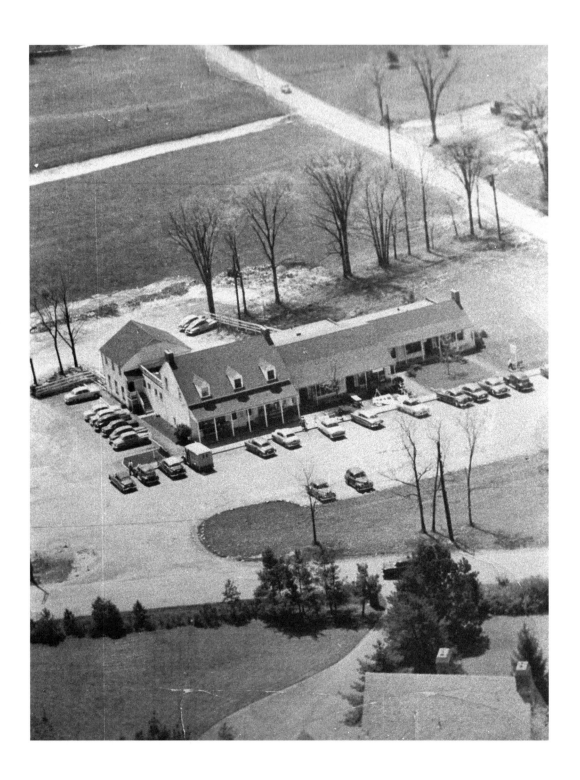

sity is now considering a combined degree called Visual and Cultural Studies. The art historian would teach on that faculty, but that would make it even less probable that the next hire of a specialist in film, television, or advertising will be in the Art History Department. If things keep going in this direction, in ten years the Art History Department will "specialize" in older art and be aligned more with the Classics or Archaeology departments.

Happily, this is not the only plot for the drama of art history and visual culture, but it is a common one. It is not chance that Rochester's Visual and Cultural Studies Program, the first of its kind, opened in a university that had no graduate program in art history. From a visual-culture standpoint, art history can appear disconnected from contemporary life, essentially or even prototypically elitist, politically naïve, bound by older methodologies, wedded to the art market, or hypnotized by the allure of a limited set of artists and artworks. In Arjun Appadurai's wonderful formula, critics of cultural studies mistrust "its 'theory' (too French), its topics (too popular), its style (too glitzy), its jargon (too hybrid), its politics (too postcolonial), its constituency (too multicultural)."[36] Or to put it more soberly, from an art-historical standpoint visual culture can appear lacking in historical awareness, transfixed by a simplified notion of visuality, careless about the differences between media, insouciant about questions of value, and sloppy in its eclectic choice of objects and methods.

Plate 6, opposite: Visual studies can also embrace aerial surveying, reconnaissance, and even digital video from missiles. The sociologist Douglas Harper has noticed that aerial photographs are a good way to break informants' accustomed sense of the place they live. This is a picture of the shopping center where my father set up his business before I was born. The rounded hoods of the cars, and the number of healthy American elms, date this to the mid-1950s. Everything that is dirt in this photo is now asphalt, and the fields are planted with ranch-style houses.

One of the turning points of such discussions is what is said to be art history's interest in the "sensuous and semiotic peculiarity of the visual," as opposed to visual culture's interest in identity politics and social constructions.[37] Part of this argument is that art history

23

has not looked at the broader contexts of artworks or paid attention to the ways in which they have created viewers. Such claims depend on a picture of art history that does not include such interests as social art history or *Rezeptionsgeschichte* (the history of reception), which is concerned with the construction of viewers.[38] Indeed, it could be argued that art history has long taken an interest in political settings and social constructions. French and German scholarship around the turn of the twentieth century were often concerned with cultural meanings because their purpose was the discovery and preservation of national memories. Examples include early twentieth-century German writing on medieval German architecture, silverwork, wooden sculpture, and painters such as Holbein and Dürer.[39] It has even been argued that the sum total of German art-historical scholarship can be considered in this light, as a protracted and often evasive or ineffectual attempt to understand art in its (German) political context.[40]

This is not to say that visual culture cannot widen and critique art history's approaches to the political and social functions of art— far from it. But the picture of art history as a blinkered aestheticizing enterprise or as a hermetic and overly intellectual elitism is predicated on a limited experience of the discipline. (I will have more to say about this in chapter 3.)

Why argue this way? Because it is important to be clear that the mistrust between the two fields springs less from genuine methodological, historical, and political disagreements than from two much less exalted sources: a fear, sometimes legitimate, about jobs and the relative position of departments within universities; and a desire for intellectual independence that sometimes has to rely on lack of familiarity. I am preaching not so much tolerance as skepticism. When it becomes meaningful to define visual culture as something apart from art history, I am as interested in the motivations as in the evidence.

WHAT IS VISUAL STUDIES?

Even though art history is the field most often compared with visual culture, some of the same dynamics can be observed in other interactions. Visual studies has also been defined as a field that springs from semiotics, poststructuralism, anthropology, sociology, literary theory, and even translation studies. In anthropology, for example, Fadwa El-Guindi has argued that fields such as visual anthropology are not part of anthropology proper but are a separate discipline.[41] Mieke Bal has approached visual culture through literary theory, art history, postcolonial theory, psychoanalysis, and most recently translation studies.[42] Certainly one of the strengths of visual culture is its magnetic effect on neighboring fields, although art history remains the most important alternate—and in some senses superseded—field.

IS VISUAL CULTURE INTERDISCIPLINARY?

The specific question of visual culture's relation to art history leads into and also springs from the general question of visual culture's relation to any discipline and to disciplinarity itself. As it stands, visual culture draws on nearly two dozen fields in the humanities, including history and art history, art criticism, art practice, art education, feminism and women's studies, queer theory, political economy, postcolonial studies, performance studies, anthropology and visual anthropology, film and media studies, archaeology, architecture and urban planning, visual communication, graphic and book design, advertising, and the sociology of art.[43]

For some scholars it matters that visual culture remains interdisciplinary: that it "cannot be localized," as Tom Conley puts it.[44] It is true that American universities continue to have difficulty deciding where to place visual culture, but it does not follow that the scattered practices are interdisciplinary in a theoretical sense. Distantly related texts can wind up in teachers' course packs, and from there

25

they can become textbooks, as Abigail Solomon-Godeau has said of Nicholas Mirzoeff's apparently and avowedly interdisciplinary *Visual Studies Reader*.[45] Their "chance" constellation—to adopt Mallarmé's metaphor—does not necessarily constitute interdisciplinarity. It may be that the question of visual culture's coherence is unanswerable because the problem itself, as opposed to the field, is dispersed among different parts of the university. The practical issues (What should we call the new interdisciplinary field? What faculty will we hire? What courses will be required?) belong to what Bill Reading calls the University of Excellence, the mostly administrative heart of the modern Western university. The theoretical issue (What counts, in this case, as interdisciplinarity?) belongs more to the University of Reason, which Readings understands as philosophy and other disciplines that represent rationality and knowledge, and also to the University of Culture, Readings's phrase for the idea that a university should represent its surrounding culture.[46] In that rather abstract sense, the problem of interdisciplinarity may itself be interdisciplinary, because its solution will be found simultaneously in several distinct domains of the university.

I will have some proposals about the practical issue later in this book. On the conceptual level, it is best to begin by trying to say what, in this particular instance, might count as interdisciplinarity. "It is not clear to me," Stephen Melville writes, "that visual cultural studies is in any interesting sense interdisciplinary, nor that it can give rise to anything I would take to be interestingly interdisciplinary."[47] A true interdisciplinarity, in Melville's sense, could occur if the new field would allow its very conceptual order or disorder to locate the object it studies. To think of things the other way around, where visual studies is a new configuration of existing interpretive methods bent on objects that are already identified, is to seek the safety of conventional interdisciplinary thinking. The question is

whether visual culture is or might be willing to let its interpretive methods and newly collected objects produce something unexpected.[48]

The existing literature points to three different possibilities.

1. *Visual culture is a new discipline.* To be a discipline, visual culture would have to be anchored by a set of founding texts as well as by favored objects and interpretive methodologies. There are certainly candidates. The theory of the gaze, together with a Foucauldian sense of institutional power, is probably the best candidate for a governing interpretive strategy, although Jonathan Crary and others have suggested that the new discipline has gathered around the concept of the gaze just "at the moment of [its] disintegration."[49] Visual culture already has a bookshelf-full of texts and textbooks and it has preferred objects (such as new media and advertising). From this perspective the visual culture is a typical academic discipline, gathering like barnacles around a foundation of common interests and assumptions. Its apparent disarray would then be largely illusory—a hope of interdisciplinarity rather than a real interdisciplinarity. There is, I think, a large measure of truth to this description: the texts I have been citing support it by their common interests, and this book as a whole could also be taken to be a sufficient description of a set of disciplinary concerns.

2. *Visual culture is interdisciplinary in what Melville calls an "uninteresting" sense*: it cobbles methods, subjects, and texts from various disciplines and calls the collection "visual culture." This is what I call the Magpie Theory of interdisciplinarity: in it, a visual culture scholar spends time arranging the seductive pieces lifted from different places, all the while imagining that the project of gathering and arranging is a formative element of interdisciplinarity. Groups that gather and collect things from other disciplines and yet do not want to be called disciplines tend to be referred to as initiatives, con-

centrations, emphases, study groups, or centers. Magpie behavior is the simplest kind of interdisciplinarity and, in Melville's schema, the least interesting.

Bob Hodge has proposed a more dynamic model. Interdisciplinarity, he says, is "a way of confirming an existing structure of knowledge, because it fills and hence reinforces the space between disciplines." Hodge thinks of interdisciplinarity as a "stable state" that conducts raids "on the darkness of interdisciplinary space in order to bring back monsters whose origins outside of disciplinarity can then be forgotten." It is even possible, he thinks, to create *transdisciplinary* fields, by "mingling discipline with discipline in a promiscuous mix" and at the same time mixing "disciplinarity with non-disciplinarity." "Bits of darkness" will then be "introjected" into the white of mixed disciplines.[50] Hodge's schema sounds Manichaean and also cosmic and quite attractive. It is important to bear in mind that in life the results can be paltry. Heather Kerr, reviewing Anne Maxwell's book *Colonial Photography and Exhibitions,* finds that the "enormous intellectual labor" that goes into finding "new models of looking" in colonial photography, together with "the almost fragile modesty of each 'new' text as event, is, at one level, frankly depressing." I do not cite this as a critique of Maxwell's book but as an unusual bit of honesty when it comes to the usual products of this kind of concerted interdisciplinarity.[51]

The Magpie Model and Hodge's raids "on the darkness of interdisciplinary space" are two different topologies. A third is Mitchell's idea that visual culture can be a "kind of de-disciplinary" operation. "We need to get away from the notion that 'visual culture' is 'covered' by the materials of art history, aesthetics, and media studies," he

writes. "Visual culture starts out in an area beneath the notice of these disciplines—the realm of non-artistic, non-aesthetic, and unmediated or 'immediate' visual images and experiences." It is about "everyday seeing," which is "bracketed out" by the disciplines that conventionally address visuality.[52] In this model, disciplinary space is above, and the "de-disciplinary" scholar scavenges quietly below: an attractive image, given the violence of Hodge's model.[53] It is a very intriguing idea, not least because it avoids the entire vexed conversation on disciplines. If there is such a thing as a demotic, de-disciplined way of thinking about "everyday seeing" it will have to emerge very gently between the many disciplinary, antidisciplinary, and transdisciplinary initiatives that currently constitute the field. It will be interesting if it does.

Detail 7, opposite: From a visual studies standpoint, a book isn't only a repository for text: it's a physical object with a history. What did cardinals mean in America in the mid-1950s, when Cardinal Editions was publishing Daphne du Maurier, Rex Stout, and Erle Stanley Gardner? Was it a slight comfort—a little sign of quality—for a reader who knew that her 35¢ (or less, in a used book store) couldn't buy a real book? Was it a sign of authenticity that pocket books became dog-eared so easily?

These three spatial models of interdisciplinarity do not exhaust the field: How could they, when interdisciplinarity has been taken as the opposite of whatever is systematic or well known? Yet each one is susceptible to Melville's observation that as long as you know what you're doing, you are likely to be operating in a way that can be described as disciplinary, even if it is a rogue disciplinarity.

It also remains possible that these kinds of interdisciplinarities will settle for self-descriptions that reveal them as disciplines. Visual studies has been presented as a maverick in the field of disciplines, but it will inevitably nourish its particular competencies, central texts, and preferred methods and end up defining itself as a discipline. Practical pressure from the University of Excellence will provide some of motivation for the change, and the rest will come from the political gain of possessing a named field of study.

3. *Visual culture is interdisciplinary in an "interesting" sense*: it does not know its subjects in advance but finds them through its preoccupations. When Richard Johnson complains about the "codification of knowledge," which "runs against some main features of cultural studies" including its "openness and theoretical versatility, its reflexive [and] even self-conscious mood, and especially the importance of critique," he sounds like an advocate of this second kind of interdisciplinarity.[54] Certainly "interesting" interdisciplinarity seems the most philosophically engaging option. Still, I wonder how often it happens in university life and whether it has an inherent advantage over "uninteresting" interdisciplinarity or even garden-variety disciplinarity. I take no particular position on this subject, because I am not sure how it would be possible to know what value should best be assigned to interdisciplinarity. The university-wide locus for the study of images that I imagine in this book would well be considered a discipline because it would have core competencies—a knowledge of the relevant histories of images and their interpretation and a knowledge of particular parts of the full range of images and image-making practices. (Those competencies are the subject of the final chapter.) At the same time, such a "locus" might well be considered the physical site of interdisciplinary work. I am attracted by the possibility that several disciplines might work together but I am not interested in confirming such a configuration as a new discipline or arguing that it is interdisciplinary because I am not sure what relation obtains between the kind of work that seems most amazing, deeply insightful, provocative, and useful and the disciplines to which it owes allegiance.

The Subjects of Visual Studies

So much for thinking about visual studies as a discipline or an interdisciplinary initiative. That kind of approach is useful because it is general, but it is limited for the same reason. Now it is time to begin to look more closely. The topic in this chapter is what is studied by scholars of visual culture: which theorists and historians are taken as models, what kinds of images are chosen for study. The chapter title makes the common pun between subjects such as films and paintings, and the philosophic subject, the person who does the studying. The two are connected and inseparable, and at the end of the book I will draw out a further implication of the pun.

THE BIBLIOGRAPHY OF VISUAL CULTURE

Some writers never think much about the visual theories they put to use. They are theoretically promiscuous, going from one interpretive strategy to the next depending on what seems to work.[1] Others are— as a colleague of mine, Robert Loescher, puts it—"theoretical virgins": they try to get along without theories at all. You might think,

given the variety of attitudes about visual culture, that writers would draw on a large number of theorists. It would also make sense, if visual culture is the general study of the production and reception of the visual, that it would include a very wide range of theories about the visuality. Neither is the case.

In Susan Buck–Morss's enumeration, the "canon" includes "Barthes, Benjamin, Foucault, Lacan, as well as a long list of contemporary writers." She then gives some key concepts, each of which can be assigned to a familiar theorist. (I have proposed some identifications in square brackets.) "Certain themes are standard," she writes: "the reproduction of the image [Benjamin], the society of the spectacle [Guy Debord], envisioning the Other [Lacan], scopic regimes [Martin Jay and others], the simulacrum [Jean Baudrillard, Gilles Deleuze, Fredric Jameson], the fetish [Freud], the (male) gaze [associated most famously with Laura Mulvey], the machine eye [Donna Haraway]."[2] Buck-Morss's list is offhand, but I think it is quite accurate. Mulvey's essay "Visual Pleasure and Narrative Cinema," for example, has appeared in at least twenty-eight publications and has been translated into German, Dutch, Polish, Czech, Russian, Swedish, and Italian. It is on the majority of visual culture syllabi that I have seen.

To some degree it would be sensible to continue adding to the list, but the entries quickly become idiosyncratic. Excluding the "long list of contemporary writers," as Buck-Morss says, next up would be Karl Marx, Frantz Fanon, Aby Warburg, Georges Bataille, Antonio Gramsci, Emmanuel Levinas, Mikhail Bakhtin, Charles Peirce, Ferdinand Saussure, Maurice Merleau-Ponty . . . no one else on this potentially endless list, I think, comes anywhere close to the

importance of Barthes, Benjamin, Foucault, and Lacan for visual culture. There is a "long list": it includes, among dozens of others, Buck-Morss herself, Svetlana Alpers, Mieke Bal, Michael Baxandall, Francesca Bavuso, John Berger, Jay Bernstein, Homi Bhabha, Judith Butler, Lisa Cartwright, Hélène Cixous, T. J. Clark, Tom Conley, Jonathan Crary, Douglas Crimp, Thomas Crow, Jonathan Culler, George Dimock, Hal Foster, Thomas DaCosta Kaufmann, Guy Debord, Paul Duro, Anne Friedberg, Jeremy Gilbert-Rolfe, Brian Goldfarb, E. H. Gombrich, Tom Gunning, James Herbert, Jürgen Habermas, Michael Ann Holly, bell hooks, Martin Jay, David Joselit, Stuart Hall, Laura Marks, Joseph Masheck, Stephen Melville, Nicholas Mirzoeff, Tom Mitchell, Toril Moi, Keith Moxey, Sheila Murphy, Fred Myers, David Rodowick, Irit Rogoff, Fatimah Tobing Rony, Richard Shiff, Hugh Silverman, Susan Sontag, Gayatri Spivak, Barbara Stafford, Leo Steinberg, Paul Virilio, Christopher Wood, and Slavoj Žižek. A couple more pages of names would probably round up the majority of citations in visual-culture essays. But it would not turn up anyone as fundamental and as often cited as Barthes, Benjamin, Foucault, Lacan, and two or three others. They are, effectively, the theoretical bases of visual culture.

Detail 8, opposite: One of the interesting challenges facing visual studies is how to describe the experience of reading illustrated books. The art historians William MacGregor and Lyle Massey have shown how technical books like this perspective treatise create complicated imaginative and associative experiences: I see the diagram, and I imagine myself in its very demanding space. At the same time I am pressed by the need to read the accompanying text to understand what I am seeing, and I am distracted and pressed, in a different way, by the lettering showing through from the other side of the page.

There is an entertaining consequence of pondering lists like this: they demonstrate with great clarity that visual studies, no matter what it might be, cannot yet claim to be a general approach to images of all kinds. Reading through this list of principal theorists— a list that is at once known to everyone and scarcely noticed—it becomes apparent that visual studies has a very specific, very disciplinary set of interests.

THE CANON OF VISUAL CULTURE

Given that listing of the field's major theorists, it is only natural to ask about its favorite subjects. Like the choice of theorists, the choice of images and artworks has a great deal to say about the scholars who do the choosing: to adapt a phrase, we are what we study.

The subjects of interest to visual studies seem, at first sight, to be scattered over the whole range of image production and reception. In John Walker's enumeration, scholars in visual culture are concerned with "photographs, advertisements, animation, computer graphics, Disneyland, crafts, eco-design, fashions, graffiti, garden design, theme parks, rock/pop performances, subcultural styles, tattoos, films, television and virtual reality"— to which I would add sex and sexuality, Las Vegas, Hollywood and Bollywood, depictions of death and violence, international airports, corporate headquarters, shopping malls, contemporary fine art such as video and installation, transgenic art, Balinese tourist art, Bakelite, Barbie, Burning Man, contemporary curiosity cabinets, snow globes, the history of buoys, Pez, Sen-Sens, microscopic sculpture, utensils made for babies, macramé, marbled endpapers, reproduction Victorian half-hoop rings at Claire's Accessories, AstroTurf, ivory *mah-jongg* sets, underwater Monopoly, found footage from 1950s health and safety films, e-mail greeting cards, *Tamagotchi*, restaurant decorations, Cat Clocks, fluorescent paint, Eastern European Christmas decorations, plaster casts of gargoyles, Ghanaian coffins in the shape of chickens and outboard motors, Santeria statuettes, pink flamingos and other lawn ornaments, miniature golf, commercial Aboriginal painting, cargo cults, nineteenth-century posters and fliers, book illustrations,

Plate 9, opposite: Visual studies is well placed to accommodate the detritus of society: the litter and discarded pieces that attracted Kurt Schwitters, the scattered refuse recorded by artists like the Boyle family. This is something that once had significance: it is a clipping from an Irish newspaper of around 1910, and it was saved for years along with other clippings of news and politics. In that time and place a lingerie hat would have been an extravagant expense. Memory, longing, and nostalgia have been parts of the visual studies from Benjamin to Susan Stewart.

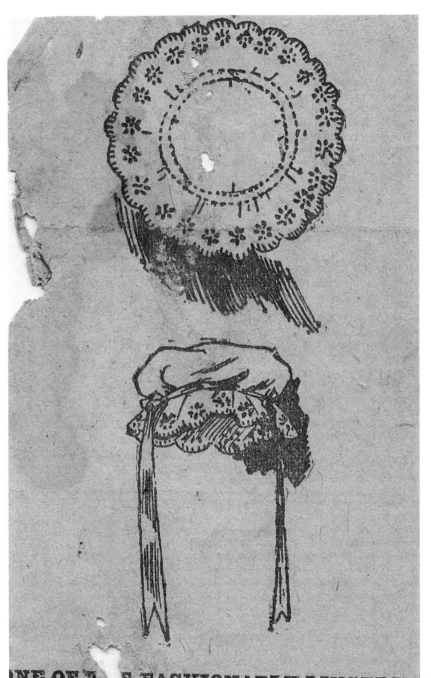

ONE OF THE FASHIONABLE LINGERIE
HATS.

children's books, passports and bureaucratic forms, tickets, maps, subway and bus charts, cigarette packages, tourist-attraction ashtrays, and many topics in photography, including family photo walls, *fin-de-siècle* gay pornography, Daguerre's dioramas, the first images of lightning and galloping horses, the history of pinhole cameras, and womens' photography from Julia Margaret Cameron to Claude Cahun, Diane Arbus, Nan Goldin, Sally Mann, and Catherine Opie.[3] The list seems hopelessly miscellaneous or happily inclusive, depending on your point of view.

In the classroom and in the applications of prospective students, visual culture is predominantly about film, photography, advertising, video including television, and the Internet, roughly in that order. It is mainly not about painting, sculpture, or architecture, and it is rarely about any media before 1950 except early film and photography and their ancestors such as dioramas. A search of recent dissertations with the key phrase "visual studies" yields a scattering of eighteenth- and nineteenth-century topics, for example Gillen Wood's "The Shock of the Real: Romanticism and Visual Culture, 1760–1860" (Columbia University, 2000) and Sarah Parson's "Imagining Empire: Slavery and British Visual Culture, 1765–1807" (Santa Barbara, 2000). The search also turns up just a few studies of older and non-Western subjects, such as Oya Pancaroglu's study of figural representation in the late Suljuk period, 1150–1250 (Harvard, 2000) and Andrea Walsh's dissertation on the visual culture of Aboriginal art texts (York University, 2000). But the overwhelming majority of dissertations in visual studies is concerned with contemporary popular art and especially film. The same imbalance is reflected in the journal literature and in conferences and annual meetings.[4] In a formula: visual culture studies the sum of popular visual practices since the mid-twentieth century, with an admixture of contemporary fine art.

There are important counterexamples: Michael Ann Holly, Keith Moxey, Mieke Bal, and Christopher Wood have used the strategies of visual culture to write about Western art before modernism.[5] In that respect, Michael Baxandall's book on fifteenth-century Italian painting remains exemplary for the new field.[6] I hope these writers comprise a field of reference for the next generation's work; but overwhelmingly, students in visual culture are concerned with the popular art of the last half-century.[7]

THE POSSIBILITY OF A GENERAL, METHODOLOGICAL APPROACH TO IMAGES

Why are there relatively few visual-culture texts on visual objects of any kind, popular or not, that were made before photography? In part it is because students aren't interested: it is not their cultural world. There is also the fact that visual culture itself was born out of the concern with popular culture first aired in English cultural studies in the 1960s, so the field itself is fitted to contemporary and near-contemporary visual art and popular culture.

Those are contingent issues; I think they are reinforced by an endemic problem, the importance given to general approaches to visuality over the traditional organization of knowledge by specialties and periods. It is possible that the very orientation of visual culture departments, toward the general and away from the usual professional stratification, works to decrease the chance that students will study premodern visuality.

At Rochester and Irvine, the first two programs of visual culture, the methodological is taken to underwrite the historical: that is to say, the programs present themselves as an opportunity to study the visual in any of its forms, through the lens of a general methodology rather than a series of chronological courses. The Visual and

Cultural Studies Program at Rochester does not offer courses with titles such as "History of Graffitti from Rock Art to the Present" or "Filmic Senses of Time from Renaissance Frescoes to Video Art." Instead they offer methodologically focused courses such as "Sociology of Art" or "Vision, Visuality, and Visual Studies." As James Herbert puts it, speaking of the program in Visual Studies at the University of California, Irvine, "the justification we made for introducing visual studies was that we were forced to give up the claim for comprehensiveness." It would be impossible to hire specialists in the myriad of visual practices, but feasible to rearrange the curriculum so that visuality, vision, and media became the subjects rather than, in his example, Japanese art. Even though "the mandate for studying visual artifacts was expanding very rapidly," the practical limitations of the university made it impossible to contemplate hiring specialists for each practice: hence the emphasis on theory.[8] The strategy in such programs is to avoid slicing through history along pre-defined lines, to escape the old-fashioned history of styles, and to open the study of the visual to a more inclusive set of concerns.

Yet I wonder whether the focus on methodology is as liberating as it is sometimes thought to be. It is true that a course on the Gaze might take its examples from Jaina deities (who are always represented with wide-open eyes, staring straight ahead), but in practice premodern examples are the rare exceptions, dropped with minimal context into much richer concoctions of postmodern visuality. The actual reach of the instructor's and students' interests largely determines the range of examples that will be called upon to illustrate the methods being taught. In addition many theories, such as the theory of the Gaze and the Look, are suited to modernism because they developed in concert with modern art. In the case of the Gaze, the list of theorists goes from Jean-Paul Sartre through Heidegger (often

neglected in this respect) and Lacan, to a miscellaneous group of contemporary writers including Mulvey, Norman Bryson, Margaret Olin, Martin Jay, Brian Rotman, and Michael Fried. That does not preclude Jaina art, but it makes the inclusion of Jaina sculpture more difficult. A focus on methodology and ideological critique is not enough to promote an expanded range of images.

The argument for a general approach to images—over a traditional art-historical sequence of courses—is that it allows visuality itself to be questioned and permits new kinds of questions to be asked that can't be easily raised in conventional classes of art history, anthropology, or sociology. I am in broad agreement with that motive but I think it also enhances the probability that a given student of visual culture will be interested mainly in current images and in postmodernism.

There are, broadly speaking, two antidotes. The first, which few scholars of visual culture would want, is to incorporate some conventional art-historical specialties into the curriculum, and require period-based courses on premodern art. The second is to make sure that every course on visuality, the Gaze, or any other general subject spends *equal* time on current images and on premodern or non-Western visuality. Naturally that means a tremendous amount of work for the teachers, who would be compelled to spend a substantial amount of time reading, for instance, about the permissible poses of Jaina sculptures (standing or sitting, never dancing or lying) and the disposition of divine gazes within the temple.

Another practical problem with the emphasis on methodology is that art history students who specialize in Jaina art are not likely to transfer into visual-culture departments for graduate training in what will appear as modern and postmodern visuality. That, I think, is one of the best arguments against setting up independent programs in visual culture: if the courses in visual culture are kept

39

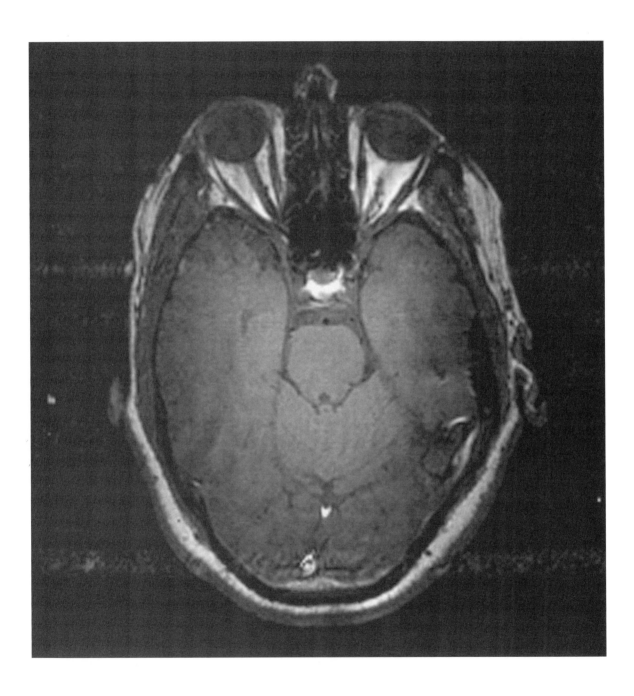

within art history or anthropology departments, where each faculty member is a specialist in a different period or culture, then it is more likely that students interested in Jaina visuality will also be conversant with issues brought forward by visual culture. (At the University of Chicago, for example, Mitchell teaches a freshman-level course that introduces visual culture to students in a number of different disciplines. The problem then is how to integrate higher-level visual-culture courses into the graduate curriculum when students have little time for courses outside their specialties.)

The decision to base visual culture on a general ideological, social, and methodological approach is a difficult problem for me because I am advocating a kind of visual studies that would be *even more* general, welcoming scientists from various disciplines, moving beyond premodern Western visuality and into non-Western art, archaeology, and the visual elements of linguistics. That presupposes disciplinary expertise on the part of the faculty who might participate. As they stand, departments of visual culture risk becoming conventional specialized disciplinary programs like any others—they risk becoming places where students can go to study photography, advertising, television, and the Internet exactly as students might go to an art history department to study painting or to an anthropology department to study Jaina worship. A more wide-ranging visual studies like the one I describe in the following chapters would avoid that particular problem, but it would have to include specialized faculty. There is no single answer: later I will suggest several possible configurations. What matters here is that the decision to emphasize a general methodological approach has two practical consequences, neither

Plate 10, opposite: Here I am, inside an enormous magnetic resonance imaging machine, immobilized in the narrow tube, bombarded by the machine's incessant clicking, looking down my nose and out of the tube at a television monitor which was flashing annoying patterns of distorted checkerboards. It was part of a functional MRI experiment at Duke University, and I was the unhappy volunteer. The two bright spots at the bottom, in my visual cortex, are evidence I am processing the checkerboard pattern. When visual studies can be written with this kind of data in mind, the field will be mature.

of them very desirable: it means that visual culture looks increasingly like an ordinary discipline, specializing in television, advertising, and other popular imagery; and it means that visual culture courses attract students who are interested mainly in popular art of the last fifty years.

A NOTE ON THE COLLAPSE OF MEDIA

Before I go further into this description of visual culture's subjects, I want to say a word about a common misconception. It is often said that the new field is pushing the emphasis on method to an extreme by taking as its subject the amalgamated practices of media rather than the productions of individual media. There are visual theorists who say the evidence for a conflation of media can be found in the confluence of music, video, text, and images on the Internet and the adoption of multimedia performance, video, and installation art. Mirzoeff, for example, reserves the word *visuality* to signal the "present collapse of the media into each other."[9] There has been a reaction against that stance, especially among art historians, who point out that a working memory of the separate histories of media is pertinent to current practice.[10] In my experience—and it is a view shared by Mitchell and others—the idea that visual culture is tending toward a medialess future is not borne out by what actually happens in visual culture programs. It *is* an issue, however, in European and Latin American programs that stress new media at the expense of traditional ones and treat all visual objects in terms of a universalizing semiotics.[11]

Plate 11, opposite: Terese Poulos, *Janina's Hands.* 2000. Silver gelatin print, courtesy Terese Poulos. One of a set of photographs by an artist named Terese Poulos. Her mother's hands were once considered beautiful, Poulos says, and she could have been a hand model. Her mother used to write in a lovely calligraphic style; now she has multiple sclerosis and cannot write at all. This image is one of a series that comprises a portrait of her mother through her hands and the artist's handwriting, as if the photos were a kind of extended signature. Visual studies is especially well poised to relinquish the normal modes of explanation—the iconographic, the sociological, the autobiographical— and to blend them into new forms of writing.

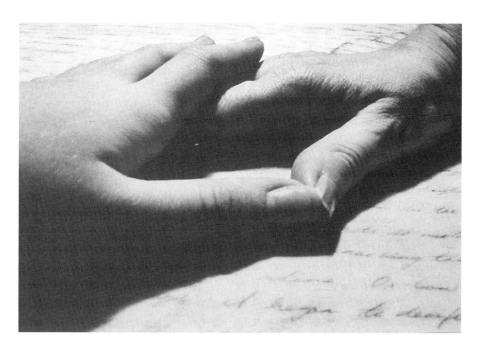

I distinguish the issue of visual culture's general approach from the notion that visual culture collapses all media into a single visuality. As Mitchell and others have pointed out, that is mainly a fear projected onto visual culture and it is not borne out by actual courses and thesis topics. On the other hand, scholarship that compresses media into a single medium is actually following a traditional theme in the arts: the difference between art itself and its various manifestations. From the Renaissance *paragone* to the fin-de-siècle *Gesamtkunstwerk*—and the intervening figures of the sketch and the romantic fragment—there is a long-standing conversation on the possibility of the merging of arts into one Art.[12] For that reason when I encounter texts that gloss the differences between media, I try first to read them in light of that older tradition. They are not, in any case, representative of what is written and taught in visual culture.

THE PLACE OF CONTEMPORARY ART IN STUDIES OF VISUAL CULTURE

In addition to contemporary mass media, visual culture also has another interest, not always well fitted to the first: avant-garde art. Recently I have seen visual-culture studies of Hans Haacke, Jenny Saville, Gerhard Richter, Fred Wilson, Chris Ofili, and the Guerrilla Girls. One of my students studied tattoos in paintings by Massimo Teraoka, and another wrote about connections between Survival Research Laboratories, Rodney Brooks, and flea circuses. Current avant-garde art is a consistent secondary interest in visual culture; the principal anthologies and readers such as Mirzoeff's go back and forth from television to neo-Expressionism, from glossy magazines to video art. What makes that mixture of interests significant is that contemporary fine art is much less well known than the other subjects of visual culture such as television programs, advertisements, and films. Postmodernism in the sense I am using it here appeals to a significantly small portion of the public: an average reader of *USA Today* or a viewer of CNN will not know about Haacke, Saville, or Survival Research Laboratories, and they will know figures such as Ofili or Mapplethorpe only from the news.

People who study visual culture belong to a very particular demographic: they are mainly extremely well-educated, liberal, populist, and knowledgeable about the art world. This is another way of noting that visual culture as it is presently constituted is not a general approach to images and visuality but a particular one—and its particularity is not fully theorized within the field, where the mix of Popeye and Pollock, Damien Hirst and Deputy Dawg is seldom posed as a problem.

It is possible, but different, to imagine a version of visual culture that looks at popular culture but omits Luc Tuymans and Raymond

Pettibon; that would also presumably count as visual culture. (The discipline that looks at Tuymans and Pettibon in preference to popular culture is already named: it is art history.) It is also possible to imagine visual culture looking only at technological, scientific, and "informational images" such as x-y graphs, or only at the most common kinds of visuality like ordinary television. The point is that visual studies as it currently exists has a narrow and statistically uncommon set of interests and a distinctive politics far from its ideal of ecumenical interest in the sum total of image production. Visual culture is at once populist and elitist: an observation that leads straight into the most important discussion within visual culture: the relation between "high" and "low" art.

THE HIGH/LOW DEBATE

Within visual culture, the difference between "high" and "low" tends to be put as a choice between two versions of the cultural history of modernism. In the first version the distinction between high and low art still holds; it is a position increasingly identified with the Frankfurt school in the mid-twentieth century, with the conservative element in art history, and with journalistic art criticism. Against this is posed a version of cultural history in which the high/low distinction has been abandoned; it is taken as a self-definition by writers in visual culture, film, and media studies. I will set out some relevant claims of the two positions before considering the more promising modes of resistance to the choice itself.

1. *High and low art remain importantly different.* Theodor Adorno has long appeared as a shadow figure of visual culture on account of his unyielding defense of the value of high art and his trenchant critique of the "culture industry." Here is one of the emblematic passages from the beginning of his "Culture Industry Reconsidered."

45

The "culture industry," he writes, "forces together the spheres of high and low art, separated for thousands of years." It destroys the "seriousness" of both, transferring "the profit motive naked onto cultural forms." In Adorno's argument, art is compelled by a logic implicit in its own materials—in the paint, words, or musical tones. High art is whatever follows that logic, which has led through successive "negations." "Each apparently progressive movement in modernist art," as Jay Bernstein puts it, "generated a growing canon of prohibitions: representation, figuration, narration, harmony, unity."[13]

Theorists after Adorno have cited the logic of negation to account for such diverse artworks as Ad Reinhardt's black paintings, Morton Feldman's music, Robert Morris and other minimalists, and various strains of conceptual art. The idea that negation is at the foundation of high art and the true avant-garde is still tremendously influential, although its effects are felt at a distance by writers not always inclined to cite Adorno directly. In art history and among those who have been skeptical of visual culture, Thomas Crow is an important example. His sense of some conceptual art as proposing important philosophic problems through the renunciation of received ideas about the relation between a work's form and its ostensible content is congruent with Adorno's program if not with the specifics of the art that Adorno knew.[14] Crow's position poses a challenge to visual studies that has not yet been fully addressed: How is it possible to take artists such as Sherrie Levine, Gordon Matta-Clark, and others as seriously as they are taken in Crow's writing, when they are mingled, as visual-culture writers tend to do, with advertisements, mag-

Plate 12, opposite: Joe Davis with his flying machine powered by frogs' legs. 2002. Courtesy Joe Davis.

The artist Joe Davis behind a prototype of his flying machine powered by frogs' legs. (The legs are in front, just under the wings.) Davis's idea was to shock the legs, making them twitch so the wings would flap. Guidance was to be achieved by suspending a shrimp below the frog-leg carriage; the shrimp would home in on red light projected from a ruby laser. Davis has been thinking up odd things like this for over twenty years, using his unpaid position at MIT as a base of operations. He is, I think, an icon for visual studies. In this context it really doesn't matter if this is art or not: it's visual, and it's part of culture.

azines, and movies? Is it possible to import serious discussions of "negative" moments in modernity—Crow's analyses of Levine, Whitney Davis's account of David Rabinowitch, Yve-Alain Bois's interpretations of Mondrian and Ad Reinhardt—to simply import such interpretations into essays that are just as interested in the modernist formalism of *Mr. Magoo* or the "modernist" austerities of Calvin Klein?[15] It is not, I think, and there has not yet been an account of which parts of the high-art discourse are lost when high and low are mixed in visual culture.

Detail 13, opposite: One danger for visual studies is to fall into an aestheticism: art history has always chosen its objects in part for the pleasure they afford, even though that pleasure might not be immediately evident through the thickets of historical scholarship. Even an anti-aesthetic or anti-art subject matter has its pleasure and its limits. Visual studies has already shown the beginnings of an aesthetic in its interest in certain kinds of advertising, television, fashion, and consumerism. It is a useful corrective to realize that much of the visual world is crude, repellent, or just visually uninteresting.

In *Mr. Magoo*, for example, color areas overlap outlines in a distinctly modernist fashion. It is therefore not much of a surprise that Jules Engel, the animator of *Mr. Magoo*, is also a serious modernist painter. In 1971, Engel was founding director of Experimental Animation at Cal Arts, and he is conversant with high modernism: his own abstract paintings include geometric color-field canvases that have a superficial resemblance to Paul Klee at his most abstract. The color fields in Engel's paintings overlap just as the light areas in *Mr. Magoo* often do. It would be legitimate, then, to write about *Mr. Magoo* and high modernism together. But it would risk incoherence to bring in references to the most serious scholarship, Crow's or Bois's for example, because the terms and values in that work are at odds with Engel's paintings. Mixing the two discourses in this instance would make it incomprehensible that the same artist could create *Directions III* (1960), a severe neo-Constructivist collage, and also the Russian sequences in *Fantasia* and the cartoon character Gerald McBoing-Boing. It is not enough in such a case to put Crow or Bois in footnotes and proceed as if their citations lead in some unspecified but

organic fashion from Hollywood animation to Adorno's rarefied theories of negativity.

Adorno's theories and the scholarship that is informed by the seriousness of modernist negation preclude certain mixtures, and as a result visual culture studies that cite such work end up assuming that the prohibition against mixtures is somehow obviated by the act of citation—just mingling Adorno with *Mr. Magoo* is taken to be enough to demonstrate the mixture of discourses. Postmodern art, Bernstein says, "directly intends a unification which has forgotten or never knew what the division between high and low art critically signified." In order to be fully reflective, an essay on modernism in *Mr. Magoo* would have to include an account of the misunderstandings between the two discourses as they are embodied in Engel's work, in Adorno's or Crow's, and in the writer's own set of interests. And doing that would force the writer to confront the fact that the discourses of high and low, at least in this case, remain distinct.

Bernstein, one of the best readers of Adorno, is not sanguine about the visual-culture idea that high and low have fused. "No matter how it is viewed," he writes, "postmodernism has not succeeded in overcoming the great divide by producing a true integration of the two domains: it is either a false synthesis capitulating to the demands of capital, or a contingent procedure for continuing the project of modernism, the project of negation, by other means." Examples come to mind: the "false synthesis" prompted by capitalism is proposed by television's mix of high and low art. A Channel 4 or BBC2 program on Caravaggio will get a certain amount of airtime in England, but its share of the programming day is influenced by

what is perceived as the market demand for Caravaggio in relation to, say, *Teletubbies*. (In the United States market pressures are more severe, and *Teletubbies* tends to win every time.) An example of an attempt to continue high art's "project of negation" by different means is Jeff Koons, whose enormous, visually pure versions of kitsch objects are a form of modernist austerity using new means. Bernstein concludes that "the project of negation will continue to have [a] point so long as the reconciliation of universal and particular remains illusory"—in other words, the separation of high and low "is not a problem of art or philosophy, it is about the abstraction of modernity."[16]

From a sociologist's point of view, the division between people who adhere to high art and those who consume low art is a readily demonstrable fact. People can be divided by noting their adherence to high art or their consumption of low art—as Pierre Bourdieu has stressed and as museum polls repeatedly demonstrate.[17] Statistically speaking, the division is endemic in Western society, so that theories that discount or critique the division (the theories I am going to review next) are compelled to say whether they disagree with the sociological evidence or just choose to interpret it differently.

2. *High and low art are no longer separate.* Visual culture is predicated on the assumption that contemporary culture has already mixed the élite and the popular, the fine and the vulgar, modernism and kitsch, to the point where it is no longer sensible to treat them separately. In this view, high and low art are names of different discourses, but they are sufficiently impure, mutually dependent, or susceptible to commodification that they can be treated using the same general methodologies.

Among the most influential advocates of this view is Fredric Jameson. "The very sphere of culture has expanded," he writes in an essay called "Transformations of the Image":

becoming coterminous with market society in such a way that the cul-
tural is no longer limited to its earlier, traditional or experimental
forms, but is consumed throughout daily life itself, in shopping, in
professional activities, in the various often televisual forms of leisure,
in production for the market and in the consumption of those market
products, indeed in the most secret folds and corners of the
quotidian.[18]

"Surely," he concludes, "what characterizes postmodernity in the cul-
tural area is the supersession of everything outside of commercial
culture, its absorption of all forms of art high and low, along with
image production itself." In the postmodern condition, "the image is
the commodity, and that is why it is vain to expect a negation of the
logic of commodity production from it."[19]

Jameson is not claiming there is no such thing as high and low
art; the idea is rather that they are superseded, absorbed, and recon-
stituted *as* commercial culture. The same focus on subsumption can
be found in Victor Burgin's writing: "at the levels of production and
distribution," he says, "all cultural workers today actually or poten-
tially rely on much the same technologies and institutions, and all
cultural products are equally subject to commodification." On the
other end of the scale, in terms of reception, "the meanings of all
products of contemporary culture tend to be cut from much the
same cloth: woven from intertextually related but institutionally het-
erogeneous strands of sense, originating in disparate times and
places." As a result, Burgin concludes, "there are no longer any def-
initely separate realms of cultural production," so that "there can be
no islands of counter-hegemonic purity."[20]

The kind of argument I am sampling in Jameson and Burgin is
a matter of emphasis, so it can be asked how much weight should
be given to phrases such as "much the same" (which Burgin uses

twice in this passage), or "interrelated but . . . heterogeneous." If I were to push Burgin's claims, I might have the passage say that even the most "disparate times and places" produce commodities "equally," although I would prefer it to say that "institutionally heterogeneous strands" of culture resist, and resist differently.

Jameson's perspective is less amenable to this kind of adjustment, because in the essay in question he is interested mainly in putting obstacles in the way of certain neoconservative theories of the image that seek to reinstate beauty, the sublime, and the ideas of modernism that accompany them. Taken at face value, Jameson's insistence that "all forms of art high and low" have been absorbed into commercialism leaves less room to locate a place for "institutionally heterogeneous strands" of production or consumption. In those closely similar arguments there is a half-hidden and important potential difference: between a postmodernism conceived as a thoroughly mixed and therefore homogeneous site of commercialized culture, and a postmodernism understood as an agent that works to mix kinds of production that are all at least "equally subject" to absorption. In these passages Jameson and Burgin stand nearly together, on either side of a line dividing those who hold to the high/low distinction and those who do not.

Visual studies is founded in large measure on the positions—closely linked but separable—I have exemplified by Jameson and Burgin. As Christopher Wood puts it, visual studies is predicated on the idea that the distinction between high and low is "specious."[21] But the view that high and low are wholly mixed and therefore no longer exist as such is more a rhetorical stance or an

assumption than a condition, a fact borne out by visual-culture texts themselves. Benetton advertisements are a touchstone for this problem.[22] They remain a favorite subject in visual culture, sometimes even serving as exemplary subjects for the field as a whole. But why write about Benetton advertisements unless it is because they are more ambiguous, innovative, and complex than other ads? And what are ambiguity, innovation, and complexity, if not high art ideals? Benetton ads are also attractive because they have resulted in lawsuits in Missouri, Kentucky, Paris, Berlin, and elsewhere—but the engagement of art and politics is more an interest of postmodern theory than of ordinary advertising.[23]

Detail 14, opposite: U.S. Navy sailors holding part of one of the world's rarest fish. Later in this book I will name it. The photograph is by William Leo Smith; this is from his letter to me: "The photo was taken 19 September 1996 at approximately 11:00 A.M. . . . on Coronado Island (barely off of the coast of mainland San Diego) at the U.S. Naval Special Warfare Center . . . It was pretty badly damaged by some sort of propeller to its head. The heart and some other organs were already pretty much gone by the time we got there. . . ." The intersection between real encounters and *Close Encounters*, between myths and their appearances, is a wonderful subject for visual studies.

If the field were really level, with high lowered and low raised and nothing to count as avant-garde, then scholars interested in advertising would study all advertisements equally, indifferent to whether they are ambiguous, innovative, complex, or politically engaged. Simpleminded ads in *Good Housekeeping* would attract as much scholarship as Benetton's provocative *Death Row* series. Kmart clothing would be studied as enthusiastically as Issey Miyake. And so on. Perhaps the principal way to justify the attention given to Benetton ads is by appealing to criteria of interest that derive directly from high-art criticism—indeed, from Clement Greenberg himself—and then it becomes increasingly difficult to justify paying attention to advertisements at all when the criteria of ambiguity, complexity, and innovation are shown so much more ambiguously and with so much greater complexity and innovation in fine art.

RESISTING THE LEVEL PLAYING FIELD OF VISUAL CULTURE

There have been a number of attempts to resist the second of these theories while also avoiding the high-art polemics associated with Adorno. I have made an informal list of the principal strategies.

Plate 15, opposite: The Spanish ceramist Xavier Toubes inspects one of his pieces outside, in the bright, even light of an overcast winter day. Toubes has been working by alternating lustre glazes with acids, so that each new firing produces a mixture of dull white patches etched by acid, and gold or purple sparkles where the lustre has risen to the surface. It is not a process that can be predicted or put into words. Pointing seems best. Art history has wrestled with this problem for a long time: hopefully the wider phenomenology of visual studies will be able to find a voice for it.

1. *Ignore the problem.* This may not sound like a successful strategy and in the long term it may not prove to be, but it is the *de facto* position of faculty members who find themselves surrounded by new faculty who have little invested in the distinctions between high and low art. (Visual-culture apologists have the reverse perspective because they do not acknowledge that it is a problem to *deny* the high/low difference. Their position is not my concern at the moment.) Art historians who specialize in any period before postmodernism are likely to want to defend some version of the difference between high and low; even if they are sympathetic to a writer such as Jameson when it comes to postmodernism, the very fact that they specialize in a period when fine art was a domain of privilege means their professional life is predicated on a firm distinction between high and low. The problem is not always visible; faculty members who get along together may not even be aware that their professional orientations, even aside from their views on contemporary culture, compel them to be ideologically at odds.

In the previous chapter I reported on an unnamed university where the Art History Department ignored the new interest in visual culture, resulting in its increasing isolation. There is some virtue in that: ignoring the problem helps keep disciplinary competence at a

3. Treat the high/low problem as a constitutive disagreement within the field of visual studies. In perhaps the most interesting move, high and low are understood as epiphenomena of a dubious ideology. We can "give up the hierarchizing cultural memory" that used to privilege masterpieces, in Cary Nelson's formulation, if only we recognize that artworks high and low are "part of wider discursive formations." That way we can see how meaning derives "primarily from an analysis of those relations rather than from an ahistorical and largely immanent formalism."[25]

In this view, the irresolvable tension between the discourses of high and low is constitutive of visual culture. This deconstructive approach is favored by Jonathan Culler, who identifies the high/low dilemma as the defining tension in the new discipline. On the one hand there is the scholar's Marxist impulse to "analyze culture as a hegemonic institution that alienates people from their interests and creates the desires that they come to have," and on the other there is a populist urge to find "an authentic expression of value" in popular culture as opposed to the artificially sustained elitism of some older art history.[26] This sounds intriguing, but its efficacy depends on how much of the current scholarship is informed by the tension, as opposed to energized by the apparently successful mingling of high and low. Work that is genuinely informed by the tension, either thematically (Melville) or in effect (Crow), can be interesting for the reason Culler defines, but work that proposes that the problem has been solved or shelved (Mirzoeff) will be less so.

This approach can also be understood as a third alternative, after the assertion of high art (as in Adorno) and the assertion of the victory of commodification (as in Jameson). In that case visual culture's position could be put as a three-part formula: visual culture disbelieves the first view, that high and low remain distinct; it is predicated on the second, that high and low have been mixed into a gen-

and other popular sources.) The surrealist critique of bourgeois society is closely allied with visual studies via the importance of Walter Benjamin, who adapted surrealist concerns to help him theorize his own writing. Pop art had a different purpose in blending high and low and a different effect on academic disciplines: it enabled critics such as Lawrence Alloway to start the leveling that found its more academic voice in philosophers such as Arthur Danto. A third historical moment that involved a leveling of high and low is postmodernism, especially since the mid-1980s when digital art and new media became more important; and that moment could be associated with Burgin and Jameson along with Virilio, Baudrillard, and many others.

I offer this very crude tripartite history to suggest that the high/low problem can also be approached as a matter of the historiography of art criticism and visual culture. Benjamin would belong to an initial moment in which the high/low distinction was undermined. Danto would belong to a second such moment, and Burgin and Jameson to a third. Our current way of putting the high/low problem would therefore be best referred to the historiography of modernism. It may be that in a few years such an approach will come to seem both adequate and illuminating, and the issues under discussion here will be subsumed into a wider study of the history of writing on visual culture. At that point, some art history's resistance to visual culture and some visual culture's exuberant insouciance about art history will appear as two sides of a common late-modernist project. Visual culture and art history will be taken as discourses best approached as interdependent ways of talking rather than as truth-claims about the world. That has not happened yet. Visual culture still appears as a potentially different form of historical study, unsettled in relation to the study of earlier art. We do not yet have enough historical distance on the issues.

ventional art history that is being taught there. Some European universities have a department that combines art history and visual culture, or visual communications and visual culture, or semiotics and visual culture. In my experience that kind of cohabitation is more expedient than productive and it only postpones the time when it becomes necessary to rethink the department's purpose and coherence.

In an essay called "Who's Afraid of Visual Culture?" Johanna Drucker takes art historians and curators to task for trying to ignore the role of popular culture in early modernism. She points to the "perverse prohibition" against considering the fact that Winslow Homer "used, rather than ignored or transcended, the seductive strategies he learned in illustrative work."[24] She says the prohibition derives from "the disadvantage American culture has always felt in its relation to European art." An icon of nineteenth-century American painting such as Homer has to be understood, in the logic of Americanist art history, as a creative genius trasmuting the raw material of popular visual culture into fine art. Drucker's complaint points to a deep-rooted difference between art history and visual studies and between high and low that will not be solved by ignoring the problem and especially not by letting the two fields coexist in mutual silence.

2. *Approach the high/low question as a historical problem.* It is possible to understand the high/low issue, together with the entire constellation of new work in visual culture that prompted this book, as the signs of a particular cultural moment. From an historical standpoint, the first mixing of high and low in the twentieth century was not Pop art, as is often said, but surrealism. (Before the twentieth century, Western art is replete with examples of high/low mixtures: Courbet, Manet, and before them Dutch painters and before them Renaissance artists all made use of broadsheets, book illustrations,

high level, so that the Art History Department can continue to concentrate on training the best possible medievalists or Renaissance specialists. Unfortunately, dividing art history from visual culture also severs the continuous history of art, which after all includes contemporary popular images, and promotes a kind of alienation that is not necessarily reflected in the actual history of image-making.

It is also true that if an art history department remains uninvolved in studies of visual culture, then visual culture can be taught in several departments within a university. That gives visual culture a kind of freedom—a literally interdisciplinary freedom—that individual departments do not usually have. Visual culture can also exist within an art history department without much contact with the con-

eral commercialism; and it can be understood by means of the third, that high and low provide different discourses whose dissonance defines the discipline.

4. *Resist the high/low leveling by launching a disciplinary critique.* This last option is a miscellaneous category, except for the fact that the opinions are aimed against visual culture as an emerging discipline and therefore they are put in the language of politics.

In an essay called "Is Art History?" published in 1977, Svetlana Alpers asked "what view of human and societal values, and . . . what understanding of the sequence of objects that we call history" will result from the jubilant leveling proposed by visual culture studies.[27] Her argument could equally well be aimed back two decades to Raymond Williams's attack on "high culture" and forward two decades at Mirzoeff's revaluation of high-art values. Alpers's question is an important one but it risks sounding like a conservative's gesture—a bid to return to the state of affairs before visual studies.

Robert Morris has written an impressionistic essay called "Threading the Labyrinth," which complains about "the great techo-empirical paradigm" that looms like a wall in contemporary culture, blocking the way back to modernism and "authentic aesthetics." The wall "curves out of sight," he says, and because it is so enormous, "Visual Culture, examining each brick in turn, does not perceive this curvature." Morris's attack on "Visual Culture" (his capitals) is motivated by what he perceives as its "causal masonry" and its fascination with technology at the expense of aesthetics.[28] Art, in this view, would be the practice that resists the "wall."

For some art historians, the most important fine art since the 1960s is preeminently nonvisual: conceptual art and minimalism depend heavily on theory, which is bypassed and therefore often undervalued by visual studies, with its emphasis on visuality. In 1996 Crow warned readers of the *Chronicle of Higher Education* about the

"hastily considered substitution of image history for art history," which he thinks will pull "all the objects of the world into a muddle of Western devising."[29] (It is debatable whether art history is less Western without the muddle, but that is ancillary to Crow's principal concern, which is the muddle of ill-considered unions between disciplines.) Crow goes on to imply that visual studies is constitutionally ill suited to recognize the existence of art that is nonvisual and highly invested in cognition and intellection (especially conceptual art). He is concerned that visual culture's "fetish of visuality" repeats the old modernist interest in vision at the expense of serious art.[30]

Detail 16, opposite: Part of a Fourier transformation of an image. This is not a representational image at all, but a graph: it can be decoded for information about the original image. The spacing of the rings and radial lines gives information about the objects in the original image. Why study things like this? Because they are part of the world of images beyond the mimetic images preferred in fine art and popular culture. It can even be argued that some of the most radical critiques of representation in modernism are less consistently antirepresentational than images like this.

Keith Moxey has described what would happen if visual culture ended up being the study of "the image-making capacity of human cultures in all their manifestations": there would be no more sense in trying to make "qualitative distinctions" between kinds of images, and the discipline would become a collection of fields "indifferent" to one another. Moxey thinks a more reasonable alternative would be to continue the job of distinguishing "cultural value" but to shrink the purview of aesthetic judgment so that it is no longer assumed that "aesthetic experience is derived from a universal response." Aesthetics would then become one form of judgment among others, each with its own history and purview. Citing Gayatri Spivak, Judith Butler, and others, Moxey proposes that aesthetics become "part of the assertion of difference" and the history of colonial power.[31] In terms of politics, this is the most radical proposal, if it could be realized—the obstacle, I think, being an unwillingness on the part of many scholars to trade Western ideas about aesthetic value for non-Western alternatives; more on this in the next chapter.

These and other objections raised by art historians—some of them, including Moxey, very sympathetic to visual studies—are part of the current mix of opinions. Together they constitute the ill-defined disciplinary reaction to the perceived threat of the newly leveled playing field.

Of these four approaches—the last one decidedly a miscellaneous category—I find the second and third the most promising. So far it has seemed that if the field is to become a truly general study of images, capable of considering production, interpretation, and dissemination of images of all sorts, then it has to adhere to its basic tenet that the difference between high and low has become inoperative. I have argued with several examples (*Mr. Magoo*, Benetton) that I do not think the high/low difference can be so easily vitiated. Given that, and given that no one I know wants to return to Adorno's sense of high modernism, I think it is best to accept the dilemma as a constitutive problem in the new field. There is, I think, an unavoidable tension between a sense of visual culture based on the idea that high and low are mingled and an approach based on the assumption that high and low remain distinct. Nothing at this point in cultural history appears as a way to harmonize that tension. It seems espe-

cially clear to me that it will not do to ignore the problem from either side; visual-culture texts that start by positing a homogeneous mix do serious damage to existing discourses of art, and art-historical texts that attempt to tell only the high art side of modernism run into trouble when they have to account for popular imagery.[32]

In the first chapter of this book, I tried to do some simple describing and surveying. I don't for a minute imagine that chapter is somehow

an objective look at the discipline, but I hope it responds to the kinds of questions that anyone new to a discipline might ask. In this chapter I have been more critical. In particular I have proposed that visual culture is not the generalized study of visuality that it tends to describe itself as being. Visual-studies scholars keep to a specific set of theorists clustered around Barthes, Benjamin, Foucault, and Lacan. They also study a very closely definable set of visual objects, which I have divided for these particular purposes into two parts: popular Western images from the invention of photography to the present; and contemporary avant-garde practices. In order to become as general as it can be, visual studies needs to consider these preferences carefully and take them into its own self-description and self-criticism.

In the next chapter I begin a constructive critique, describing ten ways I think visual culture can challenge itself to become even more interesting and even necessary for the general study of images throughout the university.

Ten Ways to Make Visual Studies More Difficult

THE SHEER DISARRAY of visual culture is a good sign of its strength and newness. Chinese postcards of outlandish tortures, American Girl Place, television coverage of Princess Di's death—who could have guessed at the variety even a few years ago? But there is a significant gap between the energetic new scholarship and the kind of concentration that could make visual studies a central concern of the university.

At the moment visual studies is, to put it directly, too easy. The scattered subjects and untheorized choices of methods make it fairly simple to generate texts and unrewarding to compare one study to another. It hardly seems sensible to evaluate individual texts; the subjects vary wildly (from tattooing to celestial charts, to name the two favorite subjects of a former student), and at the same time the methods and values are often predictable (that student preferred a collage-style exposition, with disparate examples juxtaposed for comic effect). When I propose that visual studies needs to become more difficult, part of what I have in mind is a balance; the texts would have more lasting interest, for example, if the innovative subject matter were balanced by theoretical or ideological innovation.

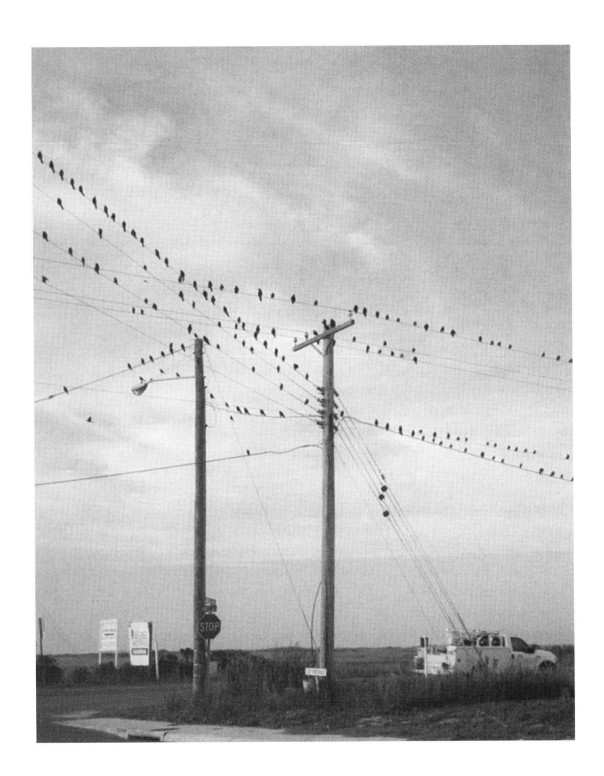

(Benjamin's fragments have that quality; his meditations about objects drive an ongoing critique of his own intentions.) I do not mean that visual studies should be more conservative in its choice of subjects or wedded to a particular methodological program, or that it should become more scholarly, or that it should find ways to condense itself into a discipline. And—as against those conservative interests—I also do not mean that visual studies should become more radical in its methods, more free in its ideological work, or wilder in its writing: Slavoj Žižek, among others, shows how difficult it can be to reconcile wild writing with wild theory.

Plate 17, opposite: I don't know when I first noticed that starlings, and other kinds of perching birds like sparrows, tend to space themselves out evenly along telephone lines. Once I started noticing this, I couldn't stop. I wonder if it means the birds all like each other the same amount, or if it would be more accurate to say they all dislike each other slightly. Often a flock of birds will choose one of two intervals: a narrow one, like on the top wire on the left, and a wider one, as on the third wire from the top. That makes their choices even more mysterious. The mystery only deepened when I observed birdwatchers doing the same thing, all strung out along a boardwalk with three feet between them.

I would like to see a visual studies that is denser with theories and strategies, more reflective about its own history, warier of existing visual theories, more attentive to neighboring and distant disciplines, more vigilant about its own sense of visuality, less predictable in its politics, and less routine in its choice of subjects. Why not make visual studies into the subject its name implies: the study (using the full range of theories from every interested discipline) of the visual (in all its forms, from the highest artwork to the lowest list)? Why not work to condense the many disparate kinds of visual competence in the arts and sciences into a single place? (Or in the complementary metaphor: Why not expand localized studies of the visual so that they can begin to intersect and merge?) Why not question the visual as stringently and vigilantly as possible?

What matters most is the ease: visual studies is too easy to learn, too easy to practice, too easy on itself. I would love to see the field become so difficult that it can do justice to the immeasurable importance of visuality, which is still slighted throughout the university. I'd

like to see it become so difficult that it can take its place at the center of discussions about visuality, vision, and visual practices.

It is promising that nothing in the current constitution of visual culture prevents such an expansion; no logic, no theory, no methodology implies that the field should not interrogate itself in such a way as to become more challenging. The ten points in this chapter are examples of what I have in mind: they comprise not a program but rather something like program notes. I have given them titles in the style of the Sherlock Holmes mysteries because each one is really a "case"—a conundrum posed to the field.

1. THE CASE OF THE CALVIN KLEIN SUIT: IN WHAT SENSE IS VISUAL CULTURE MARXIST?

English cultural studies was Marxist and in a general sense so is visual culture, because even when Marx is not mentioned, the purpose of a visual-culture analysis is often to unveil what he called a "false consciousness," revealing the ideology that makes a certain capitalist practice appear natural. In visual culture, a study might reveal the kinds of consumers that an image-maker posits and helps to create or the sense of self and society that a particular image-making practice instills. The result of a good analysis is a newly awakened sense of the ideas that were behind the creation of an image and the kinds of *unawareness* that were necessary in order for the image to please and influence its intended viewers. In Marxist terms, the end result is an unmasking, a demonstration that what had appeared to be a natural process was involved in what Marx called the "phantasmagoria" of consumerism, the creation of fetish objects, or the betrayal of use-value for exchange-value.[1]

Contemporary visual culture scholars seldom invoke Marx's terms directly, and since I started looking for references to Marx in

visual culture papers I have found very few. And yet the principal non-Marxist kinds of "unmasking" critiques—psychoanalytic critiques of unconscious ideas, Kantian critiques of unnoticed conditions of understanding—are, I think, much less influential on the study of contemporary visual studies. Marxist critique, in which Marx kept at a generous distance from the text itself, is a nearly uncontested effective purpose for much of visual culture, especially when it pertains to contemporary consumerism.

What interests me is not that the Marxist purpose is unacknowledged in current studies of visual culture, but that it is tentative. A Marxist critique can make sense only if it is directed, as his own writing was, at class consciousness rather than individual consciousness, the consciousness of a single consumer or a particular group regarding a particular product. Marxist analyses risk becoming incoherent when they take the large-scale terms that drive the Marxist project (class, labor, value) and apply them to the small scales that visual culture prefers (a particular advertisement, a snapshot, a magazine).

As an example, consider the Case of the Calvin Klein Suit: a visual-culture analysis of fashion that I have heard played out in a classroom. It begins with the teacher reminding the class that the ad agency which produces the ads attempts to create a desire in the viewers. An ordinary consumer will be aware of his or her desire for the product but not necessarily conscious of the ways the desire for the product has been instilled. In fact, so the teacher says, it can be shown that the desire is artificially constructed out of all sorts of visual cues and associations and that it is constructed in such a way that the consumer thinks only of the product. For the consumer, the product is a magical, "fetishistic" object, suffused with values the consumer barely knows.

Then the teacher shows a Calvin Klein advertisement on the assumption that it will appeal, more or less, to most of the class.

(Needless to say this exercise can be varied to suit the students; in a conservative and affluent neighborhood it might be better to choose Hermès, and in a suburban neighborhood the Gap might be a better choice.) The teacher shows how the Calvin Klein ad creates a desire to buy Calvin Klein by playing off other desires the students already have. The model in the ad looks twenty-something and she is not anorexic, showing a disregard for established fashion-world dogma. She wears a Calvin Klein sweater and pants, of course, but she looks unhappy, which appeals to students used to models who are clearly insincere. She has a lip ring, but it is not centered (that would be too punk) and it isn't too large or small (that would be too dangerous-looking or too suburban). She slouches, but not more than any of us would want to slouch if our job compelled us to stand for hours on end. In short she is a sympathetic figure, stirring a desire to be like her and even to own her clothes. When the class goes well, the teacher is then in a position to demonstrate that canny advertising decisions rather than intrinsically beautiful Calvin Klein clothes have produced a desire in at least some of the students.

Plate 18, opposite: Visual studies can be the place to carry on with old themes that seem to have been dropped by history. One such is the idea of chance images, the notion that nature creates signs and pictures for people to interpret. The notion may seem quaint, but it is very much alive in science because it poses itself irresistibly to the eye. This is a chance configuration of algae from a plankton sample taken in the Gulf of Mexico: it resembles angelic and demonic signs in Renaissance treatises, which were in turn hallucinated in natural objects like tree trunks.

The problem with this, from a Marxist perspective, is that it doesn't go very far. The students have become skeptical of one very particular kind of bourgeois consumer—the one they were themselves, to some degree, before the class began. But they still fall for other fashion advertisements and they still desire many other brands. Visual culture has shifted them a small distance within the bourgeoisie: not quite the unmasking of capitalist phantasmagoria that Marx intended. I don't mean that the class fails because it fails to be Marxist—usually Marx isn't mentioned, so there is no reason

to judge the class by his standards. What I mean is that the intrinsic logic of the class itself is incomplete, because it demonstrates a strategy of unmasking without saying why it is appropriate to stop after one example. The logic works to unmask visual meanings that consumers are unaware of and so it posits unveiling as a desirable end; nothing in the logic explains why such analysis would not be universally desirable—an unmasking with no end other than a change in class consciousness.

What makes this a lovely case (as Sherlock Holmes would have said) is that the students can see the efficacy of visual culture simply by looking at what their teacher is wearing. When I saw this demonstration done in a class, the teacher was wearing a simple dress, T-shirt, and jacket with minimal jewelry. It wasn't Armani but it was something close. Clearly, the teacher was no longer influenced by Calvin Klein ads but she was taken by Armani. As any student could see, visual culture works to unmask only individual image-making practices and leaves consumers as much in the grip of advertising as before. The class could well have continued; the teacher might have asked the students how they thought their own clothing reflected the desires and images they want to project, and the conversation might have included a discussion of the teacher's own preferences. The discussion could even pursue advertising into the domain of marketing and distribution, involving the class in a discussion of the economics of design. Classes like those can be very interesting, especially when it becomes clear that past a certain point, we often prefer *not to know* about how our desires are constructed. The visual culture critique could be made more difficult and more trenchant by raising the question of the limits of the methodology of the Calvin Klein example. Too often, a visual-culture critique will end with the demonstration of one set of constructed desires: it will move from Calvin Klein to Armani to the Gap in a series of discrete studies, but

without asking what logic internal to the arguments prevents them from continuing in the same direction—in other words, without asking what distance from capitalist practices is optimal.

This is where Rosalind Krauss's criticism of visual culture has real bite. She says that "advanced culture . . . is continually preparing its subjects to inhabit . . . the next, more demanding stage in the development of capital." Visual culture does that by teaching the production and reception of commercial images while at the same time imagining that the slightly more self-aware consumers it produces are "subversive," no longer part of the system. Visual culture sees itself as revolutionary, but "whether this revolution is indeed an insurgency, or whether it . . . serves an ever more technologized structure of knowledge and helps to acclimate subjects of that knowledge to increasingly alienated conditions of experience . . . is a question we must continue to ask."[2]

2. THE CASE OF THE POOR SCHOOLTEACHER: WHEN VISUAL STUDIES IS SELF-EVIDENT

Adorno recognized this problem decades before visual culture was an academic pursuit. In an essay called "How to Look at Television," he describes an "extremely light comedy" in which an underpaid schoolteacher tries to borrow money from her friends and ends up being "incessantly fined by the caricature of a pompous and authoritarian school principal." "Overtly," Adorno says, the show is just a "slight amusement," and it "does not try to 'sell' any idea." There is a "hidden meaning"—Adorno puts the phrase in scare quotes to show it isn't really hidden—because the viewers are invited to consider the characters "without being aware that indoctrination is present." Adorno says the script implies the following "hidden meaning":

> If you are as humorous, good-natured, quick-witted, and charming as [the teacher] is, do not worry about being paid a starvation wage. You can cope with your frustration in a humorous way; and your superior wit and cleverness put you not only above material privations, but also above the rest of mankind.[3]

Hence the script is a "shrewd" vehicle for helping viewers "reach a compromise between prevailing scorn for the intellectual and the equally conventional respect for 'culture.'" A contemporary cultural-studies analysis might end here, perhaps with the additional observation that the script is predicated on the refusal to acknowledge the "hidden meaning" even though the it is essential to the structure of the narrative itself. (That is a poststructuralist or deconstructive conclusion, aimed at the inbuilt ruptures in the text of the script itself.) But Adorno goes on: "of course, this latent message cannot be considered as unconscious in the strict psychological sense, but rather as 'unobtrusive.'" It is hidden only by the "featherweight" tone of the script, which tells viewers not to think of such weighty problems as morals and meanings. Some viewers may be unaware of the message as such and they may be guided by it without ever putting it into words; but they *could* become aware of it, because the meaning is not truly hidden. (In terms of Freud's "first topography," the "hidden meaning" of the show is *preconscious* rather than unconscious: it can be brought to mind but it isn't ordinarily in mind.) The same is true for the writers and producers of such shows: they may not think about the messages and morals they promote and they may know full well what is happening, but they "grumblingly" follow the restrictive rules of television dramas. Some know, some don't, but all *could*.

Adorno is not the only one to ask this question. Something like it is debated in studies of advertising, where the problem is the distinction—if there is one—between advertisements that inform and

those that persuade. The line is impossible to draw, because information modifies behavior as much as persuasion, and neither one needs to be entirely conscious.[4]

This is a kind of analysis often missing from contemporary visual culture: Exactly how hidden is the hidden meaning that scholarship uncovers? Hidden from whom, when, and how? Recoverable for whom, when, and why? Often, I find it is assumed that the operation of recovery comprises a sufficient interpretation. Yet I wonder when it is *not* the case that the ideological significance of television dramas is perfectly apparent but deliberately kept just out of mind so it can work "unobtrusively." A preconscious idea could be made conscious at will by viewers of the television program without the help of visual culture. The entertaining dialogue in the show about the poor schoolteacher would not work if the "hidden meaning" were put in front of viewers like the projected text in an opera. This poses two challenges for visual studies: to determine when a "hidden meaning" is hidden enough so that it is worth uncovering; and to describe the *kind of awareness,* the degree of unobtrusiveness, that characterizes the "hidden meaning" in any given instance.

Here is an example of an interpretation that is not self-evident. It is, I think, one of Adorno's most brilliant sentences:

> If an astrologer urges his readers to drive carefully on a particular day, that certainly hurts no one; they will, however, be harmed indeed by the stupefaction which lies in the claim that advice which is valid every day and which is therefore idiotic, needs the approval of the stars.[5]

Notice Adorno doesn't say that the "idiotic" ideas are harmful; what harms is the "stupefaction" that comes from accepting such ideas. There are three kinds of harm circulating in the sentence: physical harm from car accidents; harm to mental life or logical thought; and

stupefaction, the cause of the harm done to thought. Now this is an insight that is not at all obvious, even to people who read horoscopes half-seriously, always knowing they aren't really scientific or reliable, but enjoying them anyway. A fan of horoscopes takes pleasure in unexpected coincidences that are nevertheless probably not scientifically true: it's a kind of harmless pleasure, pretending that the world is rich in hidden alignments and conjunctions, and it's a respite from the dull world of actual cause and effect. Writers from Milan Kundera (who once wrote horoscopes) to Rob Brezsny (a postmodern astrologer) are fully aware of the irony and the evanescent pleasure of their avocation.[6] What they don't know, in Adorno's account, is that the "stupefaction" they let themselves in for is itself what harms them. That is more on the order of a genuine insight, a real contribution; but notice that whether or not it is true (and in Brezsny's and Kundera's cases, it may not be), it has no systematic theory behind it beyond the general interest, inherited from both Marx and Freud, in the unconscious or in the uncognized meanings behind everyday actions. Adorno's insight cannot be taught, and it would be difficult to know how to apply it to another subject; therefore it is not in any readily apparent way a part of a discipline such as visual or cultural studies. What visual culture does is more often a matter of finding preconscious meanings.

Plate 19, opposite: The whole environment of a visual practice matters. Here is a bowl of muddy water. It is on a table next to a throwing wheel in a ceramics studio. The knife has been used to pare away extra slip from the emerging form. The surplus has been scraped onto the rim of the bowl. The water and sponge are used to balance the smoothness of a wet surface against the malleability of a drier surface. The art object may be neither central nor sufficient.

It is counterintuitive, to say the least of it, that the same people who claim that we are visually literate beyond all previous periods in history (I will discuss them in the following chapter) also write undergraduate textbooks intended to teach literacy. I wonder how many freshmen need to be coached to understand the Rodney King video or the media depictions of Diana's death. How many popular

images require concerted decoding? Advertising has reached the point where it makes fun of itself and its own assumptions, leaving relatively little for visual studies to do except to tease apart the different levels of self-awareness and preconscious allusions.

3. The Case of the Ill-Conceived Essay on 9/11: When Visual Studies Is Not Helpful

Consider the events of September 11, 2001, in New York City. In October of that year, I was invited by a magazine to write a report on the merchandizing of images of the World Trade Center. Within three days of the attack, vendors were on the streets in the Financial District selling T-shirts and caps with slogans like "Victory." There were also ephemeral publications, one called *Terror*, that featured pictures of the disaster stolen from network television. At some point in late September, the Red Cross started calling for a moratorium on reproductions of the videos and images of the attack, and after that the images were no longer shown on television except in special circumstances such as television newsmagazines, *Oprah*, talk shows about survivors, and newly discovered stories of survivors. By November, the magazines and vendors were gone, and the images that had been on display were replaced by framed photos of the World Trade Center towers before they were destroyed. A number of books (at least six) appeared from major presses, celebrating the way New York looked before the attack.

My story was supposed to trace the development from the barrage of images of disaster to the sweetly nostalgic and patriotic images of the ideal city that predominated beginning in October. I was supposed to bring some expertise in visual studies to bear on the phenomenon. I visited twice that fall and collected information about the selling and display of images. The September 11 Photo Project,

which has since traveled to several U.S. cities, was then housed in a single room on Wooster Street.[7] The exhibition was not curated (anyone could submit work), and I noticed that some people had doctored their pictures in Photoshop, wreathing the Trade Towers in iridescent colors or making the clouds of smoke darker than they were. That struck me as a potentially interesting subject: it would be inadmissible for a photojournalist but entirely typical of what was done in the nineteenth century and before in depictions of natural disasters. I also visited the Ariel Meyerowitz Gallery, which had an exhibition of Joel Meyerowitz's photographs of the World Trade Center that he had taken from 1981 to 2001. Ariel, the photographer's daughter, told me that the exhibition had been arranged long before September 11. There were about fifteen photographs on display. The ones taken on cloudy days did not sell well, probably because they reminded people of the disaster. Ariel Meyerowitz kept the "famous last photograph," the final one he had taken before the attack, out of sight. Strangely, people were buying photographs that had strong colors—mostly sunsets—even though those colors were reminiscent of fire.

In the end, I did not write the essay because it seemed to me that so far, visual studies has very little to say about the September 11th events. I could have described the digitally altered photos in the September 11 Photo Project gallery, but that would be only a footnote to the history of paintings of disasters. In the seventeenth century, Piranesi exaggerated the size of Roman ruins, and in the eighteenth century, painters exaggerated the eruption of Mount Etna. This was no different, and because it was not journalism there was nothing immoral about it. I could have written about Ariel Meyerowitz: her staunch defense of the exhibition, her sense that people wanted only happy images—but that attitude was natural in the circumstances. She couldn't very well say that people were drawn to the lurid pictures for something other than nostalgic or patriotic reasons. I could have

written about the question of the quality of the images that have been inspired by 9/11 and the relevance or irrelevance of quality. (In addition to the many extremely emotional images made shortly after the attack, there have been a few genuinely interesting images whose quality—if that can be counted as a relevant term!—is very high. Among these I think particularly of a stupendous video made of the temporary memorial called the Towers of Light—two powerful beams trained up into the sky—in which a plane flies through the darkness directly into one beam and then the other, and then disappears into the night; and also a landscape by the Midwest painter Keith Jacobshagen, painted on 9/11, in which the Twin Towers are echoed in distant silos, far off across a cold Nebraska landscape.[8] But what is the *sense* of quality in such cases?) I could also have written about the T-shirts that were full of misguided pride and anger, and their subsequent removal—that would have been interesting because it would have allowed me to touch on the quality of American emotionalism that characterized the following months. But that subject would have been only incidentally about visual images.

Plate 20, opposite: A dinoflagellate, perhaps *Ceratium sp.* I have peppered scientific images throughout this book, partly to suggest that visual studies need not stop at the borders of the humanities, but more personally because I am attracted to these images myself. It is important, I feel, for visual studies not to restrict itself to things that have meaning in what Thomas Crow calls the common culture. This image does have certain conditions of production and viewing, but it is also a good example of this creature's apical and antapical horns.

The television images of the attack were extremely interesting, but often for reasons that had nothing to do with politics or human suffering. Like others at the time, I found it curious that they outdo Hollywood special effects such as those in the American remake of *Godzilla* (a film in which parts of Manhattan are destroyed); in the videos of the event, the clouds of smoke are more convincing than in the movies. The smoke billows, and as the towers fall, doughnuts of smoke fall into one another—an effect I have never seen in movies. The video of tens of thousands of papers flying like confetti around the collapsing tower was also unexpected and unforgettable. The images

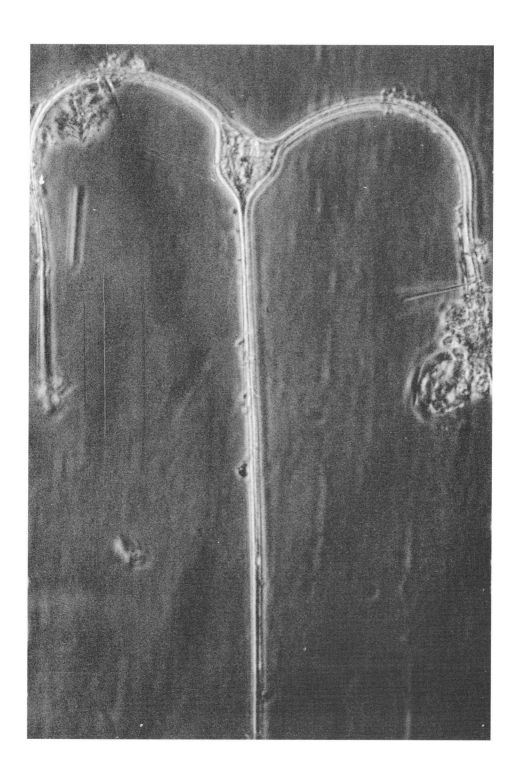

of the second plane disappearing into the building are deeply astonishing, but that astonishment has no immediate connection to patriotism, justice, terrorism, or any other such concern. The uses to which those images have been put certainly have such connections, but in those cases the image is an emblem, less of interest for what it shows than for what it symbolizes or recalls. The images are astonishing first of all because the plane simply disappears as if it were a shadow running up a wall. No one in Hollywood had ever thought of that.

Visual culture, I thought, could certainly contribute observations about other images. For example, one network ran a segment on a mother with her children in tow looking for her husband, whom she eventually found. Along the way she ran into a taped-off area of a street and was forbidden to enter. Behind the tape people could be seen wearing yarmulkes. One man behind the tape told the family they could not enter because it was a "secure zone." The network may have decided to include that scene in order to show that Jewish groups were also potential victims, although they may also have wanted to imply that Jewish groups had commandeered blocks illegally. (It is also possible they never considered the meanings that might be read into that scene.) Small insights like that, I thought, would be visual culture's main contribution.

It also occurred to me that a visual-culture analysis might address the fact that the continuous showing of the images during the first few weeks was creating an atmosphere of tension and even hysteria. The images had a kind of raw power and they were affecting people in a nonverbal way, making them nervous and heightening their emotions. A friend told me she had to stop her six-year-old from watching TV because he thought the attack was ongoing and that many cities were being destroyed. It is possible that child's response is the conscious equivalent of what many adults were feeling without knowing it. Part of the cure was the moratorium on

showing the images, and another part was the balm of nostalgic, ide-
alizing images of the city that were being sold everywhere in
Manhattan at the end of 2001.

That, I thought, could be an interesting subject. The problem
was that it applies just as well to other strong images, including war
photographs, as the historian George Roeder has demonstrated in
the case of photographs of World War II.[9] The cumulative, percus-
sive effect of strong images can also be found in reactions to recent
disasters such as the space shuttle explosion in January 28, 1986, or
the crash of February 1, 2003, both of which have been taken off the
air and are now rarely seen.[10] In other words, visual culture would
have nothing to say about the particular events of September 11. It
seems undeniably the case that the attack was intended to "change
the image of Manhattan forever" (as one newscaster put it), but it is
not clear exactly what visual studies would be able to contribute to
that use of the word "image."

Sometime in the fall of 2001, I told the editor I would not write
the story. (I had other reasons as well: writing about 9/11 has been a
poor decision for many scholars.) What does it mean, I wondered,
that visual culture has so little to say about an event so overwhelm-
ingly important and so overwhelmingly visual? Few internationally
significant events in the last hundred years have been as intensely,
protractedly, and predominantly visual—and so it would seem that
few events could be better subjects. One conclusion is that not all of
the visual world is in need of interpretation of the sort visual culture
offers: visual culture needs to consider what portions of the visual
world are appropriate and amenable to its concerns.

A related problem, which I will post here as an appendix to the
Case of the Ill-Conceived Essay, is the way that some visual-culture
essays take images as indispensable examples of certain ideas,
when the images are actually brought in just because the writers

find them significant, and the points could be made equally well without them. For example, in art history and visual culture, the photographers Catherine Opie and Claude Cahun are crucial examples of the representation of lesbian and intergender roles. But are those photographs lessons in gender, telling us things we had not known, or are they examples of roles and representations that are already known in other contexts? Or in another sphere, analyses of the media treatment of Princess Diana's death demonstrate the complicity of media in the creation of a global information network, but are the pictures themselves new information about globalism or are they instances of phenomena that can be found in other settings—including nonvisual theories of globalism? Certainly there are many contexts and collaborations from which knowledge has unexpectedly arisen, and I do not mean to say that studies of Cahun or Diana might not produce such knowledge: but that does not mean it makes sense to begin with them, and at times it can seem as if writers choose them fortuitously, because they are at hand and can be put to pressing purposes.

Recent scholarship has shown that Dr. Gross, who is pictured in Thomas Eakins's *Gross Clinic,* once performed a gender-changing operation. The texts reporting that information make it appear as if the new facts, together with the painting of Dr. Gross, constitute an advance in our understanding of the painting as well as an opportunity to learn something in and through visuality. But what is gained, exactly? Doesn't the new data about Dr. Gross work to confirm existing constructions of gender, adding an example that hadn't been known before? Does it matter that transgender identity can be confirmed in Eakins? And because a gender re-assignment operation is not the subject of this painting, what does the new information have to do with the *visual* work of visual studies—with the business of attending to the image itself?

Visual images may not always be the optimal place to look for signs of gender, identity, politics, and the other questions that are of interest to scholars. Images are deeply connected to attention, memory, sex, and any number of foundational human responses—but that does not mean that they can be taken as optimal routes to those subjects. Sometimes the images are there just because the writers are invested in them, not because images are needed to make the arguments work. As Watson would say, this is really another case: call it the Case of the Addiction to Images. It is related to the Case of the Ill-Conceived Essay because in both it is assumed that ideas and information come to us in a unique form when they are given in or as images. That assumption is tricky, because our commitment to images naturally leads us to think that ideas gotten through images are truer or more interesting than the same ideas outside of images.

4. The Case of the Neglected Crystal: Visual Culture and Non-Art Images

Seen from the vantage of the art-historical study of modernism—from the perspective of historians who study abstract expressionism, minimalism, and conceptual art—visual culture seems wild and free of boundaries. That apparent freedom is part of the field's sense of itself: it is defined by its attention to general questions and to visuality itself rather than by any historically or culturally defined practices. Yet from another point of view, the field is still severely limited. Premodern visual practices are certainly amenable to visual culture interpretations, as I noted in the previous chapter. So are non-Western visual practices, which I will address below. In addition to those largely unexplored realms, there is the enormous domain of non-art images: the uncountable different kinds of charts and graphs and nomograms and cladograms, the visual elements in scripts (in

hieroglyphs, in Chinese, in Yi and Bamum and Linear B), the visual elements in mathematical notation (matrices, vectors, summation signs, spatial integrals), pseudowriting and prehistoric kinds of marking, heraldry, calligraphy, typography, graphology and paleography, epigraphy, maps from prehistory to the present, and scientific illustrations of all sorts. Why not bring all that into the same field of visuality and visual practices? Potentially, visual studies can take an interest in image-making practices in any discipline, from paleobotany to paleontology, from circuit design to chemical modeling, from advertising to bridge-building. The fact that no one knows how to gather the imaging practices of these disciplines, that no one knows whether their visual competencies might be presented in such a way as to be mutually informative, only makes visual studies that much more interesting.

In the past decade there have been several calls to expand visual studies in the directions of graphic design and ideographic writing. (Mitchell is among the advocates of that expanded field.) Still it needs to be said that some of those practices simply cannot be treated to the *kinds* of readings that visual studies students find interesting. It is relatively unrewarding, for instance, to study crystallographic drawing as a political phenomenon or chemical modeling as a gendered activity. My own book *Domain of Images* is an attempt to survey a kind of sum total of two-dimensional visual practices, from the Upper Paleolithic to computer graphics, but to do that (as James Herbert pointed out to me), I had to give up the entire project of social and political analysis. It is not that ancient Irish Ogham script cannot be analyzed in terms of identity theory or the kinds of viewers it constructs, or that the pseudo-Chinese Yi script has nothing to say about the convoluted politics of Yi nationhood; it is that those practices are much less intimately related to the histories of gender and politics than, say, paintings by Manet. The further you go into

the fascinating hinterland of image practices—and it is a direction I love to go in, and that I wish more scholars would take—the less there is to say about social construction, commodification, and the making of the viewing subject, and the less hope there is of *also* being able to talk about political history, patronage, contemporary literature, or the host of subjects that can make art history and visual culture so absorbing.

In the *Domain of Images*, I imagined a history of Western art that would be illustrated exclusively by pictures of crystals: eighteenth-century crystal drawings would help tell the story of the Enlightenment, early twentieth-century drawings would stand for modernism, and so forth. I think such a book could be written, because the crystal drawings are just as rich in pictorial strategies as are their contemporaneous fine-art movements. In some cases, what happens in crystal drawing predates innovations in art; I pointed especially to mid-nineteenth-century crystal illustrations that anticipate Cubism's dismantling of continuous perspectival space by more than fifty years. What is missing from that imaginary textbook is the politics: no crystallographers were affected by the Haussmannization of Paris, and there are probably no unknown women crystallographers whose illustrations need to be rescued from historical oblivion. For me, the moral was that non-art images can be just as rich as art images in some ways but that they will always disappoint viewers who want art to be about politics and gender.

I wanted the book *Domain of Images* to demonstrate that the kinds of images that have been studied so far in visual culture are a minuscule fraction of the whole. To make that point I used a biological analogy: the Manets and Picassos of the world are like the spectacular large mammals that capture everyone's attention; but things like insects and protozoa and bacteria are *most* of life, outnumbering large mammals millions of times over. A field that aspires to look as

broadly as possible at images has to come to terms with its own limiting interests, just as conservators who fight to save the panda have to realize they are saving it, in large measure, because it is impossibly cute and cuddly, not because it is more biologically important or complex than a paramecium.

It seems to me it is absolutely crucial to acknowledge this self-imposed limitation. Visual culture calls for an expanded visual field, especially one that will abandon the exclusive interest in fine art that has marked art history. At the same time, I do not think visual culture really wants to look equally at non-art images.

At the moment it is possible to imagine courses on such subjects as the Gaze in Anatolian cylinder seals or gender in eighteenth-century Rosicrucian schemata (they would also be wonderful courses to attend or books to read), but that is because such courses would extend current interests in gender, identity, the Gaze, and social meaning, applying them to unusual objects that can still be considered art. If visual studies ever reaches the point where there are courses on the anatomy of dragons in runic Swedish boundary markers or the sense of Roman space implied by the stretched-out map of Eurasia known as the *tabula Peutingeriana*—and I think it would be wonderful if those courses existed as well—it will also be necessary to acknowledge that the field itself will have changed; it will have reached the point where it can take an interest in all images, even if that means intermittently relinquishing politics, gender, and the Gaze. Visual studies focuses on popular images and contemporary culture for several reasons, but not least because they are the best vehicles for the study of gender and identity. Given that, what *is* the "full" domain of images?

86

5. The Case of the Ghost of C. P. Snow: Taking Science Seriously

By "seriously" I mean *as* science: that is, as probable truth, of use in understanding vision and visuality, rather than as social construction, of use in discovering the history of ideas about vision and visuality. There are many avowals of the social construction of science; in visual culture the claim has been made most clearly by Peter DeBolla: "visuality," he writes, "is as much constructed in and through social, cultural, and discursive forms as those things that we might loosely and anachronistically take to be self-evidently visible."¹¹ What I have to say in this section is not a critique of that idea, which is fruitful and even essential throughout visual culture. It is a plea that the other side of the coin is equally interesting and that importing some of its findings will not compromise the claims of social construction.

Detail 21, opposite: This is a tiny part of a computer image of an eye: the depression at the top is the pupil, and the rim is the iris. The theory of the gaze, first elaborated by Sartre, is a foundation stone for visual analyses, and still very much a work in progress. Seeing and being seen, looking, staring, glimpsing, and glancing: they may seem complicated in Lacan's theory, but even the simplest film still can be far more intricate. Here there may be a gleam in the eye—a little light that registers something being seen.

Vision science tends to be last on the list when new visual culture courses are planned. Yet scientists in neurology, neurophysiology, the cognitive psychology of vision, artificial vision, machine-assisted imaging, image analysis, and the comparative study of animal vision generate more papers and monographs per year than all of visual studies combined (by far—although there is no easy way to count papers, I would estimate the ratio is fifty to one). Statistically, science is where vision is studied, not the humanities. Most sciences and branches of engineering and manufacture have specific visual competencies that can be included in the repertoire of visual studies; there are ways of seeing waiting to be explored, affinities to be investigated.

A number of scholars in the humanities work on the history and sociology of science, so that science studies (the humanist study of

science) already impinges on visual studies: but so far, there is prac-
tically no science in visual studies. A typical introductory course in
visual culture includes a mention of optics, but few attempts are
made to show how contemporary concerns in vision science might
bear on concerns in visual studies.

There are three fields that have special importance for visual stud-
ies: cognitive psychology, physiological optics and neurology of vision,
and neurobiology of vision. The first studies how actual observers
process visual stimuli; the second covers the relevant anatomy; and the
third is concerned with the processing of visual information in the
brain. There are studies that attempt to sum up scientific findings and
apply them to art, but that literature is a mixed bag, because the level
at which the art is presented varies widely.[12] Résumés of vision
research are more reliable.[13] People in the humanities who are inter-
ested in the science of vision continue to cite David Marr's *Vision*
(1982), but in science that is like citing Erwin Panofsky as the model
for current methods in art history. Semir Zeki and Francis Crick, two
other favorites, are more up to date, but the works that are read are
popularizations.[14] It is best, I think, to begin whenever possible with
the science itself and stay with it long enough to see that the potential
connections between vision research and visual practices are far more
various than the popular literature suggests.

It is not necessarily the case that a student's understanding of
visuality is enhanced by a unit on the anatomy of the eye or the divi-
sions of the visual cortex. Inserting science into the visual studies
curriculum in that fashion only makes it seem as if the rudiments of
science are a kind of common ground, leading in one direction to
visual studies and in another to scientific monographs. It is also mis-
leading to present the basic facts about the anatomy and physiology
of vision as if they were sufficient for an understanding of the com-
plex issues of perception, attention, and looking that concern visual

studies. For those reasons I do not advocate inserting elementary vision science or even optics into courses on visual studies. It seems much more fruitful—and more demanding, and therefore more rewarding—to look at actual monographs and specialized studies in the relevant disciplines and ask of each one individually: Does this have anything to say to the concerns of visual culture? That strategy has the advantage of treating the sciences just as the humanities are treated; the science is engaged at a high level, with due attention to the details and nuances of the accounts.

The custom of teaching a little vision science at the beginning of the semester is both condescending and timorous: it condescends to the science by demoting it to an optional introduction to more important or relevant studies; and it timorously gestures in the direction of science, acknowledging that science might have interesting things to say without admitting that those things are too difficult or simply unknown. It also perpetuates the expulsion of sciences from the humanities and the mistaken identification of science with the kind of technology that the humanities have critiqued since Heidegger (the same technologies that visual culture often embraces).

Introducing samples of science at a professional level has another advantage as well: it leaves room for many more connections between the sciences and arts and avoids the programmatic application of color science, pattern recognition, or other scientific findings to visual art. I will give a few examples.[15]

1. The entire question of animal vision looms in front of humanities-based scholarship on visuality. Many alternate ways of seeing, and therefore ways of thinking about seeing, are available in scientific research. Recently a team led by Christopher Passaglia at Syracuse University managed to decipher the neural code—the algorithms for visual processing—that help a horseshoe crab find its way around and locate potential mates. They put a little video camera on the horseshoe

crab's shell (they called it CrabCam) and at the same time they monitored an optic nerve fiber leading from one of the crab's ommatidia. An ommatidium is a light receptor, and horseshoe crabs have about a thousand in each compound eye. The ommatidium they monitored was trained on the central six degrees of the crab's visual field. Since it is impossible to monitor the entire neural output of the eye, Passaglia and his team mimicked the total output using a series of mathematical extrapolations. They then matched their predictions to the CrabCam and to the crab's actual behavior, demonstrating that they had "deciphered" the "code" that constitutes vision in the horseshoe crab. Each of the crab's eyes, they found, "transmits to the brain robust 'neural images' of objects having the size, contrast, and motion of potential mates." The team's paper is one of the first to provide a mathematical model for vision in more than a single nerve cell and to show that the crabs' eye is expressly suited for finding other creatures like itself.[16] That demonstration can be connected to other recent work showing that a particular region in the lateral occipital cortex of humans, called the extrastriate body, responds preferentially to images of people: it is the part of our brain that looks for others like us.[17] The many recent speculations about the relation between vision and the body—including the notion that the eye looks preferentially and instinctively for bodies at all times[18]—are echoed in horseshoe crabs and in human neuroanatomy. Such comparisons might nudge humanities scholarship just a little toward quantitative observations or at least to the realization of the depth and calculability of the search for bodies.

2. Since the generation of André Breton, Georges Bataille, and Walter Benjamin, there has been a consistent interest in visualizing

Plate 22, opposite: The whole field of vernacular photography is of interest to visual studies. Sociologists and anthropologists use photographs to elicit responses from informants. Roland Barthes was interested in the poignance of family photos, and John Berger was drawn to the onrush of memory provoked by simple images. There are philosophic studies of photography and trauma, memory, and time, all using vernacular photography. This is my grandfather's house in Germantown, Pennsylvania: it still exists, but my memory of it is increasingly shaped by this one surviving slide.

90

the unconscious.[19] The idea that visual art might be concerned with the traces of unconscious images or with unconscious memory remains important in the historiography of art.[20] Parallel with those interests and entirely disconnected from them, there is research in the neurology of "unconscious vision." The most well-publicized example of unconscious vision is the condition known as blindsight; in such cases the patients deny they can see, but when they are asked to guess about motions, orientations, and colors, they guess correctly. (Blindsight has a much less-well-known opposite called Anton's syndrome, in which patients are unaware that they are actually blind, or else forget their blindness or seem not to care about it or not to keep track of it. I am not sure which is more amazing: seeing when you're convinced you don't see, or not caring that you don't see.)[21] In neurological terms, there are several reasons why vision can be considered partly unconscious. At the optic chiasm, the place where the optic nerves meet and mingle on the midline of the brain, some retinal fibers bifurcate and connect to the hypothalamus. That implies that some information about the visual world never becomes conscious but influences such things as circadian cycles. After passing through the optic chiasm, some nerve fibers leave the main pathway and go to the mesencephalon; and nerve fibers also come from the mesencephalon and join the optic tract. That connection pertains to involuntary eye movements; it is a different *kind* of unconscious vision from the one to the hypothalamus. Blindsight is partly explained by this deviation from the optic tract. A third source of unconscious vision comes into play when visual information pass to the lateral geniculate bodies (LGB), little bulbs in the optic tract deeper in the brain than the optic chiasm. It appears that 80 percent of the input to the LGB—information that is then passed on to the visual cortex for processing—does not come from the retinas. That is an astonishing statistic: 80 percent of what eventually comprises

our conscious vision does not come from our eyes. It has been proposed that the LGB "may screen relevant from irrelevant visual information before it is sent on to visual cortex," but it is not clear how that can work, given that form, color, motion, and depth are processed in the visual cortex.[22] These three nonvisual interventions in vision—bifurcations at the optic chiasm, connections posterior to the chiasm, input to the LGB—point to three distinct senses that might be given to the concept of unconscious vision. They do not exhaust the field—of course!—and they do not yet connect to concerns of art theory or art history. Yet both are twentieth-century interests; they belong together in a wider understanding of unconscious vision.

There are two large obstacles to broadening visual studies in the direction of science. First, it is necessary to find a way to welcome science into the discourse of the humanities without introducing it or framing it as a social construction. Vision science has a great deal to say about issues that preoccupy visual culture, such as attention, memory, and the recording of perception; but it can contribute only if it is not always already historicized and treated as the most recent convention.[23] Second, science needs to be introduced into the visual studies curriculum without undue popularization. As C. P. Snow recognized in 1959, education in the humanities and the sciences is sufficiently different that each side tends to know only popularized versions of the other. I call this section the Case of the Ghost of C. P. Snow because for many people the ghost was laid a long time ago. The debates that Snow initiated seem old-fashioned and inapplicable to the current relations between art and science.[24] Yet one of Snow's refrains is still problematic: he complained that people in the humanities cannot talk to people in the sciences because they have trouble with the basics of science. To address this, we need to think seriously about far-reaching changes in the undergraduate curricu-

lum that would allow and encourage students to take the foundational courses in cognitive psychology, neurology, and physiological optics, enabling them to read the professional literature and find the kinds of links that are waiting to be found.

A university-wide center for the study of visuality or a regular series of faculty seminars can provide kind of interaction I have in mind. But there is an enormous gap between that kind of professional-level initiative and the field visual studies that I am imagining in this book. In order for a department of visual studies to attract students from the sciences and the humanities, both of these problems have to be addressed, and I see few signs that they are. (More on this in the last chapter.)

6. The Case of the Benjamin Footnote: Issues involved in Citing Benjamin, Foucault, and Warburg

In the last ten years of the twentieth century, Benjamin emerged as the patron saint of visual studies, cited for everything from historiographic method to the philosophy of dolls. At times he is an uneasy support for the new field, which goes in directions that would have surprised and dismayed him. The same can be said of several other central figures, in particular Foucault and a theorist of increasing importance in art history, Aby Warburg.

Normally the argument would be that the tone and even the intent of an original text have no definite bearing on the text's relevance for some new purpose, and ordinarily I would agree with that. But the disparity in mood and purpose becomes extreme, and nearly parodic, when Benjamin is cited in support of postmodern studies of consumer culture. In some of the new studies, late capitalism is imagined as a happy and even a giddy place and the spectacle of con-

sumerism is noted with pleasure. Benjamin thought very differently. Benjamin was not as intractable as Adorno when it came to the interest that might be accorded to popular culture, but he would never have imagined a shopping mall as an occasion for an untroubled romp among the wares of late capitalism. (This is what is so strange about the monumental *Harvard Design School Guide to Shopping*: it begins with malls, some of them ones Benjamin was the first to study, but it goes on to celebrate practically everything capitalist.)[25] He was intransigently melancholic, fixed to his work and the sadness of it, even to the point of using his interminable project—the suggestion is Stanley Cavell's—as a way of imagining reasons to remain alive.[26] How disturbed Benjamin would have been, and how he would have wanted to talk instead about levels of dream, phantasmagoria, and illusion. Although it is easy to leave aside his tone when citing individual passages, I don't think it is possible to keep the sadness at bay indefinitely.

Benjamin's work is steeped in metaphors of sleep, which supported his central concept of our slow awakening from bourgeois slumber. Sleep also meant unease, wariness, anxiety, and the continuous hope for the sudden "shock" or "flash" of insight. (Those tropes might have faded if Benjamin had lived, because he followed Adorno's advice and excised mentions of dream images from the 1939 revision of the résumé of the *Arcades* project.) As commentators have noticed, Benjamin's dream motifs owe something to surrealism and something to tropes of enlightenment in the Kabbalah.[27] They also have a psychic life his texts; Benjamin is leaden, pummeled by the new capitalism just as much as he is fascinated by it. The mood, that reservation, is entirely lacking in contemporary scholarship that takes postmodern joy in the spectacle, even while it studiously cites Benjamin. It is possible to extend Benjamin's work to include virtual reality and postmodern consumption, but it is

rarely done with the solemnity and the invasive doubts or the sudden jolts that mark Benjamin's writing.[28] As Richard Shiff observes in a very perceptive essay called "Handling Shocks": "Rather than explain the work of art as evidence of a continuity of culture and society, [Benjamin] concerned himself with a paradigmatic discontinuity, a very special case of negativity—the experience of 'shock.'"[29] Benjamin's was an alien interpretive strategy, if the search for unexpected "shocks" can even be called a strategy.

Benjamin looked for those moments of awakening in film provided by the shock of quick editing, close-ups, or the dilation and compression of time. And most famously he searched for them in the arcades, nineteenth-century Parisian glassed-in markets, where objects might suddenly press themselves on him, breaking the opaque shells that had hidden them among the familiar items of urban life. Those epiphanies certainly happen, but they are seldom a concern of contemporary writing on visual culture, and when they occur, they are not experienced as wake-up calls for the slumbering bourgeoisie.

This leads me to suggest several reasons to be wary of citing Benjamin to underwrite the interests of contemporary scholarship. His purpose was very different from ours, and his mood was wholly alien to our intransigent happiness. In addition, his leading concepts are often ambiguous or opaque and therefore not amenable to simple citation. I find the "aura" to be an extremely complex concept with a half-acknowledged religious feeling to it and an uncomfortably close relation to exactly those parts of the nineteenth century that Benjamin did not want to have back. In current writing, it seems to me that the aura is cited as a covert way of talking about transcendental value within texts that otherwise reject transcendental meaning and the nostalgia for it. Citing "The Work of Art in the Age of Mechanical Reproduction" is sometimes a way of smuggling in a

lingering nostalgia for late-Romantic concepts that would otherwise be prohibited.

Benjamin's concept of the "dialectical image" is even more fraught because it depends in part on what he conceived of as a "sudden" suspension of historical thought and in part on the possibility of reopening such thought, as Susan Buck-Morss has shown in detail.[30] In some current writing, the dialectical image serves as code for something much simpler: it denotes "crucial image," or simply "forceful image." Even Benjamin's "unconscious optics" has been appropriated for different purposes—in this case knowingly—in Rosalind Krauss's *Optical Unconscious.*[31]

None of this, I realize, amounts to an argument that visual culture should abandon Benjamin and it is not even an argument against the kind of citation that Derrida has taught us to accept—the citation that creates its own context, breaking with the original author's intent. It is an *ad hominem* argument to any scholar who feels it necessary to cite Benjamin to support her argument: I just want to draw attention to the large and growing distance between the melancholy and dissatisfied Benjamin, toiling over his obdurate concepts, and the many kinds of writing that he is taken to support.

It seems to me that this same kind of argument can be made about other frequently cited sources, such as Foucault and Warburg. Fredric Jameson has a provocative argument about Foucault's concept of visuality that is pertinent here: he places Foucault in the second of three stages of the theory of the Look, beginning with Sartre's account in *Being and Nothingness,* a move that reframes Foucault's potential relevance to visual culture. Foucault's sense of the Look or the Gaze, in Jameson's account, is the "moment of its bureaucratization." In this stage, "the sheer vulnerability to the Look and its measurements" reaches "the point at which the individual act of looking itself is no longer required."[32] Jameson makes a wonderful

parallel to Robbe-Grillet's novels, where "visual data betray only an unformulable underside which marks them as symptoms that must forever remain indeterminable." In novels such as *La Jalousie,* "it is something closer to an obsessional neurosis that declares itself, mindless compulsions not unrelated to workaholic efficiency, in which an absent subject desperately attempts to distract itself by way of sheer rote measurement." There follows the third stage of the Look or Gaze, the postmodern euphoria at technology, the "true moment of image society," where paranoia, bureaucracy and neurosis are completely erased.[33] (The third moment is the one I was just proposing as a kind of opposite to Benjaminian doubt.)

Here, I think, is the start of a trenchant critique of the ongoing interest in Foucault: the "bureaucratic eye" fits themes of helplessness, of surveillance and covert measurement, but it does not match up well with the postmodern interest in gazing, seeing, and being seen, and neither does it work well with earlier senses of the Look, from Sartre to Lacan, which are also current in visual culture.[34] Contemporary scholarship in visual culture makes use of Foucault to underwrite each of Jameson's "stages," and Foucault even enables the very concept of an era or "regime" of visuality, as in Jameson's three stages and as in the doctrine of "scopic regime" in Martin Jay and others. A narrowed sense of Foucault's "bureaucratic eye" is helpful in delimiting Foucauldian theories of panopticism and surveillance and preventing them from being used as general models of the relation between sight and power.

One last example, taken from art history (though it may well spill over into visual culture), is Aby Warburg. In the last ten years he has

Plate 23, opposite: Petri dishes. Clear plastic tubing. Fossilized sharks' teeth, including an enormous one (in the Petri dish in the center). Copper wire. A stopper with a transverse opening (top center). Serpentine wood from a Saguaro cactus (bottom right). A Barite rose (looks like an ogre's face, above the cactus). Agate. Petrified wood. Pins and labels from an insect collection. (One says, "Brotolomia iris Guenée / Vic[inity of the] airport / faded form?") Tools of a certain kind of visual literacy. How many kinds of visual competence are there? It is an interesting question for the future of the field, especially if the counting is going to be as specific as I think it can be.

been the subject of a rapidly growing number of monographs, the best of which is Georges Didi-Huberman's *L'image survivante*.[35] Among the attractions of Warburg for art history is his personal involvement in images and their philosophy, and his unconventional methodologies. He acutely felt the loss of meaning entailed in the passage of time, and he was fascinated by the ghosts and reincarnations of older meanings that have animated certain images from Ancient Greece to the Renaissance and beyond. Didi-Huberman is alert to the affective force of Warburg's interests in ways that some earlier writers, including E. H. Gombrich, were not, and *L'image survivante* is full of theories about the afterlife of images, the nature of their haunting, the question of repression, and above all Warburg's interest in what he called "pathos formulas" (*Pathosformeln*). As such, *L'image survivante* is the most thoughtful study of the historical life of images but it is confined, as Warburg's own interests were, to strongly expressive, evocative, pathos-laden images. I would want to argue the same way about Warburg's *Pathosformeln* as I have about Benjamin: the problem is not in the theory itself, which is unsurpassed, but in the increasingly wide range of uses to which it is being put.

Some of Benjamin's, Foucault's, and Warburg's ideas are inappropriate for current work, and others may be applied too widely. Still others, including Benjamin's aspiration to write history through and as images, are nearly impossible to put to use in current scholarship. Susan Buck-Morss has used sequences of pictures to create historical meaning: she did so at the end of *The Dialectics of Seeing*, and again in *Dreamworld and Catastrophe*.[36] I am not aware of any serious critiques of those efforts, but the sequence in *Dialectics of Seeing* seems to have the weakness of any series of images largely unsupported by text: it can be read in so many different ways that it tends not to attract discussion. (The same problem can beset wordless artist's books.) The images in *Dreamworld and Catastrophe* are

inserted into an extensive text but they are still susceptible to being read as signs of nostalgia for failed modernist utopias, and I think they would be read in that way if they had been printed in a photography magazine. Beyond the issues raised by Buck-Morss's experiments, there is also the fact that, as Max Pensky says, "if 'Passagen' had regarded *things* as texts, the later, more expressly Marxist-oriented *Passagenwerk* deals far more with *texts* as things."[37]

Warburg also attempted to tell history through images. His well-known final project, *Mnemosyne*—an attempt to diagram his theories using postcards tacked onto folding screens—is very different from Benjamin's but just as unrepeatable, and it has not proved to be a model for art-historical practice.[38]

I hope this is enough to give the flavor of an argument that would really have to be much longer. It is common to find names like Benjamin, Foucault, and Warburg in the first couple of footnotes in a visual-culture essay or scattered through the footnotes in a book. As a new field, visual culture has a nature propensity to search for founding texts and ideas, but theorists and critics can do themselves a disfavor by anchoring their work to those authors and ideas, especially where the directions of the new scholarship diverge from their sources. Most writing in visual studies can accomplish what it wants to without citing Benjamin's dialectical image, Foucault's panopticon, Warburg's *Pathosformeln*, Lacan's *objet petit a*, Peirce's icon-index-symbol, or Barthes's punctum. An idea does not always become clearer or stronger by being linked to such concepts.

This is not an argument against technical language, and I am certainly not proposing that new scholarship should stop trying to come to terms with the most interesting writers of the past. Without a constant dialogue with seminal authors and concepts, visual theory would risk becoming analytically shallow—and worse, it could become unmoored from its own history and start drifting into the

kind of perpetual reinvention of commonplace ideas that character-
izes so much contemporary art writing. What I intend is different in
kind: my moral is more about independence. By all means wrestle
with the most important writers in neighboring disciplines, but
when it comes time to write, consider the possibility of writing with-
out their help. Often the most profound connection to historical
objects and events, as Benjamin, Foucault, and Warburg all knew, is
the inadvertent similarity, the silent affinity, the unacknowledged
approach. Why parcel out your voice among the footnotes if what
you want to say is your own?

7. The Case of the Unclaimed Inheritance: Seeking Deeper History of the Discipline

The expression *visual culture* is usually assigned to Michael Baxandall.[39]
The genealogy that leaps from Baxandall to the present is a typical
amnesic gesture of visual studies because, as Baxandall himself would
be the first to point out, the idea of writing a history of visual practices
goes back significantly further. The *de facto* family tree of visual culture
has a trunk labeled "Foucault," or "Foucault and Benjamin," and roots
that reach down to Marx. The full genealogy goes deeper, and includ-
ing it can make visual studies more versatile and historically reflective.

The history of visual culture studies begins with fifteenth-cen-
tury antiquarian studies, which were carried out by people interested
in a whole range of the detritus of the past—clothing, urban spaces,
coins and medals and cameos, and military equipment.[40] In the sev-
enteenth century keepers of curiosity cabinets were interested in a
great variety of objects and when they collected cultural artifacts,
their purpose was not unrelated to what later became archaeology
and anthropology. Although *Wunderkammern* are well studied, what
attracts modern attention is mostly the images of the collections and

passages in Benjamin's *Arcades Project* that contain critiques, *avant la lettre,* of the discipline of visual studies itself. And after that, visual culture could strike out toward the unknown—and who knows? In a few years there might be analyses of EuroDisney based on Giambattista Vico, without a single footnote to a twentieth-century theorist.

8. THE CASE OF THE MEXICAN SOAP OPERA: VISUAL AND NONVISUAL IN FILM AND MEDIA STUDIES

Some strains of visual culture are nonvisual for philosophic reasons: the authors are interested in aesthetics or theories of reception as much as individual images. The book *Visual Culture: Explorations in the Hermeneutics of the Visible* (1999), for example, has only eight illustrations, used in two of its eleven essays.[51] *Visual Culture* (1995), edited by Chris Jenks, is similar: aside from six illustrations of Georg Baselitz's paintings, there are only five illustrations distributed among fourteen essays, and three of those are not directly discussed in the texts.[52] Both of those books are more concerned with the interpretation of vision than with particular acts of seeing, so their relative lack of engagement with particular visual objects makes some sense.

Another reason to play down visuality in visual studies is to accommodate other senses, and especially the interlinking of sight and taste, smell, touch, and hearing. Some studies also pay attention to special conditions of the senses—particular configurations of sight, hearing, or touch.[53] It can also make sense to defer talk of the visual in order to resist claims that Western culture, philosophy, or knowledge has become preeminently visual—a common approach in recent visual-studies literature, which I will take up in the next chapter.

Aside from these special purposes, there is a growing literature in and around visual culture that is nonvisual in a different way. This

Why not expand the roster of theorists we draw upon, adding Ranke and Burckhardt, Mario Praz or Hermann Broch, Waldemar Deonna or Henri Frankfort, Elias Canetti or Robert Musil, Fernando Pessoa or Ludwig Hohl, Georges Didi-Huberman or Hubert Damisch? Why not write something based on Giambattista Vico or even Giordano Bruno? (Joyce did.) Why not take your theoretical cue from Sor Juana Iñes de la Cruz instead of Luce Irigaray? Why not look at the wider, deeper roots of the study of visual culture? So many interesting theories of images are untapped in visual studies: Leibniz's concept of images as confused ideas; Hume's distinction between impressions and ideas; Lucretius's notion of emanations; Ekhart's meditations on the inner image of God; St. John of Damascus's classification of images and their relation to God—there is enough material to launch a dozen new kinds of reading.[50]

It is true that by drawing on Benjamin or Foucault, a scholar of culture will have a better chance of saying something that will be convincing to her readers; write a study of television using Vico, and your text is likely to be significantly less persuasive. On the other hand, it might just be the case that Vico has worked through issues that concern current work more than Benjamin or Foucault, making it more coherent and useful to try to write starting from Vico.

Visual studies relies on a relatively small number of theorists. Susan Buck-Morss's list is as good as any: Barthes, Benjamin, Foucault, Lacan . . . and many others, perhaps beginning with Jean Baudrillard and Paul Virilio, and always including the specter of Marx. A number of theories circulate in visual studies, but the method that does the most interpretive work is typically a very conservative kind of iconography derived from Panofsky. To make the discipline as resourceful as it can be, the list needs to be expanded in several directions. Noncanonical texts by those same writers can to be brought to the table; for example, Barthes's strange book on Jules Michelet, or

Under the influence of Ranke, nineteenth-century historians such as Burckhardt began studying the sum total of the products of past cultures. Burckhardt's evocations of Renaissance Florence, for example, are intensely visual even though they are not illustrated; he even described aspects of private life, an interest that is usually ascribed to twentieth-century historians and anthropologists—including such things as "burial customs and ways of eating," men's hose, cosmetics, upholstery, perfume, and jewelry.[46] Burckhardt has been considered a father of cultural studies, but his legacy is contested and ambiguous. In 1893 he proclaimed that art history, as opposed to cultural history, should be concerned with "tasks" (*Aufgaben*), but exactly what he intended by that has been widely discussed, and it is not clear whether it makes sense to name him as a direct progenitor of visual culture.[47]

In the twentieth century, historical studies of visual practices were carried forward by historians such as Mario Praz, who wrote a wide-ranging history of interior decoration and a wonderfully detailed account of his own apartment in Rome, room by room and object by object.[48] Early twentieth-century collectors and art historians studied all kinds of "minor" arts—coins and medals, heraldry and arms, icons and escutcheons, geological and anatomical illustrations, genealogical and eschatological charts, microscopical and botanical drawings; and miscellaneous images from the chirurgic to the "hippological." Erwin Panofsky knew much of that literature, though it is neglected on account of its narrow or uninteresting interpretations.[49] In my experience, *fin-de-siècle* writers concerned with such subjects as eighteenth-century garden design or late Roman medallions were just as uninterested in fine art and just as fascinated by the conditions of production and reception as are recent scholars of visual culture. It is important not to overestimate the novelty of new work or assume too quickly that connoisseurship was a one-dimensional activity.

the few surviving objects. A more thorough history of visual culture studies would also take into account detailed work that has been done on the collectors' own ideas of the objects and cultures they collected.[41] The collectors' writings—some of them now translated, but most still in Latin—are studied for the light they shed on the origins of modern museums and the residual sense of wonder that artists such as David Wilson (of the Museum of Jurassic Technology) seek to recover, but they can be read more broadly for modern concepts of culture, artifact, art, and visuality.[42]

The nineteenth-century historian Leopold von Ranke is an ambiguous figure for visual studies because he was interested in visual aspects of culture (along with other mainly literary and historical elements) and he also underwrites the value historians place on archival sources and positive facts. The importance of archives is another feature of visual studies that is associated with Benjamin, on account of his years of work in the Bibliothèque Nationale in Paris, but as Benjamin himself was aware, that impetus had its roots in early nineteenth-century German historiography. The difficulty for visual culture is that Ranke took his discoveries in the archives to be absolute facts.[43] The current critique of that positivist position—that what appear as facts have to be interpreted, that facts themselves occur as part of a discourse of veracity—was anticipated and furthered by Benjamin in an observation that is not often taken to heart in contemporary visual studies: he called the notion that facts showed things "as they really were" "the strongest narcotic of the [nineteenth] century."[44] Facts are still a narcotic, although in accord with the logic of addiction, our version of the drug is stronger; now the narcotic is that, with the proper acknowledgment of the various investments we have in archives and a certain sense of history, the facts can be imported into metanarratives, where they then continue to function, as Benjamin would say, as soporifics.[45]

literature, much of which is centered in media and film studies, is concerned with spectatorship, gender, the Gaze, and narrative, and less so with visual incident, the look of a scene, its details and light, the rhythms of edits or pans, the precise disposition of a look or a gesture. As a result a number of books on film and television are printed without plates or with minimal black-and-white illustrations. At conferences it is common to have speakers show clips from films just to remind the audience of a scene rather than to demonstrate overlooked features. From an art-historical standpoint, it can seem that opportunities for close analysis are missed and, even more, that the principal quality of film—its visuality, its difference from the screenplay—is elided.

A wide variety of texts share this particular kind of nonvisuality. Gilles Deleuze's influential books on cinema have only a few illustrations because his central interest is the representation of time.[54] Kaja Silverman's books have few illustrations partly on account of her interest in the phenomenology of perception, which is necessarily poorly represented in printed black-and-white stills.[55] Laura Mulvey's work is also often unillustrated, in part because she is interested in abstract questions of the gendered gaze.[56] Adorno's writing on film and television is wholly unillustrated and lacks even cursory descriptions of scenes or individual shots. Some recent writing on television, such as David Morley's, moves deliberately away from the visual and investigates the social functions of television, the physical presence of the television in the home, and the background sounds emitted by unwatched televisions. No discussion of the television image itself is necessary in such scholarship, except to report on the fraction of time an average viewer actually looks at the screen.[57] Sociologically oriented writing, such as Douglas Gomery's, Stephen Ross's, and Robert Rosenstone's, can occasionally do without the evocation of individual scenes at all.[58]

It is difficult to put this question fairly. It is true that if the subject is the male Gaze, or the construction of women as particular kinds of objects whose significance is their *"to-be-looked-at-ness,"* then the particular look of a given scene will not be immediately relevant.[59] Or, in regard to Silverman's work, if the purpose is to excavate the philosophic foundations of visibility in Heidegger, Lacan, Arendt, and Bataille, then individual images will have limited use. And when the subject is the public presentation and reception of films, as it is in Gomery's work, then it would not be relevant to spend time (or at least, more time than the public spent) making detailed analyses. In addition it is always true that the single frame reproduced in a book cannot capture what is salient about the moving image—a restriction that has to be negotiated differently in each context.

What concerns me is not the arguments of writers such as Deleuze, Silverman, or Mulvey, but the implication of the aggregate of such texts that the account film theory has been building is theoretically adequate to its subject—that it responds to what is filmic in film, to what constitutes film as a visual medium.[60] Adorno's essay "How to Look at Television" might be more accurately titled "How to Think about the Effects of Looking at Television," which is twice removed from looking: first there is looking, followed by the effects of looking, and lastly thinking about the effects of looking. Adorno is primarily interested in the way television creates viewers, and for that purpose photographs of television shows would be irrelevant. But does the fact that all looking is ideologically determined preclude an interest in the particulars of the experience?

This is not a matter of returning to or developing a formalist criticism. Formalist and cognitive film critics such as David Bordwell or the iconoclastic Noël Carroll are often associated with polemics against structuralist disinterest in the visual qualities of film, but their own work has its own strengths and limitations and is not a

model for any visually oriented criticism.[61] Nor am I especially interested in returning to "classical film theory," with its concern for the "materiality" of film, not least because it was involved in the specific project of elevating film to a fine art.[62]

It's also true that plenty of recent work is strongly visual and also very far from formalism. Among many examples, I will mention Pablo Helguera's project on the worldwide dissemination of Mexican soap operas from the 1970s, especially *Los Ricos También Lloran* (*The Rich Also Cry*, or in Russian, *Bogaty Tozhe Plachut*).[63] When the series was broadcast on Russian television beginning in 1992, it attracted more viewers than any other television program in history. Helguera's project, called the Instituto de la Telenovela, based in Ljubljana, Slovenia, is part visual studies, part artwork, and part sociology.[64] It stays close to the appearance of the series. Something about *Los Ricos También Lloran* appealed tremendously to Russian audiences: perhaps the odd version of Mexican society (lots of hairstyling, everything a bit too clean) made it into a weird *Doppelganger* for Russian experience—who knows? Helguera's work shows that there is no intrinsic connection between formalism and attention to visual detail and it helps sharpen the question of the absence of visual interest in some media theory.

This is one of those questions best treated either quickly or at great length. What I want to do here is point to a problem in some current media and film criticism: the work is about visual objects, but the writing makes it seem as if what's being written about could just as well be novels, scripts, or screenplays. (A good test question is: What does the film-studies text describe that is not in the screenplay or the storyboard?) The issue is large and diverse; it may even be connected to the disciplinary roots of film and media studies departments, because in the United States they are as likely to be outgrowths of English or comparative literature as of art history.

9. The Case of the New Guinea Bird-watcher: Can Visual Studies Be Truly Multicultural?

In 1998, I proposed a session at the College Art Association, asking for papers about books of art history that have been published outside the West. The call for papers suggested that speakers report on art-history textbooks written in India, China, or southeast Asia. My notion was to look at the Westernness of the core narratives of art history by comparing them with histories written outside the West. The call yielded only three proposals, and two were not non-Western: one person wanted to report on the use of a Western textbook in Chinese schools, and another was a proposal to talk about art-history texts written in the early twentieth century in Poland. The organizers of that year's conference suggested I might buttonhole some people to fill the panel, but I decided to cancel it instead. In the flood of papers on multiculturalism and postcolonial theory, which accounted for perhaps fifty papers at that year's session, it appeared that very few people—perhaps just the one who applied to my panel—had been reading non-Western books on art history. To me the dearth of interest signaled the discipline's limited interest in reading outside the West as opposed to its burgeoning interest in speaking *from* the West to, and about, non-Western art.

With every passing year, visual studies is expanding its non-Western and postcolonial interests, adding studies on subjects once entirely neglected or known only to anthropologists. The increasing range of subjects is a legitimate gauge of multicultural interest, but visual studies has the opportunity to become more profoundly and radically multicultural.

The new work applies Western methodology to non-Western material, creating texts in accord with Western norms of scholarly practice. A more radical practice is imaginable that would be open to

the use of both non-Western methodology and non-Western narrative forms. Such work would cross cultural lines that are rarely crossed. This doesn't mean that a truly multicultural approach entails a mixture of languages or cultures, or some philosophic approach to Otherness such as some writers have proposed.[65] I intend something much more down-to-earth and measurable. A typical multicultural text in visual studies is still dependent on the familiar Western methodologies: psychoanalysis, Marxism, Benjaminian cultural critique, Foucauldian archaeology and disciplinary critique, anthropological theories of liminality, and postcolonial theories inspired by writers such as Edward Said or Homi Bhabha. Those, as opposed to methodologies taken from native texts. A typical visual-studies text also subscribes to Western scholarship, by which I mean, also in an everyday sense, that the text will follow Western protocols of art historical narrative, description, research, footnotes, and argument. The subject matter of such a text will be non-Western, and the writer may also be concerned with colonialism or postcolonialism, but the methodology and the writing will be Western.

This may sound both obvious and unavoidable, and yet, if the aim is to be increasingly vigilant about colonialism, Westernness, and multiculturalism, then how can it *not* be an ideal to write texts that employ Western and non-Western methodologies alternately or in concert, and texts whose sense of scholarly apparatus, narrative forms, and organization might be alternately Western or non-Western? I have argued elsewhere that an essay that takes this advice too much to heart, using non-Western methodologies and writing in non-Western ways, would risk not being taken *as* history at all (perhaps it would appear as experiment, or reverie, or even as a non-Western document of some sort), but that is not an argument against trying to produce such texts.[66]

This implies three criteria for a truly multicultural practice of visual studies. First, it should include substantial numbers of scholars interested in objects other than Western ones: that is increasingly the case, even though non-Western subjects are still in a tiny minority. A consistently multicultural practice should also be open to texts that cross two more lines, becoming non-Western not only in subject matter but in the theories that serve as models and in the form of the writing itself. To that list of three criteria I will also add a fourth: a multicultural practice of the kind I am imagining should be willing to depart from the commonest of all interpretive methods, the search for complexity and hybridity.

Let me float a large, somewhat nebulous proposal: that the majority of essays in the humanities have as their primary methodological orientation an interest in complexity and ambiguity. A plurality of texts describe cultural locations, practices, identities, and objects as hybrid, mixed, impure, marginal, dislocated, disoriented, Creole, Pidgin, transcultural, liminal, meta-, para-, quasi-, or otherwise complex and ambiguous.[67] The pleasure of the text is produced by the very focus on hybridity, mixture, and other kinds of irreducible complexity as much as by whatever other insights are gained into the cultural locations, practices, and so forth, that are the texts' nominal subjects.

To the extent that this is generally true, the commonest rhetorical strategy in recent scholarship is to demonstrate a state of unexpected complexity or a pitch of ambiguity that cannot be reduced to simpler schemata. In the realm of politics, cultural studies, and visual culture, the interest in complexity and ambiguity focuses on hybridity. Multiculturalism and postcolonial theory work in an intentionally indefinable middle ground between known concepts and therefore also, in theory, an indefinable middle ground between cultures. (As in the title of Homi Bhabha's 1994 book, *The Location of Culture*.) The current generation of scholars produces papers that

As many writers have pointed out, multiculturalism and post-colonial theory are still firmly rooted in the West. We have not yet "decolonized our methodologies," in the common phase, and the work that is being produced is not "transcultural" except in its subject matter.[75] Current writing in postcolonial studies is perhaps one quarter multicultural; it is often multicultural in its subject matter, but seldom in its principal strategy of searching for hybridity, or in its preferred theoretical models including psychoanalysis, or in the forms of the essays, monographs, and conferences. A stronger multiculturalism is waiting to be implemented, and in this context I would add that there is no reason it cannot begin with the study of images, which are associated with many kinds of unfamiliar conceptual and interpretive regimes that could help question our attraction to hybridity and our imprisonment in the "age of psychoanalysis." Outside the West there are many possibilities for genuinely different interpretive practices: Indian philosophies of visuality, Japanese senses of place and time, Chavin architectural spaces, gender in the pictographic elements of hieroglyphs, identity theory in Indus Valley tokens—there is literally no end to the possibilities. Here are two brief examples.

1. Ken-ichi Sasaki has written a provocative account of words for "seeing" in Japanese. He notes that the verb *miru* (to see) shares a root with the noun *me* (eye), and he proposes the amalgamated expression *seeing/eye* to capture that very non-Western concept. This compound verb and noun is entirely active, searching out objects in the world rather than receiving light. (Sasaki hypothesizes that the Japanese "did not have the slightest notion of *seeing/eye* as a receptive process before being taught the Western theory of perception.")[76] Amazingly, the same verb *miru* means "to have sexual relations with someone"—how different even from the archaic English Biblical euphemism "to know someone." For ordinary seeing, Japanese use

the verb *au*, but for active seeing, such as a doctor examining a patient, they use *miru*. Sasaki concludes that the "intense experience" of *seeing/eye* "fuses the subject with a distant object": in sex, in medical examinations, and in some cases of extraordinarily forceful looking.[77] What a wonderful starting place for an investigation of Japanese images! I can imagine studies of *ukiyo-e* prints, which are full of looks that could be interpreted in terms of Sasaki's *seeing/eye*; or studies of illustrations of the *Tale of Genji* such as the early twelfth century *Genji monogatari emaki*, where lovers, servants, and spies look at one another and at poetry in screened-off rooms.[78]

2. Diana Losche has done interesting work in describing words for birds in Abelam, a culture in the Sepik Province in New Guinea. She starts from the proposition that the Abelam concept "bird-ness" is incommensurate with Western concepts. The usual solutions to that dilemma are either to sharpen the definitions, using Western words more systematically or carefully (the philological solution), or to adopt Abelam words as undefined terms, placing them within an English-language text (a philosophical solution). Nor does she follow the excellent—sometimes astonishing—work of Steven Feld, who has worked on words for birds and their songs in the Kakuli culture, also in New Guinea. (Feld opts for a combination of what I am calling the philological and philosophical solutions, and he also produces CDs and poetic evocations of the songs he studies.)[79] Losche decides instead to "cast the postmodern condition in the shadow of Abelam metaphysics," producing a paper that is conceptually if not linguistically in Abelam.[80] Losche's methodological ambitions range even more widely in other essays where she attempts different configurations, writing from the perspective of anthropology in one and from the standpoint of art theory in another.[81] Needless to say these experiments cannot succeed in changing cultures and disciplinary languages entirely; what matters is that Losche is willing to try.[82]

Visual studies will be stronger and more self-consistently multicultural if it follows suit.

10. The Case of the Writing Itself: The Challenge of Writing Ambitiously

What can I say on this last subject that has not been said before by every writer to herself, or deliberately left unsaid by every academic who thinks of writing as an effect of politics, or repressed by every historian who wants to imagine that writing is the transparent vehicle of truth? Nothing new, except that it is seldom a good idea to try *not* to think about what ambitious writing means in your field. Ambition, for lack of an easier and more manageable word, is essential to a visual studies that is committed to being less easy.

A first step in writing ambitiously is to know the entire field, or as much as you can manage. If you are writing on color in the eighteenth century, why not try to be the best writer on that subject? (To read, in addition to Jacqueline Lichtenstein and John Gage, also Jean Starobinski and even David Batchelor.) My only advice to students who are just starting to frame their own interests is: read absolutely everything. In context of this chapter, that would especially include older sources for visual theory, non-Western texts, and scientific texts.

A second step is to think about the literature and respond thoughtfully, not just by citing important sources in footnotes. There are art historians—Leo Steinberg, Michael Fried, and Barbara Stafford among them—who are widely admired and often cited but very seldom argued with or truly engaged. No one has looked longer or better at the *Last Supper* or Michelangelo's Pauline frescoes than Steinberg, but little of the subsequent literature engages his insights. Fried's work on absorption and theatricality is known throughout the

United States and Western Europe, but new accounts of the principal artists he discusses, from David to Courbet, Manet to Pollock, continue to relegate his work to footnotes. Stafford's work on eighteenth-century visuality could easily be taken as a foundation for visual studies, but it has seldom been developed in more than a haphazard fashion. Do your sources the favor of a concerted encounter. Compare your thoughts to everyone's.

A third step is to write as well as you can. When it comes time to write an article or a book, think concertedly about the kind of writing you hope to produce. Make it as richly reflective, economical, and clear as you can, and write as well as you can—poetically, with the right word in every sentence. Observe and cut the common clichés. Don't "resist the hegemony" or "refuse the binary opposition" or "launch a critique" or "deploy an argument." Some writers overdo their prose, staining it with exotic locutions (for example, William Gass), and others spend so long on their sentences that they end up hard as carbon steel (as Leo Steinberg's sometimes do)—but there is no penalty for paying attention to writing itself, and often there is a reward: what you write will be read more widely.

I will close with an example to indicate how undertheorized the problem of good writing has become. In my experience, a surprisingly wide range of people who study art history and visual culture name John Berger as an important inspiration. I have been told so by scholars who specialize in such different fields as performance art, the semiotics of Cubism, and the history of design. Berger seems to have become a touchstone for social art history and visual culture to a degree that social art historians such as Frederick Antal or Arnold Hauser never did.

What makes this strange is that no art historian or specialist in visual culture writes anything like Berger. Art historians don't inter-

rupt their prose with poetry (an old tradition, with roots that go back past Montaigne to Renaissance humanists and Greek philosophers) and they don't permit themselves long parenthetic remarks or personal reminiscences. Nor do they write entire essays based on counterfactual hypotheses (as Berger did about a painting Frans Hals never made) or put their historical thoughts into the form of dialogues or short stories. But why not, when those signs of the engaged writer are part and parcel of the philosophy of the engaged viewer that Berger himself helped bring into art history? Why don't the many people who have taken inspiration from Berger's *Ways of Seeing* and *About Looking* also take on board any of the kinds of writing that he practices?

I can think of two answers, both somewhat depressing. Most of us do not think of ourselves as poets and novelists and therefore we excuse ourselves from experimentation; and most of us have, at one time, wanted tenure, and tenure requires propriety. Here is how I would put the question that I think remains when these two inadequate answers are disposed of: Given that academic social art history and visual culture have found Berger's message about the politics and gender of seeing so fruitful, what kind of elaboration of his position has allowed contemporary scholars to avoid Berger's conviction that the writer's voice is never irrelevant, that gender and politics *require* the writer to involve the writing?

A few people working on visual studies do take the writer's voice seriously—so few that I can count them on one hand: the sometimes brilliantly incoherent Jean-Louis Schefer, the ecstatic and unpredictable Joanna Frueh, the fragmentary and confessional Hélène Cixous, and of course, the slightly paranoid, inconsistent, and often inspiring Dave Hickey.[83] (That's paranoid about what academics think, inconsistent about his desire to ignore them, and inspiring for people trying to.) Writers like these do not form a set—although, by

coincidence, Hickey and Frueh teach in the two largest cities in Nevada—and that testifies to the rarity and difficulty of genuinely experimental writing. Most art historians and visual theorists interested in the writing and the writer's voice keep their experiments narrow and safe, so that academic work is well separated from poetry, reverie, and fiction. A fair number of historians have experimented in that fashion, segregating proper historical writing from experimental efforts; for example, Rosalind Krauss (for example, in the italicized passages in *The Optical Unconscious*) and Griselda Pollock.[84] It is part of the same syndrome that few people in visual studies keep up with Berger's recent nonfiction, such as *The Shape of a Pocket*—it's as if he had just one message to give, which he delivered in the 1960s.[85] (The situation is the same with Claude Lévi-Strauss: relatively few people read his book on vision and visuality, *Look, Listen, Read*, which includes a meditation on Poussin.)[86]

That is all that I think is worth saying about writing ambitiously. If you are a student or a scholar, writing is what you do. It can only make sense to do it absolutely as well as you are able.

What Is Visual Literacy?

THE EXPRESSION *visual literacy* was never uncommon in the twentieth century, but it was used mainly to refer to minimal standards of high school and college education. It was an obscure cousin of ordinary literacy, based on the notion that pictures have syntax and grammar in the same way writing does. In the 1970s visual literacy was associated with Rudolf Arnheim, and with theories of pictorial composition and color that were invented at the beginning of the twentieth century and carried forward in elementary and high school art instruction.[1] A few programs, such as one at the University of Nebraska at Lincoln, named their freshman programs "Visual Literacy" without direct connection to those precedents.[2] Searches of databases such as JSTOR (a valuable source for early twentieth-century usage, often used by linguists) and LexisNexis (an index of newspapers) also turn up references like this one: according to a reporter for the *Vancouver Sun,* Prince William's course in art history at the University of St. Andrews in Scotland—the choice was cause for a great deal of media speculation in 2001—has "the end objective of achieving 'visual literacy.'" The quotation came from an official

125

university source, and just as clearly a faculty member would not want to be quoted saying such a thing.[3]

In this chapter, I want to consider visual literacy very differently. If visual culture is going in the direction of the expanded and problematized field I have been describing, then visuality and kinds of visual competence will become increasingly important in university curricula. As it stands now, the closest that most universities have to an introductory, freshman-level course on visual culture are the "Introduction to Visuality" and "Art Appreciation" courses that are taught in art and art history departments. Such courses are intended either as elementary preparations for the study of art history or art practice, or else as surveys of art for students going on to study in other fields. Methodologically they are on a par with Robert March's *Physics for Poets* or courses with titles like "Intuitive Chemistry"— those meant to introduce the main themes of some science to students who may never take another course in the subject.[4] An expanded visual studies requires another kind of introductory course, one that provides a foundation for future work in a number of vision-related disciplines.

Some freshman-level classes do attempt more than the standard "Introduction to Visuality" or "Art Appreciation" courses. In art schools such as the one where I work, students begin at a higher level and instruction includes, *de facto*, some of the concerns common to graduate-level classes. In a few universities, including the University of Chicago, innovative visual culture courses have entirely replaced the old art appreciation classes. The best of those courses treat visuality at a high level, preparing students to think about vision more reflectively than they had before, by introducing the psychoanalytic, phenomenological, and political dimensions of seeing. The courses are designed with different purposes in mind, but in my experience they are aimed at a generalizable set of approaches to

images that can serve students in a wide range of disciplines. Thus they concentrate on the social construction of vision, the relation between seeing and saying, the lack of natural images and the necessity of interpretation, and the involvement of the viewer in what is seen. Even so, they only prepare students for further work in one or two disciplines, typically art history and studio art. They leave science and technology majors with general observations about society and sight that do not, as far as I have seen, have a purchase on what those students go on to study.

Therefore the challenge is to imagine an introductory course that will prepare a student for a major not only in art history but in visual anthropology, physics, cognitive science, or engineering. Whatever shape such a course might take, it will require a discussion about specific visual competencies and particular sets of visual knowledge; it will not be enough to fortify science students with a sense of the social construction of vision or the history of ideas of seeing. Those messages, I think, are easily swamped and forgotten in the deluge of facts and utilitarian exercises that the science students encounter later in their education. It is necessary to think much more specifically and consider exactly which interpretive skills and what kinds of images can serve as a useful common ground for an education in images. That is why I think that questions of pedagogy and visual studies lead directly to questions of visual literacy.

I have taken the freshman introduction as an example, but visual literacy will be crucial throughout a university that gives serious attention to visuality. Beyond the problem of the freshman course, it will be necessary to ask what visual competence an undergraduate student should possess and what visual competencies might be taught to graduate students in different departments of the university. At the professional level, it will be interesting to discover what ends up counting as visual literacy in an interdisciplinary con-

gregation of people engaged with images in different ways. Visual literacy is the unavoidable—indeed, natural—name for what will be at stake at each of those levels.

WAYS OF ASKING ABOUT VISUAL LITERACY

And yet the first thing that needs to be said about visual literacy is that it can't possibly mean anything. If it did mean something, then we would be able to read images, to parse them like writing, to read them aloud, to decode them and translate them. I hope that we all hope that images are not language, and pictures are not writing. Visual studies has a lot invested in the notion that the visual world and the verbal world really are different, even beyond the many arguments that persuasively demonstrate that we think we read images all the time.

An improved version of the question: What is visual literacy? might be: What sense of images impels us to think that the expression *visual literacy* is adequate or truthful? Or it might be put this way: When you ignore the fact that it doesn't make sense to say that someone is visually literate, what sense does the expression *visual literacy* still have?

There are good answers to the first version of the question (What sense of images impels us to think that the expression *visual literacy* is adequate or truthful?). Theorizing on the subject, from Charles Peirce onward, is crucial to a reflective sense of what images are taken to be in various fields. The second way of putting the question (When you ignore the fact that it doesn't make sense to say that someone is visually literate, what sense does the expression *visual literacy* still have?) is less often discussed but just as interesting, because it leads visual theory into the classroom, forcing a consideration of visuality to become a discussion what kinds of visuality are

or should be taught. It is close to Barbara Stafford's interests in *Good Looking,* a broadly based inquiry into the ways that history and philosophy can contribute to a working visual culture across disciplines.[5] For the purposes of this book I will divide the problem into three parts: historical questions (What is the history of visual literacy? How do modernism and postmodernism compare with past periods?), philosophic questions (What does *literacy* mean when it is applied to images?), and practical questions (What can be taught in graduate and undergraduate courses, and what can be put into textbooks?).

IS OUR CULTURE THE MOST VISUALLY LITERATE EVER?

There is a large body of writing on the current state of visual literacy, although much of it is in the form of passing references and undeveloped assumptions. The passages imply at least four different approaches.

1. There is a claim, often repeated, that this is the most visually literate period in history. We see more images per month or per year, so the argument goes, than people in past; and we can also process more images per minute. We see more images per month or year because we watch TV, go to movies, and read magazines; and we see more images per minute because we watch MTV and VH1, or play video games like Xbox or PlayStation 2.[6]

This position could find some support in work by Jonathan Crary about the fleeting, fragmentary nature of modern attention. The origins of our capacity to see many images in quick succession and our dislike of seeing one image for a protracted period would then be located in nineteenth-century modes of seeing, paintings, popular diversions, and the experience of the *flâneur* (the type of

wandering urban spectator, invented by Baudelaire, brought to scholars' attention by Benjamin, and subjected to gender critique by Janet Wolff).[7] The claim that ours is the most visually literate period is also commensurate with the notion of "scopic regimes," because the early twenty-first century could then be identified with a hypertrophied extension of the regime Martin Jay calls "Cartesian perspectivalism," capable of assimilating unprecedented amounts of information. Alternately, the current capacity for the visual could also be assigned to the "Baroque" mode of seeing, with its disturbances and complexity.[8] (Logically speaking, the culture that invented the concept of the scopic regime would also be the most aware of modes of visuality, if not the most visually literate.)[9]

Another version of the claim of superior visual literacy proceeds from a dichotomy between visual and verbal: "Western philosophy and science now use a pictorial, rather than textual, model of the world, marking a significant challenge to the notion of the world as a written text." That is a proposition made in the opening pages of Nicholas Mirzoeff's *Visual Studies Reader*.[10] It follows as a corollary that "forms of visual experience . . . are coming to seem a central concern in contemporary thought." (It does not follow, as Brian Goldfarb has pointed out, that "visuality is now of more importance" than in the past. That argument would be aimed differently, at the very least because the values of commodities are numerical and textual, rather than visual.)[11]

Increasingly, a version of this claim is used as an opening move in books on visual culture. Klaus Sachs-Hombach and Klaus Rehkämper open their book on the philosophy of pictures with the claim that "we live in a visual age: an age of pictures. Pictures represent information, mediate it, make it comprehensible."[12] The most systematic version of the claim is David Chaney's. First, he says, new media have made "the role of pictures in the discourses of everyday

life" more important; second, there has been "a paradigm shift" from figural to discursive thought; third, the rise of tourism has expanded the importance of "a characteristic gaze" of consumerism and appropriation; fourth, there have been shifts in "modes of embodiment" leading to the "experiencing of other senses via the activity of looking"; and fifth, there has been a "greatly increased awareness of the constitutive significance of gender."[13] There are many example of this version of the claim. Lisa Cartwright and Marita Sturken open their textbook *Practices of Looking* with the claim that "over the past two centuries, Western culture has come to be dominated by visual rather than oral or textual media."[14] Baudrillard and Barthes have said similar things in different contexts.

(In the rush to accept the idea that our culture is the most visual, some authors have been misread. Mitchell's catchphrases, such as "the pictorial turn" and "picture theory," have gained wide currency, and when they appear out of context they can seem to stand for the idea that we are a mainly pictorial society, which is not exactly what Mitchell actually claims. He says, for example, that spectatorship "may be as deep a problem" as reading, and that "'visual literacy' might not be fully explicable in the model of textuality.")[15]

This first way of thinking about visual literacy would have it that we are living in a deeply, increasingly, and perhaps principally visual culture. Images inundate us—simulacra of simulacra, some truthful and others not, some still tenuously linked to everyday life and others wildly divergent from it.[16] We can recognize last year's style in a half-second fragment of an MTV video, dissect subcultural signifiers in advertisements we glimpse on passing buses, and decode the veiled national styles in the carpet designs of international airport waiting lounges: we are, in short, more adept at the visual than any preceding culture.

Against this approach are at least three others.

2. A competing claim has it that the twentieth century was a pro-foundly nonvisual century which developed some of its key concepts without direct recourse to visuality. This argument is found mainly in Martin Jay's book *Downcast Eyes,* which surveys French struc-turalist and poststructuralist writers for their ideas about vision and visuality.

It is difficult to disagree with Jay's survey, given the terms in which he sets it out. It is trickier to go on and claim that Heidegger, Lacan, Derrida, and even Merleau-Ponty are in some fundamental sense non- or even antivisual, although I think there are moments in which such claims can make sense.[17] Consider, for example, the attention that has been lavished on the brief passages in which Lacan discusses vision.[18] Although he often returned to his description of the mirror stage, the majority of his texts are not concerned with visuality, and it can be argued that the mirror stage itself is more fun-damentally allied with the critique of Cartesian subjectivity than with the specific ocular experience—the *imago,* as Lacan calls it. I even think it is possible to construct an argument that Merleau-Ponty was nonvisual; it is not at all irrelevant that his books are mostly not illus-trated and that his descriptions of visual experiences tend to be emblematic, abstract, and general, in the way that Heidegger's are. The essential counterexample to the claim that Heidegger "shows a disturbing inattention to visuality," so the well-known Van Gogh painting he mentions in the *Origin of the Work of Art* "is not *looked* at or interrogated in its visuality," is the colloquium published as *Listening to Heidegger and Hisamatsu* (1963).[19] Yet even that forum kept to very generalized questions of originary emptiness and the appearance of form. Heidegger was engaged with Japanese art and the concept of abstraction, but not in a direction or in a language that often led him to comment on particular works. Most of the time, and

taken on its own terms, Jay's account is correct: as far as philosophy was concerned, the very twentieth-century French phenomenological and poststructural thinking that underwrites much of literary theory and theoretically minded art history was itself consistently nonvisual.

"Postocular theory," as it has been called, is a larger phenomenon encompassing "attempts to move beyond the dominant visual metaphors and schemas of intelligibility informing Western epistemology and towards a richer, dialogical-conversational conception of experience and knowledge."[20] Such a project would include Richard Rorty's critique of mirror metaphors in Western philosophy and various literary theorists and language philosophers from Wittgenstein to Mikhail Bakhtin. From that wider perspective, antiocularism would be in some degree a necessary project working against the ocular metaphors that have driven Western metaphysics and capitalism. There is no single initiative that can be called "antiocularism," but the writing is driven by a sense that it's necessary to respond to an existing ocularism—which brings this second theory close to the first.

3. From another perspective, it can be argued that even though we do possess something like a Baudrillardian virtuosity in comprehending a rapid succession of images (as the first theory proposes), we lack the kind of literacy that would allow us to comprehend slower and more complex images, making us nonvisual in a particular sense. The disciplines of visual communications and graphic design—at least in their more practical, commercial forms—are directed at the efficient communication of information. The "infographics" in *Time, Newsweek,* and *Scientific American* are meant to be seen, "read," and "digested" as quickly as possible, leaving as little as possible to puzzle or ponder.[21] Some people who study infographics are also attracted to premodern graphics, but mainly because they

provide opportunities to package more dimensions of data into eas-
ily decompressed formats.[22] Our newly acquired proficiency at read-
ing or "decoding" such images does not compensate for the erosion
of our ability to understand the more individual and sometimes
obdurate creations of past centuries. This argument is partly Barbara
Stafford's.[23] As she points out, premodern graphics were normally
not amenable to quick reading, and it took time to see them: often
enough they were encrusted with nonverbal residue that could not
be dissolved into simple messages or meanings. An example among
many is Heinrich Khunrath's early seventeenth-century mystical and
alchemical treatises (Plate 25).[24] Here the idea is not so much to
"read" or "decode" the image as it is to ponder and return repeatedly,
without hoping to ever understand once and for all. This is a repre-
sentation of the *laboratorium:* in the traditional gloss, the workplace
(*labor*) and the place of prayer (*ora*). An alchemist or the kind of
adventurous hermetically minded Christian whom Khunrath imag-
ines would study a picture like this for months or years, extracting
ideas and associations from it that might enrich the alchemical work.

Such images have largely vanished from mass media and con-
temporary visual culture and they are rare even in the fine arts, pro-
ducing generations of viewers who are like speed-readers trained to
read the grammatically simple sentences of business briefs. That
does not mean I agree with George Dimock's idea that "art history is
a reminder of a different habit or mode of seeing, a mode of con-
sciousness" that was patient and more leisurely than any we can
afford today.[25] That assumes too much about the relation between
leisure classes and modes of seeing (weren't aristocrats impatient?),
and between patient looking and speed (intensive visual investiga-
tions can also take time). Stafford's position, which I find especially
persuasive when visual literacy is linked to the graphics of *Time* or
Newsweek, is midway between the first and second theories I have out-

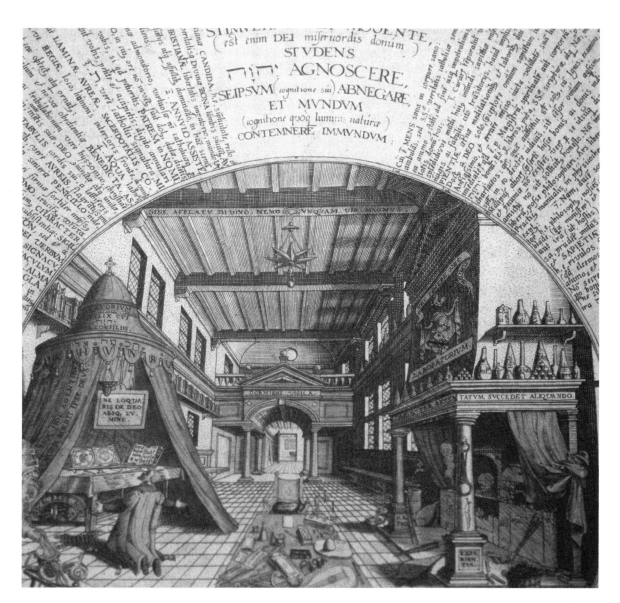

Plate 25

lined here: our culture does possess an exhilarating visual literacy, she might say, but it is a new literacy and it forgets some of its own past.

4. Finally, it has also been argued that the very concepts of visual literacy and visual culture are passé. Laura Marks has put this best: "the period of visual culture is over," she says, so "it is ironic that all these programs in visual studies are starting up, just at the point where information culture, which is invisible," is becoming the dominant mode.[26] This kind of argument depends on the idea that information (by which is meant, minimally, the things that banks and large companies know about your identity, financial status, and product preferences) is eclipsing visuality. If that is so, it is not yet reflected in cultural or visual studies. I am aware of some research in art history that seeks to displace visual analyses by economic data and in particular the microeconomics of the exchange of images. So far, at least, there has been no such work in visual studies.[27] Claims of "information culture" are common but their relation to visuality is not yet well studied.

The four approaches might easily be renumbered, and the first could readily be subdivided into differing justifications that support similar conclusions. Several of the writers I have mentioned have taken more than one of these positions. I take that as a sign that the terms of the discussion are just too general to have much purchase. The third theory, which stresses the *particular* visual competencies that obtain at the moment, seems the most promising, but given the right context, I might be persuaded by each of these theories.

WHAT IS MEANT BY LITERACY

Another reason it is difficult to make much headway with theories of this sort is that they run up against undefined senses of visual literacy. Philosophically, it is not immediately clear what capacity might

be construed as literacy when it comes to visual materials. It has been argued that recognizing an image *as* an image constitutes a kind of literacy. Beyond that there are stages of interpretation leading toward the understanding of pictorial content, significance, and use.[28] Visual literacy could be construed as an adequate capacity to identify images and to parse them according to the ways they refer to the world. I will not be following that definition here, because it tends to be disconnected from the particulars of historical and cultural practice—it is theorized as a question of semiotics, cognitive psychology, and the philosophy of representation.

Visual literacy has also been identified with the capacity to remember images. In cognitive psychology, it has been claimed that the ability to comprehend images is linked to memory itself, so that images "tell us what to remember."[29] The concerns of experimental psychology can be translated into those of visual studies by making the acts of memory more historically and culturally specific. In that case, visual literacy would be comprised of specific acts of recognition and remembrance. The problem, pedagogically, is to know how accurate and rich such recollections should be. Is it enough to recognize a given image in the same way I may recognize an allusion to a book I haven't read? Is it enough to know one or two things about an image in the same way I might be able to say a few things if the subject turned to Dante's *Paradiso*, which I haven't read since college?

(A word before I go further about the literary critic E. D. Hirsch, who has produced several lists of the things every adult American should know in order to be minimally culturally literate. In his list, which represents an extreme version of the identification of literacy with list-making, terms that need to be known about but not known in detail are printed with asterisks next to them: for example "electron" is starred because it is important, so Hirsch would say, to know what an electron is, but not necessary to know anything more about

it.[30] In Hirsch's way of thinking, if you are standing next to the coffee machine and your boss comes up and says, "Aren't electrons amazing?" then you need to know what he is talking about at least enough to hold up your end of the conversation. For that purpose you don't need to know very much about electrons. It might be enough to know they are subatomic particles and therefore invisible; that they have a negative charge; and that they orbit around the nucleus of the atom. Asterisked knowledge, as I will call it, is an important part of theories of cultural literacy, because students cannot be expected to know very much about very many things. Since the publication of his book, Hirsch has become involved in educational initiatives aimed at different levels—what every fourth-grader should know, what every third-grader should know, and so forth.[31] Those projects are motivated by a concern for the students' eventual standard of living as much as they are motivated by an interest in general cultural literacy. The conversation about electrons is not likely to make you or your boss more interested in electrons, but it might eventually lead to your not being fired. I want to put some distance between the subject of this chapter and Hirsch's project; even though no list of minimal literacy can be free of politics, I am uninterested in the economic uses to which conversations about visuality might be put.)

It may seem that these first definitions evade what is most important because they identify visual literacy with knowledge rather than modes of interpretation. Another way of looking at the problem would have it that visual literacy, if it is to have critical purchase, has to denote a kind of toolbox of interpretations. In that case, recognition or familiarity with specific images would be called something other than visual literacy—although I am not sure what. In visual culture, especially, the assumption is that visual literacy has principally or even exclusively to do with interpretation. John Walker con-

cedes that "improving students' visual literacy and increasing their knowledge of visual culture serves a vocational/instrumental role in respect of trainee architects, artists, designers, film-makers and so on," but that what really matters is that visual culture studies offers "a critical understanding" of the social functions and effects of visual practices, including "an opportunity to reflect on the complicity of visual culture in oppression and exploitation, its relation to power and its role in human conflicts."[32] In Walker's text, the phrase "visual literacy" hardly gets a look-in because it is merely "vocational/instrumental," in contrast to the more important work of interpretation.

Writers on visual studies often begin by emphasizing that images are constructed, not natural, and that images imply and construct viewers in turn. Addressing visual literacy would therefore entail revealing the ideology and "techniques of the observer" (to borrow Jonathan Crary's phrase) that give images their power. Often, I find, visual literacy is equated with the ability to deduce the "operator," as Barthes calls the agent or collective that produces a given image: to find the "intentions which establish and animate" the operator's sense of image-making, by engineering understanding in "reverse," from the spectator's standpoint. For example, a student in visual studies might learn how to see that his or her own identity has been constructed through repeated encounters with advertisements.

Given the inclination in visual culture to identify visual literacy with interpretation and to defer questions of literacy that might lead to list-making or even—to mention the forbidden term—canon formation, it is useful to bear in mind that lists and their interpretation are inextricable.[33] I cannot imagine a sense of visual literacy that is entirely focused on methodologies, ideologies, and interpretive strategies, if only because such a course of study would necessarily also entail familiarity with a certain specific, if changeable, set of images. Sometimes visual literacy means a commonly shared list of

images rather than a set of methodologies (that happens, for example, in freshman art history courses); but even there, methodologies and ideological purposes are emergent from the material itself. In other cases, such as graduate seminars, visual literacy has more to do with interpretation than knowledge, because what matters is how the visual objects are put to work in different contexts; but even there, a common vocabulary of images provides a nascent list, and those students unfamiliar with it can be left out.

With that I want to turn to the practical problems that I think are so important and so often deferred in favor of general or abstract issues. What images and image-making practices, specifically, should an ideal undergraduate student encounter? What images, exactly, should a visually literate undergraduate student be able to understand? What kinds of interpretation and understanding might constitute visual literacy at those different levels? The remainder of this chapter is an extremely informal, though hopefully not ill-formed, tour of eight competencies that I think are worth considering.

1. ART HISTORY AS A KIND OF VISUAL LITERACY

It is possible for visual culture to study art history the way that art history studies past visual practices. Despite the good intentions of a number of recent authors, the large world-art survey texts end up implying that visual literacy is largely the ability to recognize artworks and engage in some minimal interpretation. For the most part, the freshman survey courses produce students able to make the kind of starred identification Hirsch proposes; that is, a minimal identification of artist and approximate date. That kind of knowledge does not provide a basic understanding of the discipline of art history, because it is too unlike what happens later in the undergraduate or graduate curriculum. (I have been using the expression *visual*

competence in this chapter for variety, alternating it with *visual literacy*; but if there is a place it belongs, it is here, where a nearly purely utilitarian competence is one of the declared aims of the freshman survey.)

It is not clear to me that such an education provides even the rudimentary ability to distinguish among the works of important artists. The painting in Plate 26, for example, is one I have shown to students to test their engagement with objects. It is a forgery, one of several hundred from an auction catalogue comprised entirely of forgeries. (The jaunty signature, among other things, is a clue. Mondrian signed in a variable but finicky hand.) A beginning undergraduate education in art history makes it possible to tell a Van Gogh from an overt parody or pastiche such as Matthias Waske's *Van Gogh with Japanese Eye$* (Plate 27), but it does not provide much help with concepts of kitsch or camp, which are needed to understand the difference between this painting and the original.[34]

At a higher level, art history, like other disciplines in the humanities, is a conflict of methodologies. Graduate art history students learn how to distinguish a good text on Van Gogh (Plate 28) from a more marginal one (Plate 29), from texts that are entirely dubious (Plate 30). *Lust for Life* is easiest to exclude from serious consideration because it is driven by Stone's attraction to melodramatic life stories. He says on the last page that most things in the book are true except for "the Maya scene," which reads, in part: "The longer he talked, the more excited he became. Words flew out of his mouth like pigments from his tubes. . . . 'Kiss me, Vincent,' she said."[35] Nagera's book *Vincent Van Gogh: A Psychological Study* is more difficult to place: psychoanalysis remains a central method in art history, but the kind of psychoanalytic argument feels outdated and naïve. Zemel's book is the easiest to place within art-historical interests because it is *Rezeptionsgeschichte*—an account of the conditions of Van Gogh's

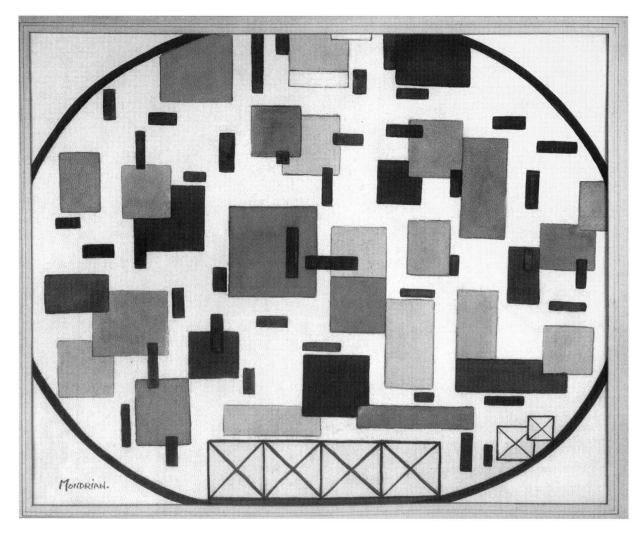

Plate 26

Plate 27

VAN GOGH'S PROGRESS

Utopia, Modernity, and Late-Nineteenth-Century Art

CAROL ZEMEL

UNIVERSITY OF CALIFORNIA PRESS

Berkeley *Los Angeles* *London*

Plate 28

VINCENT VAN GOGH

A Psychological Study

HUMBERTO NAGERA M.D.

FOREWORD BY ANNA FREUD

INTERNATIONAL UNIVERSITIES PRESS, INC.
NEW YORK

Plate 29

C·10

35¢

LUST FOR LIFE

a novel based on

the life of VINCENT VAN GOGH

Self
Portrait

VINCENT
VAN GOGH

A
CARDINAL
EDITION

BY IRVING STONE

Plate 30

fame that relies on primary, contemporaneous sources. Notice, how-
ever, that the criteria for such choices are largely verbal because they
depend as much on the conflict of methodologies and on the config-
urations of bibliographies as they do on the firsthand experience of
the works of art.

The argument here, like the one I was sketching about film and
media studies, is not easy to make. I want to point to a tendency
within art history, which is neither untypical nor conservative,
toward an education in visuality that begins with surveys of many
objects and progresses into a preeminently text-oriented education.
This trajectory has the specificity of a discipline, which is appropri-
ate for professional-level work in art history. It can be of just as much
interest for visual studies as the visual competencies of any other dis-
ciplines. At an appropriate level—say, a graduate methodology sem-
inar—art history could be reintroduced in seminars of visual studies
as a historical practice and a disciplinary regime along with the many
other less familiar disciplines within the university. (It may seem to
readers in art history that I have slighted the discipline here, but con-
sider that the scientific disciplines I mention in this book are just as
condensed. Every field has its particular competence, which it some-
times takes as a general orientation, applicable to all image-making
practices.)

2. NON-WESTERN VISUAL COMPETENCIES

Non-Western cultures are drastically understudied even within art
history, where they remain a minority interest. An expanded visual
studies needs to approach this problem differently, building
extended engagements with non-Western visual cultures into its set
of critical practices. In the previous chapter, I suggested some
methodological problems raised by scholarship on non-Western

visual practices; here I will just name some specific non-Western examples that should, I think, be included at a foundational level in the curriculum.

Some of the more complex non-Western practices, such as Aboriginal painting, are studied by art critics and art historians but known in their full complexity only by anthropologists. Despite the growing literature on Aboriginal painting, no art historian has yet come to terms with the complexity of meanings the paintings had for their makers. As Howard Morphy and other anthropologists have shown, Aboriginal paintings are dense with meanings, and the visual literacy they demanded has yet to be included in the visual competencies of art history. The astonishingly intricate meanings of Aboriginal paintings are effectively veiled: first because the painters themselves are sometimes counseled not to tell the art dealers more than is necessary; then because the dealers are uninterested in anything more than the kinds of abbreviated titles that would make the paintings viable on an international market; and most insidiously by the interpretive interests of art history itself, which do not always extend to the kind of recitation of specific topographies and myths that the paintings demand.[36] I will not illustrate an example here, because the outward look of the paintings is very familiar, and reproducing one without a full exegesis would do it the usual injustice.

The same could be said of Mayan visual practices, which are studied within art history but remain a specialized interest, unknown to the discipline as a whole. Within Mayan studies, a tremendous amount remains to be done to understand how a Mayan viewer would make his or her way through a complex image made of mingled words (glyphs) and images. Most viewers, presumably, would have only had a vague notion of the writing, although some larger number would have been able to recite dates and names. But among the few literate Mayans, how would complex images have

Plate 31

leaf

Water-Lily Jaguar growling

personification head

rear head personified blood

blood scroll

front head

blood signs

diadem

ax

God C

Vision Serpent

personified blood

Chac-Xib-Chac

been parsed (plate 31)? Some Mayan objects are astonishingly complex, and art historians can only guess at how they might have been seen. In this Classic period tripod plate, a figure identified as Chac-Xib-Chac stands waist deep in water (see the key, bottom right). His left hand has been amputated, and in his right he holds an axe. The stalk issuing from his severed wrist is "personified blood"—notice the grinning face—and the blood is also identified by a glyph for blood (facing Chac-Xib-Chac, where the stream from his wrist turns upward), and a "blood scroll" (beneath the face of personified blood). More blood sprouts from his head. One stream has a jaguar and an unidentified head, and there are more personified blood heads, blood scrolls, and blood signs. The entire central scene is just part of a complete Mayan cosmology, with heavenly and "underwaterworld" figures. The meaning is fixed by three sets of glyphs. Three glyphs just right of Chac-Xib-Chac's headdress name him; an L-shaped set of glyphs to the right presumably gives an historical meaning (they are partly cropped in this detail), and a longer L-shaped sequence of glyphs toward the top of the bowl gives the astrological significance of the scene (though much of it is also undeciphered).[37] Even aside from the unidentified deities and historical references, this image is outlandishly intricate. Who knows why the blood branches just the way it does? Who knows when blood would be read, and when it would be seen? Would readers—or viewers—look along the blood scrolls in any particular order?

At Cacaxtla, a late Mayan site, the glyphs are no longer legible as writing—presumably the knowledge had been lost in wars—but they still function differently from the images. In Plate 32 there is a wonderful sign at the upper left shaped like an architectural plan, set with three suns, each with an eye, and ornamented with two hands and an eyed wing. It may be the name of a god or a ruler. The figure himself is a man-jaguar, and he stands on a serpent-jaguar, which

Plate 32

the Mayans associated with the full moon.[38] Beyond that, no one knows. Exactly because they raise so many questions, examples like these should be part of the repertoire of images available for comparison in discussions of the legibility of monuments, the place of ruins, and the architectural memory of cities.

Among many other non-Western possibilities, let us not forget the history of visual competence in China. From the Tang dynasty to the present, China has had the longest unbroken tradition of painting in the world. Before the twentieth century, Chinese painters formed more schools, named more styles, and were written about by more critics and historians than their counterparts in the West. And yet how many Westerners can recognize this artist (Plate 33)? He is as famous and important in the Chinese tradition as Michelangelo or Picasso are in the West. (What would you say to a student who failed to recognize the Sistine Ceiling, or *Guernica*?) Behind that basic fact of nonrecognition spreads an enormous literature, richer in names and books, places and problems, than the West. What future form of visual studies can afford to take such an astonishing tradition as one discourse among many?

3. UNRECOVERABLE VISUAL LITERACIES

Visual studies is in a position to contribute to a fundamental critique of art history. There is an entire field waiting to be opened that would study past modes of seeing rather than conclusions that can be drawn given the current ways of interpreting images. I will illustrate this idea, which I think is largely inaccessible from within disciplinary art history, with an example from David Hockney's book *Secret Knowledge*.[39]

It has been noted that in Caravaggio's *Supper at Emmaus*, St. Peter's right hand, the one thrust back beyond the table, looks

Plate 33

Peter's left hand in focus

Christ

table

image

Peter

1m

1m

$d_i = 2m$

$d_s = 2m$

mirror
$f = 1m$

Peter's right hand in focus

image

Christ

table

Peter

1m

1m

$d_i = 1.90m$

$d_s = 2.11m$

mirror
$f = 1m$

Plate 34

slightly too large (Plate 34, top). Hockney thinks the disparity might be due to the fact that the painting was made with the aid of an optical projection, which had to be refocused midway through the painting process. Hockney's book was the subject of a conference in the autumn of 2001 at New York University; at the conference a scientist named David Stork discussed some detailed calculations he had made which imply that if Caravaggio had used an optical device, it would have bumped into the table (Plate 34, bottom).[40]

To some art historians at the conference, the debate between Stork and Hockney seemed outlandish because it was weirdly narrow (they were arguing about the hands of one figure and ignoring the painting's larger cultural context). It sounded strange to hear Stork say that St. Peter's right hand is 1.1 times the size of his left. Yet art historians commonly look at details like those. For me the conference and discussions brought out a curious fact: from Caravaggio's time to the mid-twentieth century, no one seemed to notice those hands, whether they spoke about them loosely, as art historians had done, or precisely, as Hockney and Stork proposed to do. No one had looked at Caravaggio's painting in that way, with that eye for detail, that analytic eye that measures as much as it looks. Hockney's hypertrophied attention to details had brought out the strangeness of a characteristically modern kind of seeing. It may be that viewers from Caravaggio's generation to the mid-twentieth century did notice those hands, but if so then it would need to be explained why not one observer mentioned them.

The same question can be asked of Manet's elaborate games with mirror reflections in the *Bar at the Folies-Bergère*. The position of the mirror implies that the reflection of the bar girl should be just behind her. It isn't, and in addition, the off-center reflection reveals the person to whom she must be speaking, who is paradoxically in our own place. The various explanations for this have taxed art his-

torians for over twenty years: and yet they were virtually unnoticed in Manet's generation.[41] How is it that Manet and his contemporaries were relatively unbothered by the "illogical" reflection?

Once, when Titian was away from Venice, his friend Pietro Aretino wrote to him, saying he would have enjoyed the beautiful "reds, oranges, yellows, and pinks" of a Venetian sunset.[42] That is almost the only mention of the specific colors of Titian's paintings, which seem so much more finely observed. There are contemporaneous accounts of colors in Sannazzaro and Ariosto, but there are almost no other passages on colors in paintings. Titian's contemporaries did not mention his astonishing colors. How, then, did they experience the paintings? Did they even notice the colors? Could Aretino not think that his clunky description would be an insult to the painter, since it is clear evidence he did not appreciate what Titian was trying to do?

Contemporary art-historical seeing, despite its historical awareness, is anachronistic in the name of what is taken to be incipient meaning. The assumption is that the things current researchers find in paintings are integral to the works, no matter how subtle and seldom noted, and therefore require interpretation. When I say that this problem is inaccessible for art history, I mean that paintings like the *Supper at Emmaus* and the *Bar at the Folies-Bergère* exist for art history as the sum of many interpretations, the majority of which are anachronistic in the sense I am proposing. Visual studies might be able to pose the problem effectively and find ways to think past it. What exactly did seventeenth-century viewers see in the *Supper at Emmaus?* Can the history of viewing be reconstructed in such a way that it would not surprise those viewers? (At least not more than the art historians at Hockney's conference were surprised to hear such exact measurements of St. Peter's hands?)

Plate 37

Astronomy also has its common images, recognizable to the broad community of astrophysicists (Plate 38). This is a gravitational lens, where a distant galaxy has been refracted around a nearer group of galaxies. Its image is split into five parts, labeled A through E, like a light seen through the bottom of a bottle. The astrophysicists reconstruct the distant object by measuring the distortions of the images and end up with three possibilities (Plate 38, bottom). It is a galaxy with a "disturbed" morphology, typical of very distant— and therefore very young—galaxies. The authors note that the forty-five galaxies of the nearer cluster, together with unseen dark matter associated with them, comprise an extremely complicated lens, and that the Hubble Space Telescope, which took the image, adds another set of lenses, making the whole into a "compound microscope."[47] Most astronomers would not be familiar with this exact image or even know the mathematics behind the reconstruction of the distant source, but a broad community of people interested in space would recognize the gravitational lens and know the significance of "disturbed" galaxies.

Diagrams of particles and waves play an important part in physics, and their general forms would be widely recognized (Plate 39). In this image, a strong set of standing waves at the left encounter an energy barrier, represented by the raised level of the "flooring" (note the dashed lines, which rise in the middle portion of the image). In classical physics, the barrier would be too high for the waves to cross, but in accord with the quantum-mechanical law of tunneling, the waves go *through* the barrier and emerge on the right. What is represented here is the wave equation for a particle; in ordinary terms, the particle might be an electron and the barrier a transistor. Sociologists and philosophers of science have studied the history and interpretations of such images, so their history as well as their physics is part of the science community.[48]

Plate 38

Tunnel Effect, Stationary States

Plate 39

The Mandelbrot set is another common image known to mathematicians and physical scientists in various fields (Plate 40). It offers many interesting points to visual studies; for instance, the images are often printed in garish 1960s-style colors, even though the mathematics does not call for color at all—the colors are reflections of the programmers' ideas about art and beauty. (I think they are sometimes inspired by tie-dye T-shirts and psychedelic colors.) The Mandelbrot set is also part of the history of visualization, in that its equation is simple, but the sheer amount of computation necessary to reveal it ensured that it was unknown *as an image* until the 1908s. The hairy, bulbous Mandelbrot set itself became an icon of science in the last twenty years of the twentieth century. (The Mandelbrot set is studded with little copies of itself. In this detail, one is partly visible at the lower right; three more of various sizes are attached to invisible filaments. The set as a whole, if this image were zoomed out, would be a near-replica of the little black blobs.)[49]

166

Plate 40

Biological images that demand competence include the now-famous map of the Y-chromosome and the molecular models of DNA, but it would also be possible to ask a certain recognition level of straightforward images in biology. What is Plate 41, for example? In natural history, visual competence can be largely a matter of being able to place what you are looking at in the appropriate taxon and knowing what features to look for in order to pursue a more accurate identification. Birds, mosses, fish, bacteria—the whole of natural history depends on a kind of competence that involves both memorization and the ability to spot distinctive features. (This is one of the rarest fish in the world, the deep-sea oarfish. It has red roosterlike tassels on its head.)

In meteorology there is also a large component of identification tempered by experience. Everyone knows tornadoes and hurricanes, but not many people know about sun dogs (parhelia), halos, and other unusual kinds of weather phenomena. The photograph in Plate 42 captures the left-hand arc of a rainbow and also the slightly less common double bow (just visible at the upper left.) The bow that rises almost vertically is something different. A person conversant with images of weather phenomena would be able to deduce that it is a reflection of the primary rainbow.[50] Such a person would possess a particular set of visual competencies that is not common in the humanities but very useful for interpreting the natural world and images of it.

Materials science is another field with particular visual literacy (Plate 43). Most of us know very little about the materials that comprise ordinary household objects: How is the metal of a toaster made? What is in the glass of a car windshield? Or the glass of an oven window? How are the fake-wood patterns of a plastic cabinet made? Or the chips in a computer? These are laser-engraved stainless steel tags. I chose them because they are ubiquitous and nearly

Plate 41

Plate 42

NATIONAL BAND & TAG COMPANY
○ 304 Stainless Steel Etched
USA (606) 261-2035

T-14

LELAND
Gas Technologies Since 1965

Sales, Parts, & Service
800.984.9793
www.lelandltd.com

"Our family serving
Yours since 1965."

My mom's can't miss recipe:
1 pint heavy cream, a few drops
vanilla extract, 2 tbs pwd sugar.
Charge up & Serve!

44MA00

REACH FT IN

B-CVR-05-511
B-TCV-05-511-01

PYC-P-95-ED2
C.02
541-E-CR01N-2

American Cold Storage System Inc.
Cincinnati, Ohio

DOOR C-

513-891-9955

006106422

Plate 43

unnoticed. How are they made? Who makes them? How many different kinds are there? Here is what the company's Web site says they make:

> Adjustable Tags, Advertising Specialty Tags, Aluminum Bands, Anti-Pix Devices, Beak Guards, Bicycle License Tags, Bird Bands, Bird Bits, Bird Blinders, Bit-Fitter, Book Binding, C-Less Blinders, Cable Markers, Cage Tags, Cage Tags, Cannibalism Control, Cat Tags, Cat License Tags, Cat Rabies Tags, Cattle Tags, Conservation Tags, Ostrich Bands, Crab Trap Tags, Disconnect Seals, Dog & Cat Tags, Dog Tags, Dog License Tags, Dog Rabies Tags, Ear Punch, Ear Tags, Electrical Markers, Electrical Markers, Emu Bands, Fish Tags, Garden Markers, Garden Stakes, Gill Net Tags, Hog Rings, Hog Tags, Horse Saddle Tags, Industrial Tags, Inventory Tags, Key Chain Tags, Leg Bands, Livestock Tags, Locker Tags, Locking Seal Tags, Locking Seals, Metal Tags, Motor Leads, Pelt Tags, Pipe Leads, Pipe Tags, Plant Labels, Plastic Bangles, Plastic Ear Tags, Plastic Wing Bands, Plate Tags, Plumbing Tags, Pool Passes, Poultry Bands, Poultry Peepers, Poultry Wing Bands, Poultry, Rabies Tags, Rabies Vaccination Tags, Rhea Bands, Self-Piercing Ear Tags, Self-Piercing Tags, Self-Piercing Bands, Sheep Tags, Sign Hanging Spirals, Slot Tags, Small Animal Ear Tags, Small Animal Leg Bands, Spiral Bands, Survey Markers/Tags, Survey Marking Tags, Swimming Pool Tags, Swine Tags, Swivel-Lok Blinders, Terminal Tags, Toe Punch, Tongue & Slot Tags, Tool Check Tags, Tree Tags, Tree Tags, Truck Seals, Truck Seals, Turkey Tags, Turtle Tags, Valve Tags, Variable Size Tags, Vehicle License Tags, Wing Badges, Wing Bands, Wing Tags, Wire Grouping Tags, Wire Harness Banding, Wire Markers, Wired Tags, Wrap Around Tags, Write-On Tags, Write-on Tags.[51]

That is a nice laundry list of unstudied objects. ("Cannibalism Control?") I would not argue that visual literacy should encompass all the

high-tech substances that surround us in everyday life, but materials science is a mine of interesting visual skills. If you could tell the translucent plastic of a designer extension cord from the transparent plastic of an aquarium-style purse, who knows what else you might see differently.

Plate 44 shows a scientific example closer to the humanities. It is common in art history to ask undergraduates to learn a little about realistic images and the history of realism. If there is a canonical image in this regard, it is Masaccio's *Trinity,* the first fairly accurate perspective picture. But it would not seem reasonable to ask students to know how it was made (Plate 45), or to study the books that Renaissance artists read and wrote on the subject (Plate 46).

What exactly is visual competence in this case? Recognizing a perspectival picture? Knowing how it created meaning or served the Church or the state? That would certainly be enough for most under-graduate students, but then it would be necessary to admit that none of the math is actually learned; the single most important confluence of science and art in the West would be given only through its picto-rial result and not by the natural science that made it possible. In effect, "perspective" would be starred: students would be required to know of it, but not to know about it. What is sad about this situation is that many of the students in a freshman-level course, a typical set-ting in which the *Trinity* is first shown, are science majors and may know more science than the instructor. Such students should be *learning science* in the visual studies classroom, and they should be learning much more than just perspective.

(A last note about science. I suspect that for many readers, this book will seem unduly slanted toward science and non-art images. But contemporary culture is slanted that way. I am not proposing a new technophilia, simply a new inclusiveness. Images cross bound-aries that humanists do not.)

Plate 44

Plate 45

hoc
KG
ipfi
am
ion
qui
cto
pa-
pa-
en-
que
fe-
em
F;
ne
ter
in
ip-
s,
a-
X
in
in
fe

re in L, E quidem in M, & C in O? At ve-
BF æquidiftans, ducatur OP ipfi BF paralle-
fectione, vbi apparet CG. ex quibus fequitur fi-

Plate 46

6. SPECIAL EFFECTS AND DIGITAL IMAGES

Whenever there is a new high-budget blockbuster film, TV shows such as *Entertainment Tonight* and *Access Hollywood* run a standard kind of promotional spot which is supposed to unveil the secrets behind the movie. In recent years I have seen such spots for *Titanic, Jurassic Park I, II,* and *III,* and *A.I.*

The spot begins with a clip from the movie and then goes to a wireframe (Plate 47, bottom). That is about all the explanation that is given, and for people who do not already know how the effects are done, it amounts to saying that digital images are built the same way papier-mâché masks are built on chicken-wire frames. Somehow, the computer builds the wireframe into the image of a dinosaur or of Michelangelo's *David* (Plate 47, middle).

Visual literacy in this case would include a knowledge of what lies behind that kind of explanation. Students who can claim basic visual literacy in relation to digital images know the commercial image-editing tools, beginning with Photoshop and going on to Avid and other video software packages. Such students also know the language of image processing: wrapping, bump maps, texture maps, kernels, histograms, convolution, and clipping windows.[52] That literacy is easily shared with people who are not specialists in computer imaging. The example in plate 47 is from the Digital Michelangelo Project, an initiative begun at Stanford University to capture a 3–D digital file of the *David* in the highest possible resolution. The computer scientists studied the theoretical limits of laser technology (when the subject is marble, the resolution cannot be improved past a certain point), and they were interested in the possibility of reconstructing sculptures that are accidentally or deliberately destroyed.[53] Their work has political and historical as well as technical interest,

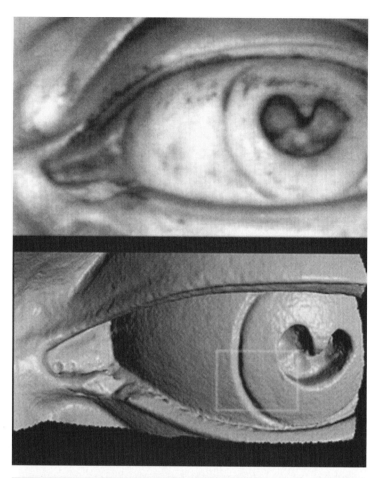

Plate 47, top and middle

Plate 47, bottom

and it goes hand in hand with the kinds of technology that go into movies like *Jurassic Park*. All of it is information that could be part of the *lingua franca* of contemporary visual studies.

I mention the technical side of digital imagery because a number of programs in visual studies concentrate on digital media and the Internet but leave the details of production aside. Departments such as the one I teach in offer many opportunities to discuss the meaning of digital images, cyberspace, and the Internet, but they do not require competence in any particular programs or assume that knowledge in their teaching. Digital images are a good example of my fourth point, because the community of consumers often overlaps with the community of makers. Unfortunately that is not always the case, and visual studies is in just as much danger of becoming alienated from the details of computer hardware and software as art history is in danger of forgetting the meanings that emerge from making. Especially in the twenty-first century, a visual studies undergraduate curriculum should include a year-long required course in the basics of Photoshop or another photo-editing program, a Web-design program, and Avid or another video-editing program. A working knowledge of such programs is essential for the development of a common critical language in assessing digital images. Beyond those programs are many others that are more specialized but still important: NIH Image, Exbem, FITS, MRI software—those are the equivalent of graduate texts. Each could usefully be taken as a text for a year-long course, just as Foucault or Benjamin are. It has always been tempting in the humanities to keep to the higher ground of interpretation and leave technological details alone. But as the last thirty years of research into photography shows, criticism and art history are hugely enriched by attention to the gritty technological details.

7. GRAPHICS AND DESIGN

Perhaps it is not necessary to add a section here on graphics and design, because to some extent those fields are already part of visual culture. There is excellent new scholarship on the subject, such as Maud Lavin's *Clean New World,* which questions the usual ways of distinguishing design, art, and commercialism and shows how political actions have been effected by women designers.[54] My only contribution here is to underline the importance of looking entirely beyond fine art *and* capitalism to understand design.

An example is the diagram of the London Underground, first designed by Harry Beck in 1931. Beck's diagram has been widely praised as a modernist icon and it has influenced any number of diagrams of train and bus routes throughout the world. Basically, it distorts the distances between stops in the name of greater clarity (enlarging Central London and squeezing the suburbs around it) and it avoids all lines except verticals, horizontals, and forty-five-degree diagonals (Plate 48, top). Ken Garland's very entertaining book *Mr Beck's Underground Map* goes point by point through Beck's refinements and the tribulations of his later career, when he was sidelined and nearly forgotten.[55] The diagram has been taken as a modernist icon, and Garland mentions Mondrian by way of expressing his surprise at the public acceptance of the diagram in 1933; "it might have been expected," he writes, "that the advent of such an abstract, schematized image would generate a response similar to one's first sight of a Mondrian painting: respectful, awed, intrigued, maybe mystified, but surely, never *affectionate*? Yet it was so."[56] Yet as Garland knows, there is no evidence Beck was interested in Mondrian or modernism. The origins of the Underground map also lie in two fields very much ignored in the study of modernism: topology and electrical schematics. An intuitively worked topology

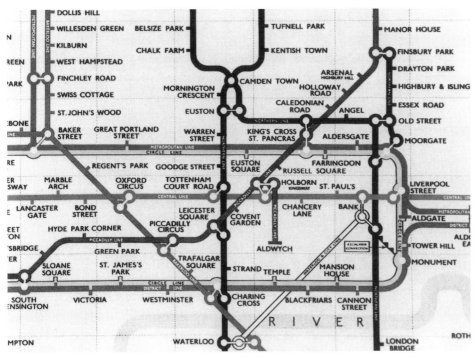

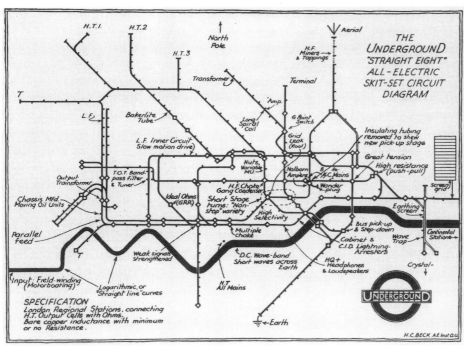

Plate 48

was at issue when Beck had to represent very complex three-dimensional intertwining of tunnels, for example the Camden Town/Mornington Crescent/Euston complex, which is like a problem in knot theory. The influence of electrical schematics is in evidence in Beck's own work. He even made a spoof of his own underground map, labeling the stops as if the underground was a wiring diagram (Plate 48, bottom). No one, including Garland, has yet studied the influence of mathematical diagrams or electric circuit design on the London Underground map; all three comprise parts of the intersection of modernism and design. In Europe and Latin America, graphics and design are often affiliated with semiotics; in North America and Western Europe, they tend to be more integrated into social issues (as in Lavin's work). The full Venn diagram of adjacent fields would have to include specific skills—not least of them the drawing of Venn diagrams themselves, as they are lucidly set out by their inventor, John Venn (Plate 49).[57]

Design also includes a wonderful array of images from all corners of visual life. Here is an example I came across by chance, when I was lost in the library at Champaign-Urbana (the world's third-largest academic library, behind Harvard and Yale). They are from an old issue of the *Transactions of the Cave Research Group of Great Britain,* and they show different ways to represent caves. Plate 50, upper left, imagines a cave as an architectural structure, with air shafts, stairways, and corridors, as in an apartment building. At the upper right is a comparison of two ways of representing a three-dimensional labyrinth: one more realistic, and the other schematic but hard to read. At the bottom is a naturalistic map with added symbols. Notice the round-bellied stick figure at the bottom center: he is x'd out to indicate a tight spot that fat people cannot squeeze by. In the cave passage at the lower right are three skinnier stick figures. One has a wavy line at his ankles, the second at his waist, and the

being an aid to the eye. What is required is that we should
be able to identify any assigned compartment in a moment.
Thus it is instantly seen that the compartment marked with
an asterisk above is that called $\overline{x}yzw$. The simplest diagram
I can suggest for five terms is one like this, (the small ellipse
in the centre is to be regarded as a portion of the *outside* of
z; i.e. its four component portions are inside y and w but are
no part of z).

It must be admitted that such a diagram is not quite
so simple to draw as one might wish it to be; but then
consider what the alternative is if one undertakes to deal
with five terms and all their combinations;—nothing short of
the disagreeable task of writing out, or in some way putting
before us, all the 32 combinations involved. As compared
with *that* the actual drawing of such a figure as this is surely
an amusement, besides being far more expeditious; for with
a little practice any of the diagrams we have thus offered
might be sketched in but a minute fraction of the time
required to write down all the letter-compounds. I can only
say for myself that having worked hundreds of examples, I
generally resort to diagrams of this description, in order to
save time, to avoid unpleasant drudgery, and to make sure
against mistake and oversight. The way in which this last
advantage is secured will be better seen presently, when we

Plate 49

Figure 4.
Pictorial and diagrammatic presentations of a complex cave system.

Plate 50

WHITE GROTTO

third over his head. They indicate rising water levels. There is no end to the reach of design-related issues and no way to cordon design from other subjects in visual studies.

8. A WIDER RANGE OF ARCHITECTURAL SPACES

I have not said much in this book about architecture and urban spaces, because those subjects tend to be taught in separate departments. Yet a more wide-ranging visual studies would want to also look at the ways visuality is imagined in interior architecture, landscape architecture, and the history and criticism of urban design. The field has a large literature, much of which is relevant for visual studies, beginning with Henri Lefebvre's study of metaphorical spaces and going on to contemporary surveys such as Spiro Kostof's.[58] Visual studies already includes an interesting cross section of urban design, including some wonderfully eccentric studies of the paths that commercial airlines take through the air as they travel and a specialized literature on "micronations," tiny regions throughout the world that have been declared independent countries.[59] The *Harvard Design School Guide to Shopping* is also a good starting place for student work; it includes sections on the history of escalators, waiting rooms, and pedestrian passages in malls.[60]

Given this variety, it is difficult to think of any one study or group of studies that would be reasonable to recommend. I will just note the fact that—once again—non-Western sources have a tremendous amount to offer. There is, for example, the astonishing town of Sravana Belgola in the Hassan District of Karnataka, India. The town is a Jaina pilgrimage center, and for almost fifteen hundred years pious Jaina have been going there to practice the custom of voluntary renunciation of life; essentially, they slowly starve themselves and wait to die. Plate 51 shows a wandering monk on a visit to the Small Hill, a stone

185

Plate 51

outcrop where mendicants go to die. Some have their places of death commemorated by a pair of footprints carved into the rock (Plate 52). Others, with more means, have inscriptions carved, monuments and statues erected, and even buildings constructed in their memory. Today the village has the largest number of Jaina temples in any one place, the most commemorative monuments (called *nisidhis*), and two gently sloping rock hills entirely covered with inscriptions, monuments, sacred stones, carved steps, and intaglio footprints.[61] It is an incredibly rich assemblage of architecture, sculpture, writing, and interior and exterior spaces: in short, one of the most complex funerary monuments in the world. It makes an interesting comparison with the more restricted spaces and architectural forms of the catacombs in Rome or Paris, or the large European cemeteries.[62]

It might be salutary to begin a study of urban spaces with an unsurpassably complex object like Sravana Belgola rather than the usual rehearsal of canonical examples—the Athenian agora, Haussmann's Paris, or the Cathedral and Baptistery in Florence. And it might be interesting to require a unit on, say, the history of elevators or the invisible paths of airplanes in the sky, just to hint at the depth of material that is studied in urban planning and architecture.

REMARKS ON THE SPECIFICITY OF VISUAL IMAGES

It is tempting to go on with this wish list. I believe the university would be a richer and more challenging place if a range of such images were a *lingua franca*—a shared experience among undergraduates and graduates. Students could then draw on a broad and detailed knowledge of image practices in order to understand new material. There is, of course, no end to what is possible. The top image in Plate 53 is al-Buruq, the winged horse that took Mohammed overnight from Mecca to Jerusalem. It is shown as it

Plate 52

was painted on the sides of a truck in Kabul in 1965. The image below it in Plate 53 is a source that the painter probably used, a popular poster printed in Pakistan and sold in Kabul. There is rich material here: the development of truck- and bus-painting in Afghanistan up to the present, given the enormous political changes since these photographs were taken, and the very obscure genealogy of the popular posters, a subject that could also be studied in India, Mexico, China, and elsewhere. The mixture of Western and Asian motifs in Pakistani and Afghani truck-painting could help in understanding the mixed styles in American airbrushed vans and cars.

Another example: the toys and totems used in Uruk over two thousand years ago provide a different frame of reference for looking at contemporary folk art (Plate 54). These are Parthian goddesses from the second century B.C. They have been very carefully studied by the archaeologists Margarete van Ess and Friedhelm Pedde; they come in three groups and two types and have certain coiffures and breasts and navels. Group II, Type A (no. 1437) has breasts that point to either side and a nose like a shallow V—and so forth. Despite this minute anatomization, the function of the statuettes is not known. Ess's and Pedde's exacting examinations are salutary because they show how to squeeze each drop of meaning out of even simple objects. Students who had such visual experiences would be more demanding of images, more alert to uses to which images are put. They would also be more demanding on their teachers, pushing questions about images beyond the customary disciplinary boundaries. It is tempting, therefore, to write the dictionary of this *lingua franca*—the sum total of essential image-making practices and interpretations.

Luckily, such a dictionary is both inadvisable and impossible to complete, and so I will stop with these eight elements of visual literacy. I want to end with two stories intended to cast doubt on any schema for an education in visuality that aspires to be too systematic.

Plate 53

1432 1433 1434 1435 1436

1437

1438

Plate 54

When I was a graduate student, I supported myself one year by teaching tenth-grade geometry in the University of Chicago Laboratory High School. The day I was hired, the chair of the Mathematics Department told me that midway through the semester there would be a parents' night, and I would be asked about the relevance of geometry. The parents, as I already knew, were often concerned about the Lab School's high tuition fees, and they wanted value for their money. I was counseled to say that Euclidean geometry made the students better at logical reasoning, preparing them for various mathematical and nonmathematical tasks in the real world. When parents' night came, I was asked the question, and I said the opposite of what I had been coached to say: I told them that Books I through III of Euclid's *Elements,* which I had been teaching, would help their kids to think like Books I through III of Euclid's *Elements.* Euclid's way of thinking, I said, had absolutely no relation to anything in the world or even in the rest of mathematics. I exaggerated a little—I do think Euclid's *Elements* can help students understand some other classical geometric proofs—but I believed, and I still do believe, that it is false reasoning to claim that logical proofs in Euclid can spur logical thought that is useful outside of geometry.

The parents were hoping their children would become literate at mathematics and at logical inference in general. Euclid was meant to exemplify properties of logical thinking that are structurally similar in Euclid's *Elements* and in unforeseeable occasions in the real world. In a similar fashion, if the ideal of verbal literacy is to make sense, there has to be a structure of analogies that can carry over from one reading to another; analogic extensions of specific literacies will produce, by iteration, a general literacy. Occasionally that structure does seem to be at work; Euclid is sometimes helpful (although too rarely to justify it from the parents' viewpoint), and reading poetry and literature in undergraduate courses can certainly jump-start encoun-

ters with literature outside college. Analogies exist, even if they are far less reliable than some educators and parents hope. But is the same true for visual literacy? I suspect, although I have no sense of how it might be possible to make a sensible proof of such a thing, that the visual world is less amenable to analogies than the worlds of language or mathematics.

A short passage from Barthes's *Camera lucida* is illuminating here. Earlier I quoted Barthes's idea of the "operator" and his idea that the academic study of images—visual culture as such had not yet been invented—is aimed at finding the "intentions which establish and animate" images. Barthes calls the pursuit of such meanings *studium,* which is his word for the uninteresting, everyday manner of seeing that comprises habit, directed inquiry, and common experience. He opposes it to the *punctum,* which stands for him as any kind of seeing that is personal, embodied, and unpredictable. Ultimately the experience of the punctum is the entire point of attending to images in the first place. I do not think it has been recognized that *Camera lucida* contains this succinct critique of visual studies *avant la lettre.* The book condemns the rote pursuit of unexamined assumptions, ambiguous meanings, constructed viewers, systems of ideology, potential literacies, and whatever is systematic and therefore teachable; that is all of visual studies, start to finish. Now there is something to ponder.

I will end with an example of a visual work—one I think is interesting enough to be included in a course on visual studies—that cannot be used as a lesson for other kinds of viewing. It is disanalogic: the ideas to which it leads are dissimilar to it, so the work remains an isolate, a *hapax,* as linguists say—something that is effectively unique. The work in question is a room full of drawings (Plate 55). They were made in the winter of 2001 by an artist from Belgrade named Jelena Mitrovic; she took 1,440 pieces of paper, about three

Plate 55

by four inches each, and she numbered them, one for each minute in a twenty-four-hour day. Then she stayed up twenty-four-hours and made a drawing every minute (Plate 56).

She did this several times: one series was scribbled self-portraits, and another, shown here, was of abstract signs of her state of mind. They are brilliant works because it is very challenging to know how to see them: how much attention to pay, how to read *her* levels of attention, whether to look in sequence or randomly, whether to look close up or just take it all in at once, whether to linger or move quickly through the gallery.

In that sense Mitrovic's drawings resemble no other works of visual art I know: they are wonderful because they lead to no literacy I can name or teach. Here, then, is the paradox of visual literacy: it is crucial to begin thinking of the common pool of images that a university-wide program of visual studies might want to share, and at the same time it is entirely misguided to construe such a collection as an emblem of some general visual literacy.

Plate 56

Envoi

I WILL END WITH some specific recommendations, less because I think there is any particular hope of seeing these implemented than because I want to make the practical import of what I have been describing as clear as I can.

1. *A freshman-level course* in visual studies should ideally be geared to the entire undergraduate body of the college or university, and that means doing more than studying image discourses such as those on iconophilia, iconoclasm, semiotics, or iconography. Even eclectic anthologies such as Bruno Latour's monumental *Iconoclash* do not go as far as it's possible to go toward particular practices of image-making and interpretation.[1] Specific visual competencies have to be taught and critiqued. For example, the course could offer week-long units on the basics of heraldry, Renaissance broadsheets, television-set design, biological image analysis using NIH Image, elementary particle detectors, writing hieroglyphs (Egyptian, Hittite, Easter Island), and the obscure history of x-y graphs. That kind of specificity would give the course lasting relevance for students in dif-

ferent fields. Science students in particular would probably not encounter another such course on their own imaging practices. Units on particular imaging practices need not take away from more general considerations: on the contrary, the new pieces of knowledge would give political and philosophic critiques a stronger grip.

2. *An undergraduate major* in visual studies could also present itself as a field of interest to all undergraduates—perhaps as a minor or second major for students in other disciplines. Students would be attracted to such a major provided it offered courses that show how different theories of images and visuality can be relevant for a variety of disciplines. A major that included courses in the Gaze, scopic regimes, or the hermeneutics of the visible would not attract many students outside the humanities. The courses would have to be experimental, inviting, and eclectic, and at the same time they would have to offer rigorous introductions to the major theoretical concerns of visual studies: "The Theory of the Gaze From Lascaux to Madonna"; "Scopic Regimes of Television"; "The Hermeneutics of the Visible in Popular Religious Imagery." I'm only half-serious about those titles, but I do think that the courses would have to blend systematic exposition of theories with tightly focused and unusual collections of visual material. Otherwise an undergraduate major in visual studies would collapse back into the humanities, where it would risk being ignored by most of the university and even by students in adjoining disciplines. In that spirit, upper-level undergraduate courses could be more specific and just as experimental: "Potential Applications of the Theory of the Gaze in Mesoamerican Art"; "The Concept of Scopic Regimes in Twentieth-Century Physics"; "The Hermeneutics of the Visible in the Design of Microprocessors." They might sound odd, but they would test the theories, challenge disciplinary boundaries, and attract students. The crucial point, I think, is the same as in the introductory fresh-

man-level course: *specific, detailed* visual practices from the widest possible range of disciplines.

3. *A university-wide center for visual studies* could accompany a graduate or undergraduate visual studies program. Of the four proposals I am making here, this one is the easiest to implement. Some universities already have something of the kind: the University of Chicago had such a center until the mid-1990s; Berkeley's and Harvard's humanities centers are appropriate venues; and the Humboldt-Universität in Berlin has such a program, cofounded by Horst Bredekamp. The idea would be to bring together people who work in images from various parts of the university to hear individual lectures or day-long presentations on particular imaging problems. In one session at the University of Chicago's Image Studies Center, a speaker gave a paper on software used to reveal breast cancer in mammograms, and then another speaker talked about software used to identify irregular galaxies on astronomical plates. The two speakers were surprised to find affinities between their software routines. That session could easily have been followed by an art historical paper on the aesthetics of asymmetrical forms from the Rococo onward. If such a center were run in an interesting, engaged, and adventurous fashion, it could easily attract people from many disciplines.

4. *A set of courses with ties to practices outside the university* would be a natural extension of the critical drive of visual studies. Visual studies is partly about the art market, publishing, advertising, nationalism, and globalism, so it stands to reason that scholarship is only part of its purpose. The title of Chapter 2, "The Subjects of Visual Studies"—meaning both the objects of study and the people who do the studying—is meant to carry on Douglas Crimp's approach to visual culture: he identifies art history with certainty about what art and history are for, and cultural studies with ongoing

uncertainty about who might need its knowledge and what use they may find for it. "What is at stake," he concludes, "is not history per se, which is a fiction in any case, but what history, whose history, history to what purpose." The essay in which he argues this is called "Getting the Warhol We Deserve"—a snipe at reductive readings of Warhol that serve the needs of historians.[2] Crimp has long been interested in a kind of visual studies that is *generative* as well as reactive: it produces practices as well as critiquing them, creating new subjects (practitioners) for new subjects (fields of study). Because the School of the Art Institute, where I teach, is an art school, our own undergraduate program in Visual and Critical Studies involves both production and scholarship. My colleagues Maud Lavin, Gregg Bordowitz, Joseph Grigely, Vanalyne Green, George Roeder, Chris Bratton, Carol Becker, and others have all done work that is neither wholly scholarly and reactive nor exclusively activist and generative. My emphasis in this book has been on the reactive side for two reasons. First, in universities—my principal concern in this book—the confluence of disciplines includes only a minority of critical practices that are intended to affect the state of affairs outside of academic discourse. Second, an overconfident activism based on an underinterrogated discourse is a recipe for uninteresting work. What matters is *uncertainty* in "what history, whose history, history to what purpose," and for me that uncertainty is deepest in the theoretical ground on which the field is built.

Each of these proposals is feasible and sensible, given the current directions of visual studies. But before visual studies can become the place where the visual itself is debated, where philosophers might want to go to talk to art historians, or physicists to experts in Photoshop, or Lacanians to cognitive psychologists, it needs to become more ambitious, more wide-ranging, more difficult.

A slower and less self-assured interpretation is also a more reflective interpretation, one whose author is more likely to doubt her disciplinary contexts and purposes. I hope this short book can work like a weir, slowing the torrent of interpretation. I love visual objects and practices because they are often—by their nature—tremendously difficult to put into words, and so I would like to hobble the interpretation of visuality, making it less smooth and confident.

Whatever we decide to make of visual practices, it is best if we do it in full awareness of the fact that the desire to interpret may take us in directions that ruin the very theories and concepts we want to use and even undermine our understanding of the objects that we set out to study. Visual studies is easy because it has already asked and answered the big questions, giving its authors the freedom to take pleasure in all the bizarre and quirky productions of contemporary culture. The greater pleasure, I think, is in questioning the notion that freedom and understanding can be attained so quickly.

We need to become irritated at our favorite theories and theorists and tired of our usual list of visual objects. Visual studies should be ferociously difficult, as obdurate and entangled in power as the images themselves. Complacency on that score leads back toward the fun house of aimless impressionistic writing about the joys of contemporary consumerism. There is so much more out there waiting to be understood.

Notes

Chapter 1

1. Hoggart, *The Uses of Literacy* (London: Chatto and Windus, 1957); Williams, *Culture and Society: 1780–1950* (London: Chatto and Windus, 1958); and Hall, "Cultural Studies: Two Paradigms," *Media, Culture, and Society* 2 (1980): 57–72. For more on Williams, see, first, Andrew Milner, *Re-Imagining Cultural Studies: The Promise of Cultural Materialism* (Thousand Oaks, CA: Sage, 2002). "Culture" was a purposive choice at the time, partly understood in opposition to "civilization." For the latter, see Diana Goodrich, *Facundo and the Construction of Argentine Culture* (Austin, TX: University of Texas Press, 1993), 7–8. "Culture" was also an anthropological and therefore less of a classist concept. See, for example, Leslie White, *The Concept of Culture: A Key to Understanding Tribes and Nations* (New York: Columbia University Press, 1975).
2. For a token of how times have changed, see L. Hodges and J. Judd, "Red-Brick Universities are 'More Elitist Than Oxbridge,'" *Independent* (London), October 6, 2000, p. 10.
3. Baxandall, *Painting and Experience in Fifteenth-Century Italy: A Primer in the History of Pictorial Style* (Oxford: Clarendon Press, 1972).
4. Wolff, "Cultural Studies and the Sociology of Culture," *Invisible Culture: An Electronic Journal for Visual Studies* 1 (Winter 1998), available at http://www.rochester.edu/in_visible_culture/issue1/wolff/wolff.html.
5. Crimp also says that for him, "visual culture is the object of study in visual studies." Crimp, "Getting the Warhol We Deserve," *Social Text* 59: 17 (1999): 49–66, quotation on p. 52.

6. Roeder, "Filling in the Picture: Visual Culture," *Reviews in American History* 26: 1 (1998): 275–93, quotation on p. 275.

7. *Visual Culture: Images and Interpretations,* edited by Michael Ann Holly, Keith Moxey, and Norman Bryson (Middletown, CT: Wesleyan University Press, 1994); Victor Burgin, *In/Different Spaces: Place and Memory in Visual Culture* (Berkeley, CA: University of California Press, 1996); and Barnard, *Art, Design, and Visual Culture: An Introduction* (New York: St. Martin's, 1998). See also the unusual review of *Visual Culture* by F. Clerc in *Études Theologiques et Religieuses* 74: 1 (1999): 137–38.

8. *Visual Culture,* edited by Chris Jenks (London: Routledge, 1995); Mirzoeff, *Visual Culture Reader* (London: Routledge, 1999); and Marita Sturken and Lisa Cartwright, *Practices of Looking: An Introduction to Visual Culture* (Oxford: Oxford University Press, 2001). See the review of *Visual Culture* by D. Tiffany, "Theoretical Pictures," *Semiotica* 129: 1–4 (2000): 197–200.

9. Margarita Dikovitskaya, "From Art History to Visual Culture: The Study of the Visual after the Cultural Turn," Ph.D. thesis, Columbia University, 2001, unpublished.

10. W. J. T. (Tom) Mitchell, "Interdisciplinarity and Visual Culture," *The Art Bulletin* 77: 4 (1995): 540–44. See also Mitchell, "What Is Visual Culture?" in *Meaning in Visual Arts: Views from the Outside,* edited by Irving Lavin (Princeton, NJ: Institute for Advanced Study, 1995), 207–17.

11. Quoted in Dikovitskaya, "From Art History to Visual Culture," 142, with scare quotes around "tarred": "One of the criticisms in the *October* 'Questionnaire' was that the study of visual culture represents an inferior version of cultural studies, in the sense of no longer being about form itself, so much as social meaning. . . . We wanted to make sure our program was not exposed to such a charge."

12. Dikovitskaya, "From Art History to Visual Culture," 94. First names added and punctuation altered.

13. Elkins, *Domain of Images* (Ithaca NY: Cornell University Press, 1999).

14. Jon Simons and Sunil Manghani at the Postgraduate School of Critical Theory and Cultural Studies, University of Nottingham, are planning an anthology called *Image Studies Reader.* Personal correspondence, November 2002.

15. Dikovitskaya, "From Art History to Visual Culture," 87, quoting an interview with Mitchell.

16. *Peterson's Graduate Programs in the Humanities, Arts and Social Sciences,* 36th edition (New York: Peterson's, 2002), vol. 2, 276–77, 701–2. Notice, too, the existence of more commercially oriented disciplines under the headings of "media studies" and "telecommunication."

17. In a separate volume, *Peterson's* also lists programs in the *vision sciences,* some of which are in the same universities; those would be the natural candidates for an expanded study of vision that goes beyond the humanities. *Peterson's Graduate*

Programs in Business, Education, Health, Information Studies, Law, and Social Work, 36th ed. (New York: Peterson's, 2002), vol. 5, 2029–30.

18. Happily, there are many exceptions, including the University of California at Riverside's Film and Visual Studies Department, founded in 1993, which includes art history.

19. I thank Sunil Manghani for this information.

20. For the Sarai Program, see http://www.sarai.net/aboutus/aboutus.htm. Other programs include the Film Studies Program in Jadavpur, Calcutta; the Sri Sri Centre for Media Studies, Bangalore; and the Cultural Studies doctoral program at the Centre for the Study of Culture and Society, Bangalore. I thank Ravi Vasudevan for this information.

21. To make this comparison clear, compare Hal Foster's *Design and Crime, and Other Diatribes* (London: Verso, 2002) with Prashant Parikh's *The Use of Langage* (Stanford, CA: CSLI Publications, 2001), an attempt to apply mathematical game theory to the arts, including painting. Foster's book is informed by North American–style writing on design theory and history; Parikh's is informed by a very different sense of the importance of quantification. I thank Parikh for drawing my attention to his book.

22. See Régis Debray, "Three Ages of Looking," *Critical Inquiry* 21 (1995): 529–56; John Taylor, *Body Horror: Photojournalism, Catastrophe, and War* (New York: New York University Press, 1998); Robert Nelson, "Appropriation," from *Critical Terms for Art History*, ed. Nelson and Richard Shiff (Chicago: University of Chicago Press, 1996), 116–28; and Lev Manovic, "The Automation of Sight: From Photography to Computer Vision," from *Electronic Culture: Technology and Visual Representation*, ed. Tim Druckrey (New York: Aperture, 1996).

23. I thank Hans Dam Christiansen for information about the University of Bergen and the following Scandinavian universities.

24. See http://www.hf.ntnu.no/IKM/kunsthistorie.html.

25. Monash University in Victoria, Australia, has a roughly similar program, and so do several other institutions; the criterion I am applying here is the existence of a full four-year program in visual studies that is not comprised of individual classes that are nominally in separate departments such as Art History. The distinction is impossible to define since it depends on the syllabi of individual courses and the names that universities choose for departments. The field is also changing too rapidly for any account to be thorough: as this book goes to press I have learned of several more universities and schools that are implementing undergraduate visual studies programs, including the Pratt Institute and Cornell University.

26. I thank Mikkel Bolt Rasmussen for drawing my attention to several of these.

27. I thank Hannah Benett for these.

28. As in the case of academic programs, library subject headings are not of direct help. Hannah Bennett, librarian at the Ryerson and Burnham Libraries at the

Art Institute in Chicago, suggests the following: Arts and Society—Periodicals; Communication in Art—Periodicals; Image (Philosophy)—Periodicals; Popular Culture—Periodicals; Social Evolution—Periodicals; Visual perception—Periodicals.

29. Mirzoeff, *An Introduction to Visual Culture* (London: Routledge, 1999); *Interpreting Visual Culture: Explorations in the Hermeneutics of the Visible,* ed. Ian Heywood and Barry Sandywell (London: Routledge, 1999); Sturken and Cartwright, *Practices of Looking* (Oxford: Oxford University Press, 2001).

30. *Bild-Bildwahrnehmung-Bildverarbeitung: Interdisziplinäre Beiträge zur Bildwissenschaft,* edited by Klaus Sachs-Hombach and Klaus Rehkämper (Wiesbaden: Deutscher Universitäts-Verlag 1998); Belting, *Bild-Anthropologie* (Munich: Wilhelm Fink, 2001). See further *De l'image somme texte au texte comme image,* double special issue of *Journal canadien de recherche sémiotique (Canadian Journal of Research in Semiotics),* ed. René Lindekens 6: 3 and 7: 1 (1979); and Jean Paris, *Lisible/Visible: Essai de critique générative* (Åaros: Laffont, 1978). I thank Hans Dam Christiansen for bringing these to my attention.

31. See further *Der Zweite Blick: Bildgeschichte und Bildreflexion,* edited by Hans Belting and Dietmar Kamper (Munich: Wilhelm Fink, 2000).

32. Krauss, "Welcome to the Cultural Revolution," *October* 77 (summer 1996): 83–96.

33. Crow, response to "Visual Culture Questionnaire," *October* 77 (summer 1996), 34–36.

34. "Ten Myths about Visual Culture," lecture handout, unpublished, 2001. It has been published as part of Mitchell's "Showing Seeing: A Critique of Visual Culture," *Journal of Visual Culture* 1: 2 (2002): 165–81; p. 170 offers a prize for anyone who can identify all ten unattributed quotations. I couldn't.

35. In addition to work in journals such as *October,* see *The Image in Dispute: Art and Cinema in the Age of Photography,* ed. Dudley Andrew (Austin: University of Texas Press, 1997) and Garrett Stewart, *Between Film and Screen: Modernism's Photo Synthesis* (Chicago: University of Chicago Press, 1999). I thank Jeff Skoller and Ed Branigan for these references.

36. Appadurai, "Diversity and Disciplinarity as Cultural Artifacts," in *Disciplinarity and Dissent in Cultural Studies,* ed. Cary Nelson and Dilip Parameshwar Gaonkar (New York: Routledge, 1996), 23–36, quotation on pp. 29–30, as quoted in Dikovitskaya, "From Art History to Visual Culture," 41.

37. Mitchell, "Interdisciplinarity and Visual Culture," 543.

38. Michael Ann Holly, *Past Looking: Historical Imagination and the Rhetoric of the Image* (Ithaca, NY: Cornell University Press, 1996); for an introduction to reception history in literature, see *Rezeptionsgeschichte oder Wirkungsästhetik,* ed. Heinz-Dieter Weber (Stuttgart: Klett-Cotta, 1978).

39. For examples, see Oskar Bätchmann, *Einführung in die kunstgeschichtliche Hermeneutik: die Auslegung von Bildern* (Darmstadt: Wissenschaftliche Buchgesellschaft, 1984).

40. Hans Belting, *The Germans and Their Art: A Troublesome Relationship,* trans. Scott Kleager (New Haven, CT: Yale University Press, 1998).

41. El-Guindi proposes to call visual anthropology a "field" rather than a "subdiscipline" of anthropology, because anthropology is conventionally divided into "sociocultural, biological, archaeolog[ical], and linguistic" fields. See El-Guindi's extremely critical review of Jay Ruby, *Picturing Culture: Explorations of Film and Anthropology* (Chicago: University of Chicago Press, 2000), in *American Anthropologist* 103: 2 (2001): 522–27, quotation on p. 525.

42. Bal, *Ecstatic Aesthetics, Metaphoring Bernini,* Critical Issues Series 4 (Woolloomooloo, New South Wales: Artspace Visual Arts Cenre, 2000); and see Joanne Morra, "Translation into Art History," *Parallax* 6: 1 (2000): 129–38. Bal's essay takes several shots at my own work, saying it polices art history's purity to defend it against literary theory.

43. Some items on this list are from the description of a course called "Introduction to Visual Culture," offered in the Interdepartmental Program in Film Studies, in 2002, at the University of Massachusetts at Amherst.

44. "Visual Culture Questionnaire," 32.

45. Solomon-Godeau, review of *The Visual Culture Reader,* ed. Nicholas Mizroeff (London: Routledge, 1999), in *Artforum* (Autumn 1998): 39–40.

46. Readings, *The University in Ruins* (Cambridge, MA: Harvard University Press, 1996). The "Universities" are discussed in Stephen Melville, "Art History, Visual Culture, and the University," in "Visual Culture Questionnaire," 52–54.

47. Melville, response to "Visual Culture Questionnaire," 53.

48. "Visual Culture Questionnaire," 53. Melville puts this as the difference between the "'scientific' (Panofskian) line" and the "'disciplinary' line" represented, for the sake of his abbreviated argument, by Wölfflin and Riegl.

49. "Visual Culture Questionnaire," 33.

50. Hodge, "Monstrous Knowledge: Doing PhDs in the New Humanities," *Australian Universities' Review* 2 (1995): 35–39, quotations on p. 37. Hodge's text is cited in Heather Kerr, "The 'Real Lesson' of an Education in Visual Culture," *Postcolonial Studies* 4: 1 (2001): 91–104, citations on pp. 95–96.

51. Maxwell, *Colonial Photography and Exhibitions: Representations of the 'Native' and the Making of European Identities* (London: Leicester University Press, 1999), reviewed in Kerr, "The 'Real Lesson'," p. 100.

52. Mitchell, "Showing Seeing," 178.

53. I do not mean to suggest that this is a leading model for Mitchell; in fact he has tried out some others. In an interview he compares art history to the study of literature, and visual culture to linguistics: the latter is simply a "much broader field." Dikovitskaya, "From Art History to Visual Culture," 362.

54. Johnson, "What Is Cultural Studies Anyway?" *Social Text* 16 (1986–87): 38–80, quotations on p. 38; quoted in Dikovitskaya, "From Art History to Visual Culture," 40.

CHAPTER 2

1. I offer a counterargument to this position in *Our Beautiful, Dry, and Distant Texts: Art History as Writing* (New York: Routledge, 2000), by proposing that the cogency of art historical writing depends in part on the existence of a way to account for *how* theories are chosen and balanced with one another.

2. Buck-Morss, reply to "Visual Culture Questionnaire," 29.

3. Walker, "Visual Culture and Visual Culture Studies," *Art Book* 5: 1 (January 1998): 14–16, quotation on p. 14.

4. I have not surveyed the Modern Language Association (the American association of English and literature teachers), but it appears that more papers each year involve visual themes and a substantial number are on nineteenth-century topics. See Ann Cvetkovich, "Histories of Mass Culture: From Literary to Visual Culture," *Victorian Literature and Culture* 27 (1999): 495–99, especially n. 1, p. 499.

5. *The Subjects of Art History: Historical Objects in Contemporary Perspectives*, ed. Mark A. Cheetham, Michael Ann Holly, Keith Moxey (Cambridge, UK: Cambridge University Press, 1998); Holly, *Past Looking: Historical Imagination and the Rhetoric of the Image* (Ithaca, NY: Cornell University Press, 1996); Moxey, *Peasants, Warriors, and Wives: Popular Imagery in the Reformation* (Chicago: University of Chicago Press, 1989); Moxey, "Nostalgia for the Real: The Troubled Relation of Art History to Visual Studies," in his *The Practice of Persuasion: Paradox and Power in Art History* (Ithaca, NY: Cornell University Press, 2001), 103–123; Bal, *Quoting Caravaggio: Contemporary Art, Preposterous History* (Chicago: University of Chicago Press, 1999); Wood, *Albrecht Altdorfer and the Origins of Landscape* (Chicago: University of Chicago Press, 1993).

6. Especially *The Limewood Sculptors of Renaissance Germany* (New Haven, CT: Yale University Press, 1980), praised in such a way as to bring out its interdisciplinarity in Thomas Crow, *The Intelligence of Art* (Chapel Hill: University of North Carolina Press, 1999).

7. Out of many interesting younger scholars who put visual-culture concerns to work on older art, I will name William MacGregor, who has written excellent material on early modern prints. See MacGregor, "The Authority of Prints: An Early Modern Perspective," *Art History* 22: 3 (1999): 389–421.

8. Herbert is quoted in Dikovitskaya, "From Art History to Visual Culture," 145.

9. In this book I use *visuality* more informally, to denote the sum of practices related to images. Mirzoeff, interviewed in Dikovitskaya, "From Art History to Visual Culture," 91. *Visualization,* he says, connotes "the study of visuality by medium."

10. See Rosalind Krauss, *"A Voyage on the North Sea": Art in the Age of the Post-Medium Condition* (London: Thames and Hudson, 2000).

11. Wolfgang Dreschler and Peter Weibel, *Bildlicht: Malerei zwischen Material und Immaterialit?* (Vienna: Wiener Festwochen, 1991); *Jenseits von Kunst*, ed. Peter

Weibel (Vienna: Passagen, 1997); Göran Sonesson, *Pictorial Concepts: Inquiries into the Semiotic Heritage and Its Relevance to the Interpretation of the Visual World* (Lund, Sweden: Lund University Press, 1989).

12. Jean-Luc Nancy, "Pourquoi y a-t-il plusieurs arts, et non pas un seul?" in *Les Muses* (Paris: Galilée, 1994), 9–70.

13. Adorno, "Culture Industry Reconsidered," in *The Culture Industry: Selected Essays on Mass Culture,* ed. Jay Bernstein (London: Routledge, 2001), 98–99; quotation from Bernstein on p. 21.

14. Crow, *Modern Art in the Common Culture: Essays* (New Haven, CT: Yale University Press, 1996).

15. Davis, *Pacing the World: Construction in the Sculpture of David Rabinowitch* (Cambridge, MA: Harvard University Art Museums, 1996); Yve-Alain Bois's essays in *Piet Mondrian, 1872–1944,* exh. cat. (Milan: Leonardo Arte, 1994) and *Ad Reinhardt,* exh. cat. (New York: Museum of Modern Art, 1991). Davis's work on Levine is unpublished (2002). Crow's analysis of Levine is in his *Modern Art,* 73–78.

16. The first quotation is from Bernstein, "Introduction," in *The Culture Industry: Selected Essays on Mass Culture,* 1–28, quotations on p. 26. The second is from Bernstein, "Aporia of the Sensible: Art, Objecthood, and Anthropomorphism," in *Interpreting Visual Culture: Explorations of the Hermeneutics of the Visual,* ed. Ian Heywood and Barry Sandwell (New York: Routledge, 1999), 218–37, quotation on p. 221. "Aporia of the Sensible Art" originated as a response to a paper of mine, which later became "Why Don't Art Historians Attend Aesthetics Conferences?" (1996), online at http://davinci.ntu.ac.uk/iaa/iaa4/je.htm (*International Yearbook of Aesthetics*), ed. Richard Woodfield (2000).

17. Bourdieu, *The Love of Art: European Museums and their Public,* trans. Caroline Beattie and Nick Merriman (Cambridge, UK: Polity, 1991).

18. Jameson, "Transformations of the Image," in *The Cultural Turn: Selected Writings on the Postmodern, 1983–1998* (London: Verso, 1998), 93–135, quotation on p. 111.

19. Jameson, "Transformations of the Image," 135.

20. Burgin, *In/Different Spaces: Place and Memory in Visual Culture* (Berkeley: University of California Press, 1996), 20.

21. "Visual Culture Questionnaire," 68.

22. See Niels Marup Jensen, "Billedernes Tid: Teorier og Billeder I den Visuelle Kultur" ("The Time of Images: Theories and Pictures in Visual Culture"), unpublished book manuscript (Copenhagen, c. 2000).

23. Here I am thinking of the mainly academic discourse that has sprung up around Benetton. Oliviero Toscani himself is, I think, an opportunist with a minimal sense of what he is making. Speaking of his eighteen years with Benetton, Toscani said to an interviewer "I cheated them—they made money." See William Shaw, "Salesman of the Century," *Sunday Review* (London *Independent*) July 7, 2002, 12–15, quotation on p. 15.

24. Drucker, "Who's Afraid of Visual Culture?" *Art Journal* 58: 4 (1999): 36–47, quotations on p. 37.

25. Nelson, "Literature as Cultural Studies," 65, as quoted in Dikovitskaya, "From Art History to Visual Culture," 53–54.

26. Culler, "What Is Cultural Studies?" in *The Practice of Cultural Analysis: Exposing Interdisciplinary Interpretation,* ed. Mieke Bal (Stanford, CA: Stanford University Press, 1999), 335–47, quotations on p. 338.

27. Alpers, "Is Art History?" *Daedalus* 106: 3 (1977): 1–13, quotation on p. 9.

28. Morris, "Threading the Labyrinth," *October* 96 (Spring 2000): 61–70.

29. Crow is quoted in Scott Heller, "Visual Images Replace Text as Focal Point for Many Scholars," *Chronicle of Higher Education* (July 19, 1996), p. A8.

30. "Visual Culture Questionnaire," 35.

31. "Visual Culture Questionnaire," 57–58.

32. An example of high-art discourse in trouble with low art is Kirk Varnedoe's infamous High and Low exhibition in 1990, which was at once naïve, obvious, and tentative in its approach to low art. Varnedoe and Adam Gopnik, *High and Low: Modern Art [and] Popular Culture* (New York: Museum of Modern Art, 1990); *Modern Art and Popular Culture: Readings in High and Low,* ed. Varnedoe (New York: Museum of Modern Art, 1990).

CHAPTER 3

1. Marx, *Capital,* trans. by Eden and Cedar Paul (London: Dent, 1972), chap. 1.

2. Krauss, "Welcome to the Cultural Revolution," *October* 77 (1996): 83–96, quotations on pp. 84, 96.

3. Adorno, "How to Look at Television," *The Culture Industry,* 158–77, quotations on pp. 106–107, translation modified.

4. Malcolm Barnard, "Advertising: The Rhetorical Imperative," in *Visual Culture,* ed. Chris Jenks, 26–41, esp. 35–38.

5. Adorno, "Culture Industry Reconsidered," *The Culture Industry,* 98–106, quotation on p. 106.

6. I thank Maud Lavin for telling me about Brezsny. See www.freewillastrology.com.

7. See http://www.sep11photo.org. I thank Walter Markham and Michael Feldschuh for information on the project.

8. The former is a silent 1 minute, 15 second video loop made on April 13, 2002, by the artist Jecca. Three low-res stills are on her Web site at www.jecca.info.

9. Roeder, *The Censored War: American Visual Experience during World War II* (New Haven, CT: Yale University Press, 1993).

10. The footage can still be seen on the Internet: for example, http://www.fas.org/spp/51L.html. "Percussive" is from Elaine Scarry, *The Body in Pain: The Making and Unmaking of the World* (New York: Oxford University Press, 1985).

11. DeBolla, "the Visibility of Visuality," in *Vision in Context: Historical and Contemporary Perspectives on Sight,* ed. Teresa Brennan and Martin Jay (London: Routledge, 1996), 68.

12. Sidney Perkowitz, *Empire of Light: A History of Discovery in Science and Art* (Washington, DC: Joseph Henry Press, 1996); Leonard Shlain, *Art and Physics: Parallel Visions in Space, Time, and Light* (New York: Morrow, 1991).

13. For example, the excellent anthology *Colour: Art and Science,* ed. Trevor Lamb and Janine Bourriau (Cambridge, UK: Cambridge University Press, 1995).

14. Zeki, *Inner Vision: An Exploration of Art and the Brain* (Oxford: Oxford University Press, 1999); Crick, *The Astonishing Hypothesis: The Scientific Search for the Soul* (New York: Scribner, 1994); Marr, *Vision: A Computational Investigation into the Human Representation and Processing of Visual Information* (San Francisco: W. H. Freeman, 1982).

15. These are brief examples. In two other publications I have proposed more extended examples which give a better idea of the possibilities. First, the chapter "Figure and Ground in Philosophy, Neurophysiology, Phenomenology, Psychology, Painting, and Psychoanalysis," in my *On Pictures and the Words That Fail Them* (Cambridge, UK: Cambridge University Press, 1998), 78–128; second, the half-dozen case studies in *Domain of Images* (Ithaca, NY: Cornell University Press, 1998), 31–44. An unpublished book, *Six Stories from the End of Representation* (Stanford, CA: Stanford University Press, forthcoming), offers a general theory of the interaction of art historical interests and those of physics.

16. Christopher Passaglia, Frederick Dodge, Erik Herzog, Scott Jackson, and Robert Barlow, "Deciphering a Neural Code for Vision," *Proceedings of the National Academy of Sciences of the United States of America* 94 (1997): 12649–12654, quotation on p. 12649.

17. A. E. Downing, Yuhong Jiang, Miles Shuman, and Nancy Kanwisher, "A Cortical Area Selective for Visual Processing of the Human Body," *Science* 293 (September 28, 2001):2470–2473.

18. A claim made, for example, in my *Pictures of the Body: Pain and Metamorphosis* (Stanford, CA Stanford University Press: 1999).

19. Rosalind Krauss, *The Optical Unconscious* (Cambridge, MA: MIT Press, 1993).

20. Georges Didi-Huberman, *L'image survivante: Histoire de l'art et temps des fantômes selon Aby Warburg* (Paris: Éditions de Minuit, 2002).

21. Lawrence Weiskrantz, "Blindsight," in *Handbook of Neuropsychology,* vol. 2, ed. Françoise Boller et al. (Amsterdam: Elsevier, 1989): 375–385; Weiskrantz, *Blindsight: A Case Study and Implications* (Oxford: Oxford University Press, 1986); M. Adrich et al., "Cortical Blindness: Etiology, Diagnosis, and Prognosis," *Annals of Neurology* 21 (1987): 149–158.

22. Information comes from the mesencephalic reticular formation, thalamic nuclei, the posterior parietal cortex, and the occipital cortex. Jonathan Trobe, *The Neurology of Vision* (Oxford: Oxford University Press, 2001), 21; see also L. Kline,

"Anatomy and Physiology of the Optic Tracts and Lateral Geniculate Nucleus," in *Walsh and Hoyt's Clinical Neuro-ophthalmology*, vol. 1, edited by Nancy Newman and Neil Miller (Baltimore, MD: Williams and Wilkins, 1998), 101–120.

23. A good guide to the possibilities is Ian Hacking, *The Social Construction of What?* (Cambridge, MA: Harvard University Press, 1999).

24. Begin with Snow, *The Two Cultures: And a Second Look* (Cambridge, UK: Cambridge University Press, 1963); then Roy Porter, "The Two Cultures Revisited," *Cambridge Review* 115: 2324 (1994): 74–80; Paul W. Boytinck, *C. P. Snow, A Reference Guide* (Boston: G. K. Hall, 1980); Marjorie Nicolson, "Resource Letter SL-1 on Science and Literature," *American Journal of Physics* 33: 3 (1965): 175–83; and John de la Mothe, *C. P. Snow and the Struggle of Modernity* (Austin: University of Texas Press, 1992).

25. *Harvard Design School Guide to Shopping*, ed. Chuihua Judy Chung, Rem Koolhaas, et al. (Cologne: Taschen, 2001). I thank Maud Lavin for bringing this to my attention.

26. Cavell, review of *The Arcades Project* in *Artforum* (April 2000): 31–35; the observation is on p. 35.

27. Margaret Cohen, *Profane Illumination: Walter Benjamin and the Paris of Surreal Revolution* (Berkeley: University of California Press, 1993); Susan Handelman, *Fragments of Redemption: Jewish Thought and Literary Theory in Benjamin, Scholem, and Levinas* (Bloomington: Indiana University Press, 1991); Max Pensky, "Tactics of Remembrance: Proust, Surrealism, and the Origin of the *Passagenwerk*," in *Walter Benjamin and the Demands of History*, ed. Michael Steinberg (Ithaca, NY: Cornell University Press, 1996), 185–89.

28. A counterexample is Anne Friedberg, *Window Shopping: Cinema and the Postmodern* (Berkeley: University of California Press, 1993). For a very good discussion of such extensions of Benjamin, see Vanessa Schwartz, "Walter Benjamin for Historians," a review essay of the English translation of the *Arcades Project*, in *American Historical Review* (December 2001): 1721–43, esp. 1732–33. I thank George Roeder for bringing Schwartz's essay to my attention.

29. Shiff, "Handling Shocks: On the Representation of Experience in Walter Benjamin's Analogies," *Oxford Art Journal* 15: 2 (1992): 88–103, quotation on p. 90.

30. Buck-Morss, *The Dialectics of Seeing: Walter Benjamin and the Arcades Project* (Cambridge, MA: MIT Press, 1989). "Sudden" from Benjamin, *Arcades Project*, 462, convolute N 2a, 3.

31. Krauss, *Optical Unconscious*. The reference in the title derives from Benjamin's sentence "the camera introduces us to an unconscious optics as does psychoanalysis to unconscious impulses." Benjamin, "The Work of Art in the Age of Mechanical Reproduction," in *Illuminations*, ed. Hannah Arendt (New York: Schocken, 1969), 217–52, quotation on p. 236. For debates about the essay's title

in English translation, see Schwartz, "Walter Benjamin for Historians," 1733–34, n. 55.

32. Jameson, "Transformations of the Image," in *The Cultural Turn: Selected Writings on the Postmodern, 1983–1998* (London: Verso, 1998), 93–135, quotations on pp. 105, 106, respectively.

33. Jameson, "Transformations of the Image," 108, 110.

34. Jameson's account fits very well with an extended study by Thomas Flynn, "Foucault and the Spaces of History," *The Monist* 74: 2 (1991): 165–86, which elaborates on an argument of Edward Said's that Foucault offers "adjacency" rather than "sequentiality" as argument (ibid., pp. 181–82). A study that shows many other nonbureaucratic contexts of surveillance is Astrit Schmidt-Burkhardt, "The All-Seer: God's Eye as Proto-Surveillance," *Ctrl [Space]: Rhetorics of Surveillance from Bentham to Big Brother,* ed. Thomas Levin, Ursula Frohne, and Peter Weibel (Karlsruhe: ZKM Center for Art and Media, 2002), 16–31.

35. Didi-Huberman, *L'image survivante*. A translation is forthcoming from Penn State Press.

36. Buck-Morss, *Dreamworld and Catastrophe: The Passing of Mass Utopia in East and West* (Cambridge, MA: MIT Press, 2000).

37. Pensky, "Tactics of Remembrance: Proust, Surrealism, and the Origin of the *Passagenwerk,*" in *Walter Benjamin and the Demands of History,* ed. Michael Steinberg (Ithaca, NY: Cornell University Press, 1996), 164–89, quotation on p. 188.

38. In addition to Georges Didi-Huberman's *L'image survivante*, it is useful to compare other attempts to create meaning by sequences of pictures; for example, James Agee and Walker Evans, *Let Us Now Praise Famous Men* (Boston: Houghton Mifflin, 1941); and Margaret Olin, "'It Is Not Going to Be Easy to Look into Their Eyes': Privilege of Perception in *Let us Now Praise Famous Men,*" *Art History* 14 (1991): 92–115; John Berger and Jean Mohr, *Another Way of Telling* (New York: Pantheon, 1982); Michael Lesy, *Wisconsin Death Trip* (Albuquerque: University of New Mexico Press,1973); Horst Janson, *Key Monuments in the History of Art, A Visual Survey* (New York: Harry N. Abrams, 1959); *Kunstgeschichte in Bildern, Neue Bearbeitung, Systematische Darstellung der Entwicklung der bildenden Kunst vom klassischen Altertum bis zur neueren Zeit,* ed. H. Schafer et al. Part 1, *Das Altertum* (Leipzig: Alfred Kröner, 1913). The latter two are discussed in my *Stories of Art* (New York: Routledge, 2002); I thank George Roeder for drawing my attention to Lesy's and Berger's books.

39. For example, by Thomas DaCosta Kaufmann, untitled response to "Visual Culture Questionnaire," *October* 77 (Summer 1996): 45–48.

40. *Producing the Past: Aspects of Antiquarian Culture and Practice, 1700–1850,* ed. Martin Myrone and Lucy Peltz (Aldershot, Hampshire, UK: Ashgate, 1999).

41. Georg Eberhard Rumpf, *The Ambonese Curiosity Cabinet,* trans. E. M. Beekman (New Haven, CT: Yale University Press, 1999) is mostly concerned with

Southeast Asian marine life but is typical of the detail of such catalogues; see also *Ole Worm's Correspondence with the Icelanders,* ed. [in Latin] Jakob Benediktsson (Copenhagen: E. Munksgaard, 1948).

42. Stephen Bann, *Under the Sign: John Bargrave as Collector, Traveler, and Witness* (Ann Arbor: University of Michigan Press, 1994).

43. A good introduction to Ranke's methodology is Anthony Grafton, *The Footnote: A Curious History* (Cambridge, MA: Harvard University Press, 1997).

44. Benjamin, *Arcades Project,* trans. Howard Eiland and Kevin McLaughlin (Cambridge, MA: Harvard University Press, 1999), 463, convolute N 3, 4.

45. See Carolyn Steedman, *Dust: The Archive and Cultural History* (New Brunswick, NJ: Rutgers University Press, 2002), for a good assessment of Derrida's *Archive Fever: A Freudian Impression,* trans. Eric Prenowitz (Chicago: University of Chicago Press, 1996).

46. Burckhardt, *The Civilization of the Renaissance in Italy,* trans. S. G. C. Middlemore (London: Penguin, 1990). The quotation is from a description of Burckhardt's interests by Anthony Grafton, "A Passion for the Past," *New York Review of Books* (March 8, 2001), 47–53, quotation on p. 51. Grafton is making a comparison with modern anthropology. Also relevant in this context, because it highlights Burckhardt's visual adventurousness, is *Jacob Burckhardt und Heinrich Wölfflin: Briefwechsel und andere Dokumente ihrer Begegnung, 1882–1897,* ed. Joseph Gantner (Basel: Schwabe, 1989).

47. See the excellent essay by Ján Bakos, "Metamorphoses of Jacob Burckhardt's Legacy," *Horizons: Essays on Art and Art Research,* ed. Hatje Cantz (Zürich: Schweizerisches Institut für Kunstwissenschaft, 2001), 345–52.

48. Praz, *An Illustrated History of Interior Decoration: From Pompeii to Art Nouveau,* trans. William Weaver (New York: Thames and Hudson, 1982), and his wonderful book *The House of Life,* trans. Angus Davidson (New York: Oxford University Press, 1964).

49. For "hippological" facts and Panofsky's mastery of them, see my *Our Beautiful, Dry, and Distant Texts: Art History as Writing* (New York: Routledge, 2000), 274.

50. An excellent introduction to these and others is *L'image,* ed. Laurent Lavaud (Paris: Flammarion, 1999).

51. *Visual Culture: Explorations in the Hermeneutics of the Visible,* ed. Ian Heywood and Barry Sandywell (London: Routledge, 1999).

52. *Visual Culture,* ed. Chris Jenks (London: Routledge, 1995). My copy was the fifth printing (2002).

53. Georgina Kleege, *Sight Unseen* (New Haven, CT: Yale University Press, 1999); I thank Grigely for drawing this to my attention.

54. Deleuze, *Cinema,* trans. Hugh Tomlinson and Barbara Habberjam, 2 vols. (Minneapolis: University of Minnesota Press, 1986, 1989).

55. Silverman, *World Spectators* (Stanford, CA: Stanford University Press, 2000); *The Threshold of the Visible World* (New York: Routledge, 1996).

56. Mulvey, "Visual Pleasure and Narrative Cinema," originally published in *Screen* 16: 3 (Autumn 1975), revised in *Feminist Film Theory*, ed. Sue Thornham (New York: New York University Press, 1999), 412–28.

57. Morley, "Television: Not So Much a Visual Medium, More a Visible Object," *Visual Culture*, ed. Chris Jenks (London: Routledge, 1995), 170–89.

58. Gomery, *Shared Pleasures: A History of Movie Presentation in the United States* (Madison: University of Wisconsin Press, 1992); Stephen Ross, *Working-Class Hollywood: Silent Film and the Shaping of Class in America* (Princeton, NJ: Princeton University Press, 1998); and Rosenstone, *Revisioning History: Film and the Construction of a New Past* (Princeton, NJ: Princeton University Press, 1995). I thank George Roeder for bringing these to my attention.

59. Mulvey, "Visual Pleasure and Narrative Cinema," 418.

60. This is a point made, for example, by *Revisioning History: Film and the Construction of a New Past,* ed. Robert Rosenstone (Princeton, NJ: Princeton University Press, 1995), 3, cited in Roeder, "Filling in the Picture," 278; see also Miriam Hansen, "Introduction," in *Theory of Film: The Redemption of Physical Reality* (Princeton, NJ: Princeton University Press, 1997).

61. Carroll, *Interpreting the Moving Image* (Cambridge, UK: Cambridge University Press, 1998), with a very useful introduction by Tom Gunning; Carroll, *Theorizing the Moving Image* (New York: Cambridge University Press, 1996); Bordwell's principal arguments are in his "Why Not To Read a Film," the final chapter in *Making Meaning: Inference and Rhetoric in the Interpretation of Cinema* (Cambridge, MA: Harvard University Press, 1989); and *On the History of Film Style* (Cambridge, MA: Harvard University Press, 1997), first and fifth chapters; and further Kristin Thompson, "The Concept of Cinematic Excess," in *Narrative, Apparatus, Ideology: A Film Theory Reader,* ed. Philip Rosen (New York: Columbia University Press, 1986).

62. Siegfried Kracauer, *Theory of Film: The Redemption of Physical Reality* (Princeton, NJ: Princeton University Press, 1997 [1960]); Sergei Eisenstein, *Film Essays and a Lecture,* ed. Jay Leyda (Princeton, NJ: Princeton University Press, 1982); Béla Balázs, *Il film: Evoluzione ed essenza di un'arte nuova* (Torino: G. Einaudi, 1964); and Jean Epstein, *Esprit de cinéma* (Geneva: Jeheber, 1955). I thank Melinda Szaloky for these references.

63. Among many others, Yvette Biro, *Profane Mythology: The Savage Mind of the Cinema* (Bloomington: Indiana University Press, 1982); Charles Affron, *Star Acting: Gish, Garbo, Davis* (New York: Dutton, 1977); Gregory Currie, *Image and Mind: Film, Philosophy, and Cognitive Science* (New York: Cambridge University Press, 1995); and so forth—books that exemplify a myriad of approaches to the visual.

64. See http://telenovela.tvheaven.com/.

65. For example, Stuart Hall and Roger Ames, *Thinking from the Han: Self, Truth, and Transcendence in Chinese and Western Culture* (Albany: State University of New

York Press, 1998); an excellent introduction to these and other theories is Robert Wardy, *Aristotle in China: Language, Categories and Translation* (New York: Cambridge University Press, 2000).

66. See my *Stories of Art* (New York: Routledge, 2002).

67. See also the exemplary texts of Nestor Canclini, for example *Hybrid Cultures: Strategies for Entering and Leaving Modernity* (Minneapolis: University of Minnesota Press, 1995); also Homi Bhabha, "Signs Taken for Wonders: Questions of Ambivalence and Authority under a Tree outside Delhi, May 1817," in *The Location of Culture* (New York: Routledge, 1994), 102–22. A useful recent anthology is *Hybridity and Its Discontents: Politics, Science, Culture,* ed. Avtar Brah and Annie Coombes (London: Routledge, 2000); and further, Robert Young, "Hybridity and Diaspora," *Colonial Desire: Hybridity in Theory, Culture, and Race* (New York: Routledge, 1996), 1–28; Mary Louise Pratt, "Introduction: Criticism in the Contact Zone," in *Imperial Eyes: Travel Writing and Transculturation* (London: Routledge, 1992), 1–11; and Nelly Richard, "Postmodern Decentredness and Cultural Periphery: The Disalignments and Realignments of Power," in *Beyond the Fantastic: Contemporary Art Criticism from Latin America,* ed. Gerardo Mosquera (Cambridge, MA: MIT Press, 1995), 260–69. I thank Jill Casid for these last four references (they were on her syllabus for "Visual Transculture" [2001] which she kindly shared).

68. I owe this use of "zone" to Melinda Szaloky, although my usage is different from hers.

69. As an example: the confluence of the fetish, the stereotype, and the Lacanian Imaginary in the essay called "The Other Question" is a moment of obscurity that is both crucial for the larger sense and utility of the essay, because it grounds the entire theory of the stereotype that the essay offers, and also unreadable when it is judged in relation to its immediate context. Bhabha, "The Other Question—The Stereotype and Colonial Discourse," *Screen* 24: 6 (1983): 18–36.

70. Derrida, "'To Do Justice to Freud': The History of Madness in the Age of Psychoanalysis," *Critical Inquiry* 20 (1994): 227–66.

71. Paul Ricoeur has argued similarly; see *Freud and Philosophy: An Essay on Interpretation,* trans. Denis Savage (New Haven, CT: Yale University Press, 1970).

72. A good illustration of this is the places of Lacan in Žižek's *The Spectre Is Still Roaming Around! An Introduction to the 150th Anniversary Edition of the Communist Manifesto* (Zagreb: Arkzin, 1998).

73. Spivak, *Critique of Postcolonial Reason: Toward a History of the Vanishing Present* (Cambridge, MA: Harvard University Press, 1999), 421.

74. This description is not meant to be a review of Spivak's text, but a methodological observation. For a good introduction, see the review by Mark Sanders in *Postmodern Culture,* available at http://www.jefferson.village.virginia.edu/pmc). For an intransigent review which nevertheless touches on the problem of

Derrida, see Terry Eagleton, "In the Gaudy Supermarket," *London Review of Books* 21: 10 (May 13, 1999); and for a longer meditation with a very direct and honest account of the difficulty of knowing how to read Spivak's book, see Mieke Bal, "Three-Way Misreading," *Diacritics* 30: 1 (2000): 2–24. If I were to extend this reading, I would begin by asking what it means that Spivak's book ends with a very straightforward nine-page primer on Derrida's work (*Critique*, 423–31).

75. Nicholas Mirzoeff, *An Introduction to Visual Culture* (New York: Routledge, 1999), 129–31; Bill Ashcroft, Gareth Griffiths, and Helen Tiffin, "Transculturation," in *Key Concepts in Postcolonial Studies* (New York: Routledge, 1998), 233–34.

76. Sasaki, "The Sexiness of Visuality: A Semantic Analysis of the Japanese Word: Eye and Seeing," *Filozofski-Vestnik* [Ljubljana] 17: 2 (1996): 159–70, quotations on p. 162, 163.

77. Sasaki, "The Sexiness of Visuality," 170.

78. For other examples along these lines, see *Looking at the Other: Historical Studies of Images in Theory and Practice*, ed. Kari Alenius, Olavi Falt and Seija Jalagin (Oulu, Finland: University of Oulu, 2002); and Sara Maza, *Servants and Masters in Eighteenth-Century France: The Uses of Loyalty* (Princeton, NJ: Princeton University Press, 1983). I thank George Roeder for bringing these to my attention.

79. Feld, *Sound and Sentiment: Birds, Weeping, Poetics, and Song in Kakuli Expression* (Philadelphia: University of Pennsylvania Press, 1982); one of his CDs is *Bosavi: Rainforest Music from Papua New Guinea* (Washington, DC: Smithsonian Folkways Recordings, 2001); another is *Voices of the Rainforest* (Salem, MA: Rykodisk, 1991).

80. Losche, "The Importance of Birds: Or the Relationship Between Art and Anthropology Reconsidered," in *Double Vision: Art Histories and Colonial Histories in the Pacific*, ed. Nicholas Thomas and Diane Losche (Cambridge, UK: Cambridge University Presss, 1999). The quotation is from an essay in that volume by Peter Blunt, "Clumsy Utopians: An Afterword," ibid., 272.

81. Losche, "The Sepik Gaze: Iconographic Interpretation of Abelam Form," *Social Analysis* 38 (1995): 47–60, and Losche, "Skin, Organs, Bone: Narrative, Image, and the Body," *Visual Arts and Culture* 1: 2 (1999): 135–48.

82. I am indebted to a wonderful review for bringing Losche to my attention: Heather Kerr, "The 'Real Lesson' of an Education in Visual Culture," review of *Double Vision*, in *Postcolonial Studies* 4: 1 (2001): 91–104, esp. 94.

83. Jean-Louis Schefer, *The Enigmatic Body: Essays on the Arts*, trans. Paul Smith (New York: Cambridge University Press, 1995); Joanna Frueh, *Monster/Beauty: Building the Body of Love* (Berkeley: University of California Press, 2001); Hélène Cixous, *Stigmata: Excaping Texts* (London: Routledge, 1998), and most recently her *Portrait de Jacques Derrida en jeune saint juif* (Paris: Galilée, 2001); Hickey, *Air Guitar: Essays on Art and Democracy* (Los Angeles: Art Issues Press, 1997).

84. Krauss, *The Optical Unconscious* (Cambridge, MA: MIT Press, 1993); Fred Orton and Griselda Pollock, *Avant-Gardes and Partisans Reviewed* (Manchester, UK: Manchester University Press, 1996).
85. Berger, *The Shape of a Pocket* (London: Bloomsbury, 2001).
86. Lévi -Strauss, *Look, Listen, Read,* trans. Brian Singer (New York: Basic Books, 1997).

CHAPTER 4

1. For example, Doris Dondis, *Primer of Visual Literacy* (Cambridge, MA: MIT Press, 1973); also Edmund Feldman, "Visual Literacy," *Journal of Aesthetic Education* 10 (1976): 195–200; and Feldman, "The Teacher as Model Critic," *Journal of Aesthetic Education* 7 (1973): 50–57.
2. I thank Michael James for information about this program.
3. Stewart Muir, "No Easy Ride in Ancient School: Prince Must Achieve 'Visual Literacy' in Four-Year Arts Degree Program," *Vancouver Sun,* September 24, 2001, p. A8.
4. March, *Physics for Poets,* 3rd ed. (New York: McGraw-Hill, 1992).
5. Stafford, *Good Looking: Essays on the Virtue of Images* (Cambridge, MA: MIT Press, 1996).
6. In addition to sources cited below, see Paul Virilio, *Vision Machine* (Bloomington: Indiana University Press, 1994); Donald Lowe, *History of Bourgeois Perception* (Brighton, Sussex, UK: Harvester Press, 1984); and Elizabeth Chaplin, *Sociology and Visual Representation* (New York: Routledge, 1994).
7. Crary, *Suspensions of Perception: Attention, Spectacle and Modern Culture* (Cambridge, MA: MIT Press, 1999); for the *flâneur,* see Janest Wolff, *Feminine Sentences: Essays on Women and Culture* (Berkeley: University of California Press, 1990); the feminist revision is critiqued as missing Benjamin's point in Schwartz, "Walter Benjamin for Historians," 1732–33.
8. I have not elaborated on scopic regimes in this book because they are so easily bent to various purposes. Jay, "Scopic Regimes of Modernity," in *Vision and Visuality,* ed. Hal Foster (Seattle, WA: Bay Press, 1988), 3–28, esp. 5–7. An example of the flexibility that Jay's concept has is provided by Rolland Paulston's dubious essay "Mapping Visual Culture in Comparative Education Discourse," *Compare* 27: 2 (1997): 117–52, which takes the schematic form of Jay's regimes and applies them *en masse* to education theory.
9. See Barry Sandywell, "Specular Grammar: The Visual Rhetoric of Modernity," in *Interpreting Visual Culture: Explorations in the Hermeneutics of the Visual,* ed. Ian Heywood and Barry Sandywell (London: Routledge, 1999), 30–56.
10. *Visual Studies Reader,* ed. Nicholas Mirzoeff (London: Routledge, 1998), 5.
11. Goldfarb, quoted in Dikovitskaya, "From Art History to Visual Culture," 111.

12. Klaus Sachs-Hombach and Klaus Rehkämper, "Einleitung," in *Bild - Bildwahrnehmung - Bildverarbeitung* (Wiesbaden: Deutscher Universitäts-Verlag 1998), 9–11, quotation on p. 9, translation mine.

13. Chaney, "Contemporary Socioscapes: Books on Visual Culture," *Theory, Culture, and Society* 17: 6 (2000): 111–24, quotations on pp. 112–13. I have changed Chaney's numbering, splitting one of his four reasons to make five.

14. *Practices of Looking: An Introduction to Visual Culture* (Oxford: Oxford University Press, 2001), 1.

15. W. J. T. Mitchell, *Picture Theory* (Chicago: University of Chicago Press, 1994), 16, quoted in Mirzoeff (ibid.) in the expanded sense that I am criticizing here. Mitchell is stronger on this subject in "Showing Seeing: A Critique of Visual Culture," *Journal of Visual Culture* 1: 2 (2002): 165–81, esp. p. 173: "I did not mean to make the claim that the modern era is unique or unprecedented in its obsession with vision and visual representation."

16. Nicolas Bourriaud, "Croire aux images," *Beaux Arts Magazine* 181 (1999): 43.

17. The issue appears, for example, in my "Marks, Traces, *Traits*, Contours, *Orli*, and *Splendores:* Nonsemiotic Elements in Pictures," *Critical Inquiry* 21 (1995): 822–60.

18. As Mikkel Borch-Jacobsen has pointed out, Lacan's sense of visuality is "frozen," predicated on static images. See *Lacan: The Absolute Master*, trans. Douglas Brick (Stanford, CA: Stanford University Press, 1991).

19. *Listening to Heidegger and Hisamatsu*, ed. L. Alcopley [Alfred Copley] (Kyoto: Bokubi Press, 1963), recently studied in Véronique Fóti, "Heidegger and the 'Way of Art': The Empty Origin and Contemporary Abstraction," *Continental Philosophy Review* 31 (1998): 337–51. The quotations are Fóti's, ibid., 343.

20. Barry Sandywell and Ian Heywood, "Appendix: The Original Project," in *Interpreting Visual Culture*, 238–250, quotation on p. 246. See also *Modernity and the Hegemony of Vision*, ed. David Levin (Berkeley: University of California Press, 1993); *Vision and Textuality*, ed. Stephen Melville and Bill Readings (Durham, NC: Duke University Press, 1995).

21. T. Knieper, *Infografiken* (Munich: Reinhard Fischer, 1995).

22. Edward Tufte, *Envisioning Information* (Cheshire, CT: Graphics Press, 1990).

23. For example, Stafford, "Introduction: Visual Pragmatism for a Virtual World," in her *Good Looking* (Cambridge, MA: MIT Press, 1996), 3–17.

24. Khunrath, *Ampitheatrum Sapientiæ Æternæ, Solius Veræ* (Hamburg [?], s.n., 1595); also Khunrath, *The Amphitheatre Engravings of Heinrich Khunrath*, trans. Patricia Tahil, ed. Adam McLean (Edinburgh, UK: Magnum Opus Hermetic Sourceworks, 1981).

25. Dimock, quoted in Dikovitskaya, "From Art History to Visual Culture: The Study of the Visual after the Cultural Turn," Ph.D. dissertation, Columbia University, 2001, unpublished, 114.

26. Quoted in Dikovitskaya, "From Art History to Visual Culture," 113.

NOTES

27. This work is being done by a group of art historians including Gary Schwartz and Hans van Miegroet. See van Miegroet and Neil De Marchi, "Exploring Markets for Netherlandish Paintings in Spain and Nueva España," *Dutch Art Historical Yearbook* 50 (1999): 81–111.

28. Oliver Scholz, "Was heißt es, ein Bild zu verstehen?" in *Bild-Bildwahrnehmung-Bildverarbeitung,* ed. Klaus Sachs-Hombach and Klaus Rehkämper (Wiesbaden: Deutscher Universitäts-Verlag 1998), 105–18.

29. L. Standing, "Learning 10,000 Pictures," *Quarterly Journal of Experimental Psychology* 25 (1973): 207–22; S. Madigan, "Picture Memory," in *Imagery, Memory, and Cognition,* ed. J. C. Yuile (Hillsdale, NJ: Erlbaum, 1983); both are discussed in an excellent article by Johannes Engelkamp, "Gedächtnis für Bilder," in *Bild-Bildwahrnehmung-Bildverarbeitung,* 227–42. The quotation is from Susan Sontag; it was made in the course of a debate on scientific images. For the context see my review, "Who Owns Images: Science or Art?" review of an MIT conference, "Image and Meaning," June 2001, in *Circa* 97 (2001): 36–37.

30. Eric Donald Hirsch, Joseph Kett, and James Trefil, *The Dictionary of Cultural Literacy* (Boston: Houghton Mifflin, 1988).

31. Hirsch, *What Your Second-Grader Needs to Know: Fundamentals of a Good First-Grade* [sic] *Education,* Core Knowledge Series, vol. 2 (New York: Doubleday, 1991). The series includes books from first through sixth grade. The "[sic]" is the inspired editing of a librarian at the University of Chicago. Also *A First Dictionary of Cultural Literacy: What Our Children Need to Know,* ed. E. D. Hirsch (Boston: Houghton Mifflin, 1989).

32. Walker, "Visual Culture and Visual Culture Studies," *The Art Book* 5: 1 (1998): 14–16, quotations on p. 16.

33. This was argued at the height of the discussions about the canon, in the 1970s, in Ihab Hassan, *Paracriticisms: Seven Speculations of the Times* (Urbana: University of Illinois Press, 1975).

34. *Matthias Waske: Visionen und Parodien,* exh. cat. (Munich: Museum Villa Stuck, 1991).

35. Stone, *Lust for Life* (New York: Cardinal Edition, Pocket Books Inc., 1951 [1934]), [472], 389, respectively.

36. Eric Michaels, *Bad Aboriginal Art: Tradition, Media, and Technological Horizons* (Minneapolis: University of Minnesota Press, 1994); further references in my *Domain of Images,* 48–51, 166–67. For Howard Murphy, see first *Aboriginal Art* (London: Phaidon, 1998).

37. This reading is from Linda Schele and Mary Ellen Miller, *Blood of Kings: Dynasty and Ritual in Maya Art* (New York: Braziller; Fort Worth: Kimbell Art Museum, 1985), 310–12.

38. Beatriz de la Fuente et al., *Pintura Mural Prehispánica* (Barcelona: Lunwerg, 1999), caption to fig. 55.

39. David Hockney, *Secret Knowledge: Rediscovering the Lost Techniques of the Old Masters* (London: Thames and Hudson, 2001).

40. See http://www.artandoptics.com/papers/stork_fs.html.

41. *Twelve Views of Manet's* Bar, ed. Bradford Collins (Princeton, NJ: Princeton University Press, 1996); my "Precision, Misprecision, Misprision," Reply to Thierry de Duve, in *Critical Inquiry* 25: 1 (1998): 169–80.

42. Aretino, *The Letters of Pietro Aretino,* trans. Thomas Chubb (Hamden, CT: Arcon, 1967).

43. Unpublished lecture, American Academy in Berlin, October 2001.

44. Some results are discussed in my *Our Beautiful, Dry, and Distant Texts: Art History as Writing* (New York: Routledge, 1997), 50–59, and similarly in my "Histoire de l'art et pratiques d'atelier," *Histoire de l'art* 29–30 (1995): 103–112.

45. Snow, *The Two Cultures: And a Second Look* (Cambridge, UK: Cambridge University Press, 1963), 21.

46. For further information, see J.-O. Malmo and Jan-Olov Bovin, "The Real-Time Growth of Atom Planes on Ru, Rh and Sn Microcrystals Observed at Atomic Resolution," *Journal of Crystal Growth* 89 (1988): 165–70.

47. Wesley Colley, J. Anthony Tyson, and Edwin Turner, "Unlensing Multiple Arcs in [Cl] 0024+1654: Reconstruction of the Source Image," *Astrophysical Journal* 461 (April 20, 1996): L83–L86, quotations on p. L86.

48. David Kaiser, "Stick-Figure Realism: Conventions, Reification, and the Persistence of Peynman Diagrams," *Representations* 70 (2000): 49–86.

49. Mandelbrot, *Fractal Geometry of Nature* (San Francisco: W. H. Freeman, 1982); for the nineteenth-century origin of chaos theory in relation to visualization, see Peter Galison, "Images Scatter into Data, Data Gather into Images," *Iconoclash* (Cambridge, MA: MIT Press, 2002), 300–21. My "The Drunken Conversation of Chaos and Painting," *Meaning* 12 (1992): 55–60, discusses the misunderstandings between mathematical and humanist uses of fractal geometry.

50. For a full explanation, see www.meteoros.de/spiegel/spiegel.htm.

51. See http://www.nationalband.com/.

52. The standard textbook is John Russ, *The Image Processing Handbook* (Boca Raton FL: CLC Press, 1995). A good index to literacy in this case is Peter Cope, *The Digital Photographer's Pocket Encyclopedia* (Whittlesford, Cambridge, UK: Silver Pixel Press, 2002).

53. For more information see graphics.stanford.edu/projects/mich/head-of-david/.

54. Lavin, *Clean New World: Culture, Politics, and Graphic Design* (Cambridge, MA: MIT Press, 2001); see also Michele Bogart, *Advertising, Artists, and the Borders of Art* (Chicago: University of Chicago Press, 1995).

55. Garland, *Mr Beck's Underground Map: A History* (Harrow Weald, Middlesex, UK: Capital Transport, 1994).

56. Garland, *Mr Beck's Underground Map,* p. 19.

57. For an interesting use of the diagrams see George Boole, *An Investigation of the*

Laws of Thought, on Which Are Founded the Mathematical Theories of Logic and Probabilities (New York: Dover, 1951 [1854]). The primary source is John Venn, *Symbolic Logic* (London: MacMillan and Co., 1881).

58. Lefebvre, *The Production of Space,* trans. Donald Nicholson-Smith (Oxford: Basil Blackwell, 1991); Kostof, *The City Shaped: Urban Patterns and Meanings through History* (Boston, MA: Little, Brown, and Co., 1991).

59. David Pascoe, *Airspaces* (London: Reaktion, 2001); Erwin Strauss, *How to Start Your Own Country* (Port Townsend, WA: Breakout Productions, 1999); and for micronations see also http://members.tripod.com/rittergeist/.

60. *Harvard Design School Guide to Shopping,* ed. Chuihua Judy Chung, Rem Koolhaas, et al. (Cologne: Taschen, 2001).

61. S. Settar, *Inviting Death, Indian Attitude towards the Ritual Death* (Leiden: E. J. Brill, 1989); Settar, *Pursuing Death, Philosophy and Practice of Voluntary Termination of Life,* Monographs and Theoretical Studies in Sociology and Anthropology in Honour of Nels Anderson, vol. 28 (Dharwad: Institute of Indian Art History, 1990).

62. Compare, for example, Richard Etlin, *The Architecture of Death, The Transformaton of the Cemetery in Eighteenth-Century Paris* (Cambridge, MA: MIT Press, 1984).

Envoi

1. *Iconoclash* (Cambridge, MA: MIT Press, 2002).

2. Crimp, "Getting the Warhol We Deserve," *Social Text* 59 17 (1999): 49–66, quotation on p. 60.

Sources and permissions

Plate 25 The *Laboratorium*. From Heinrich Kuhnrath, *Ampitheatrum Sapientiæ æternæ*, 1595. Hand-colored copy with gold and silver paint, in the Duveen collection. Courtesy University of Wisconsin, Madison.

Plate 26 "Mondrian, *Colored Composition*. Watercolor." Undated. Forged, c. 1996. Present location unknown. From *C. B. Charles Galleries: Nineteenth and Twentieth Century Impressionistic, Modern and Contemporary Paintings,* auction catalogue (Pompano Beach, FL: C. B. Charles, 1997), catalogue no. 73, p. 29. Auction scheduled for February 2, 1997, canceled by the FBI on January 27, 1997.

Plate 27 Matthias Waske, *Vincent with Japanese Eye$*. 1990. Acrylic on canvas. From *Matthias Waske: Visionen und Parodien*, exh. cat. (Munich: Museum Villa Stuck, 1991), fig. 14.

Plate 28 Title page from Carol Zemel, *Van Gogh's Progress: Utopia, Modernity, and Late-Nineteenth-Century Art* (Berkeley: University of California Press, 1997).

Plate 29 Humberto Nagera, *Vincent Van Gogh: A Psychological Study,* with a foreword by Anna Freud (New York: International Universities Press, 1967)

Plate 30 Irving Stone, *Lust for Life* (New York: Cardinal Edition, Pocket Books Inc., 1951). Photo: author.

Plate 31 Top: Mayan tripod bowl. Classic period, c. 600–800 A.D. Private collection. Bottom: diagram of part of the tripod bowl. Diagram by Linda Schele. Top: Photo © Justin Kerr. Bottom: drawing by Linda Schele. Courtesy Sylvia Perrine, Foundation for the Advancement of Mesoamerican Studies, Inc.

Plate 32 Cacaxtla. Mural. Late Mayan. Mexico. Photo from Beatriz de la Fuente et al., *Pintura Mural Prehispánica* (Barcelona: Lunwerg, 1999), fig. 55. Photo courtesy of the Intituto de Investigaciones Estéticas, UNAM, Mexico City.

Plate 33 Dong Qichang, *The Qingbian Mountain*. 1617. Cleveland Museum of Art, Leonard C. Hanna, Jr. Fund, 1980.10.

Plate 34 David Stork, Measurements of St. Peter's hands in Caravaggio's *Supper at Emmaeus*. London: National Gallery of Art. Diagram courtesy David Stork.

Plate 35 Rhodium atoms precipitating into a crystal. Photo courtesy Jan-Olov Bovin.

Plate 36 A cell in bright-field illumination (top), phase-contrast (middle), and Hoffman modulation contrast (bottom). Modified from Robert Hoffman, "The Modulation Contrast Microscope: Principles and Performance," *Journal of Microscopy* 110: 3 (1977): 205–22, fig. 14. Courtesy Bruce Phillips, Modulation Optics Inc.

Plate 37 Fourier transformations of plates 14 (top), 2 (bottom left), and 16 (bottom right). Diagram: author, using NIHimage.

Plate 38 Top: gravitational lens. Bottom: three reconstructions of the object being lensed. From Wesley Colley, J. Anthony Tyson, and Edwin Turner, "Unlensing Multiple Arcs in 0024+1654: Reconstruction of the Source Image," *Astrophysical Journal* 461 (April 20, 1996): L83–L86. Composite of figs. 1, 2, 3; composite by the author.

Plate 39 The tunnel effect. Diagram: author, using InterQuanta.

Plate 40 Mandelbrot set, detail, centered around (-0.23, 0.83I). Diagram: author, using MandelZot.

Plate 41 Deep-sea oarfish. Top: photographer July 26, 1990, off Anami seashore, Hamasaka, Hyogo Prefecture, Japan. Photo courtesy of M. Kajinami. Bottom: Photo © William Leo Smith. Used with permission.

Plate 42 Rainbow, with two reflected bows. Photo © Matthias Zscharnack, Dresden. Used with permission.

Plate 43 Laser-etched stainless steel tags. Courtesy of National Band & Tag Co.

Plate 44 Masaccio, *Trinità*. Santa Maria Novella, Florence. Photo: Art Resource.

Plate 45 Diagram of Masaccio's *Trinità*. From M. Christiani-Testi, "Di Masaccio: Struttura e autografia nella Trinità di Santa Maria Novella," in *Scritti di storia dell'arte in onore di Roberto Salvini,* ed. C. de Benedictis (Florence: Sansoni, 1984), 271–279.

Plate 46 Perspective diagram. From Guidobaldo del Monte [Guido Ubaldo, marchese del Monte], *Guidiubaldi e'Marchionibus Montis Perspectivae libri sex* (Pesaro, 1600).

Plate 47 Top: The right eye of Michelangelo's *David*. Middle: Laser scan at 0.29 mm resolution. Bottom: Portion of the wire frame used to generate the laser scan. Photos courtesy Marc Levoy, the Digital Michelangelo Project and the Soprintendenza ai beni artistici e storici per le province di Firenze, Pistoia, e Prato.

Plate 48 Top: Harry Beck, London Underground Map, detail. 1959 version. Bottom: Beck, parody version of the London Underground map, imagining it as an electrical schematic. March 1933. From Ken Garland, *Mr Beck's Underground Map: A History* (Harrow Weald, Middlesex, UK: Capital Transport, 1994), 48, 25, respectively.

Plate 49 John Venn, Logic diagram for a problem with five terms. From Venn, *Symbolic Logic* (London: Macmillan and Co., 1881), 107.

Plate 50 Pictorial and diagrammatic cave maps. Upper left: the cave imagined as architecture. Upper right: a 3–D labyrinth in diagrammatic and naturalistic forms. Bottom: a naturalistic map with symbols. From S. J. Collins, "Maps to Assist the Caver," *Transactions of the Cave Research Group of Great Britain,* special issue, "Symposium on Cave Surveying" 12: 3 (1970): 165–176, maps on pp. 169, 170, 171.

Plate 51 A wandering Jaina mendicant, called a *Digambara*, on his way to the Small Hill in Sravana Belgola, India. From S. Settar, *Inviting Death: Indian Attitude Towards the Ritual Death* (Leiden: E. J. Brill, 1989), pl. xxx.

Plate 52 The carved foootprints of Jaina mendicants who ended their lives on the Small Hill in Sravana Belgola, India. From Settar, *Inviting Death,* pl. xviii, a, b.

Plate 53 Top: Nureddin, painting on a truck. Saray-e Ferqameshr, Kabul, 1965. From Micheline Centlivres-Demont, *Popular Art in Afghanistan: Paintings on Trucks, Mosques and Tea-Houses,* trans. from French by Robin Charleston (Graz, Austria: Akademische Druck- und Verlagsanstalt, 1976), plates 5a-b. ISBN 3–201–00976–8. Bottom: Poster, printed in Pakistan. From *Popular Art in Afghanistan,* plate 6.

Plate 54 Sculptures of a goddess. Bone. Parthian. 2nd century B.C. From Margerete Van Ess and Friedhelm Pedde, *Uruk: Kleinfunde II,* Deutsches Archäeologisches Institut, Abteilung Baghdad (Mainz am Rhein: Verlag Philipp von Zabern, 1992), nos. 1432–1438.

Plate 55 Jelena Mitrovic, *One Drawing Every Minute for 24 Hours = 1440 Drawings.* 2001. Paper, pen. Installation view. Photo courtesy the artist.

Plate 56 Jelena Mitrovic, *One Drawing Every Minute for 24 Hours = 1440 Drawings.* 2001. Paper, pen. Detail. Photo courtesy the artist.

Index

INDEX

Index